The Contemporary Art Scene in Syria

This book focuses on the expanding contemporary art scene in Syria, particularly Damascus, during the first decade of the twenty-first century. The decade was characterized by a high degree of experimentation as young artists began to work with artistic media that were new in Syria, such as video, installation and performance art. They were rethinking the role of artists in society and looking for ways to reach audiences in a more direct manner and address socio-cultural and socio-political issues.

The Contemporary Art Scene in Syria will be of interest to scholars of global and Middle Eastern art studies, and also to scholars interested in the recent social and cultural history of Syria and the wider Middle East.

Charlotte Bank is an art historian and independent curator with a PhD in Arabic from the University of Geneva.

Cover image: Visual Art Festival, Damascus 2010, view of opening celebration, Zaituna Square, Damascus. Photo credit: Salah Saouli.

Routledge Advances in Art and Visual Studies

This series is our home for innovative research in the fields of art and visual studies. It includes monographs and targeted edited collections that provide new insights into visual culture and art practice, theory, and research.

Abstract Painting and the Minimalist Critiques
Robert Mangold, David Novros, and Jo Baer in the 1960s
Matthew L. Levy

Arte Ambientale, Urban Space, and Participatory Art
Martina Tanga

Theory of the Art Object
Paul Crowther

The Digital Interface and New Media Art Installations
Phaedra Shanbaum

Ecocriticism and the Anthropocene in Nineteenth Century Art and Visual Culture
Edited by Emily Gephart and Maura Coughlin

Popularization and Populism in the Visual Arts
Attraction Images
Edited by Anna Schober

Dialogues Between Artistic Research and Science and Technology Studies
Edited by Henk Borgdorff, Peter Peters, and Trevor Pinch

Contemporary Art and Disability Studies
Edited by Alice Wexler and John Derby

The Outsider, Art and Humour
Paul Clements

The Contemporary Art Scene in Syria
Social Critique and an Artistic Movement
Charlotte Bank

For a full list of titles in this series, please visit https://www.routledge.com/Routledge-Advances-in-Art-and-Visual-Studies/book-series/RAVS

The Contemporary Art Scene in Syria

Social Critique and an Artistic Movement

Charlotte Bank

Routledge
Taylor & Francis Group

NEW YORK AND LONDON

First published 2020
by Routledge
52 Vanderbilt Avenue, New York, NY 10017

and by Routledge
2 Park Square, Milton Park, Abingdon, Oxon OX14 4RN

Routledge is an imprint of the Taylor & Francis Group, an informa business

Library of Congress Cataloging-in-Publication Data
Names: Bank, Charlotte, author.
Title: The contemporary art scene in Syria : social critique and an artistic movement / Charlotte Bank.
Other titles: Contemporary art scene in Syria (Routledge (Firm))
Description: New York : Routledge, 2020. |
Series: [Routledge advances in art and visual studies] |
Based on the author's thesis (Ph. D.)--Université de Genève, 2017, under the title: Contemporary art scene in Syria 2000-2010 : between the legacy of social critique and a contemporary artistic movement in the Arab world. |
Includes bibliographical references and index.
Identifiers: LCCN 2020001296 (print) | LCCN 2020001297 (ebook) |
ISBN 9780367244781 (hardback) | ISBN 9780429282713 (ebook)
Subjects: LCSH: Art and society--Syria--History--21st century. |
Art, Syrian--21st century.
Classification: LCC N72.S6 B33 2020 (print) |
LCC N72.S6 (ebook) |
DDC 709.5691/090511--dc23
LC record available at https://lccn.loc.gov/2020001296
LC ebook record available at https://lccn.loc.gov/2020001297

ISBN: 978-0-367-24478-1 (hbk)
ISBN: 978-0-429-28271-3 (ebk)

Typeset in Sabon
by Taylor & Francis Books

Contents

Figures

Acknowledgements

This book is in many ways a labour of love. The research at its basis was begun during the 2000s as a curatorial project triggered by some puzzling ideas about the non-existence of any interesting contemporary artists in Syria, that I read. It developed into a dissertation project, which I was happy to conclude at the University of Geneva in 2017 under the supervision of Professor Silvia Naef. I would like to thank her for invaluable support she has offered me throughout the project, since I presented my initial idea to her. A position as research assistant in the project *Other Modernities: Patrimony and Practices of Visual Expression Outside the West*, funded by the Swiss National Science Foundation, allowed me to concentrate on my research and writing through a three-year grant. The project managers and my colleagues in the SNSF-funded Sinergia project offered valuable advice during the discussions we had at our regular meetings. A grant from the Fondation Schmidheiny in Geneva allowed me to finish my dissertation and a three-month doctoral fellowship at the Orient Institut in Beirut in 2016 allowed me to supplement my initial research with newer findings related to Syrian artists and their work since the beginning of the uprising as well as to consult a number of private archives and libraries. On this occasion, Saleh Barakat of Agial Gallery in Beirut kindly offered me access to his collection of books and catalogues. Since travelling to Damascus was out of the question, his help was invaluable.

After finishing my PhD, a postdoctoral fellowship of International Scholarship Program at the Staatliche Museen zu Berlin – Preußischer Kulturbesitz gave me the opportunity to spend three months at the Museum of Islamic Art, which I used as a basis to carry out research among displaced Syrian artists in Berlin. It gave me the opportunity to catch up with artist friends from Damascus and also make some new acquaintances.

During my stays in Syria between the years 2007–2010, I was lucky to meet a great number of people who shared with me their thoughts about the role of art in Syria and the importance of allowing a space for young artists and new, contemporary media. I would like to thank Diana El-Jeiroudi, Orwa Nyrabia and Firas Chehab for their help and advice at the beginning of my research and Abir and Nisrine Boukhari from All Art Now, Myriam Jakiche of Ayyam Gallery and Rafia Kodmani of Rafia Gallery for sharing their thoughts about the contemporary art scene in Syria with me during those exciting years, when the art scene in Damascus seemed so promising.

I would like to thank the artists Dani Abo Louh, Ammar Al-Beik, Reem Al-Ghazzi, Hazem Alhamwi, Buthayna Ali, Reem Ali, Mustafa and Samer Barkaoui, Rami Farah, Mohamad Malas, Oussama Mohammad, Kevork Mourad, Mohammad Omran, Yaser Safi and Hrair Sarkissian for sharing their works with me and Mohamad Malas for our discussions about the importance of uncompromising aesthetics in cinema and the arts.

Later, in Beirut, Youssef Abdelké discussed ideas of artistic critique and the commitment of artists with me. I am grateful to Soudade Kaadan for our long, ongoing conversation on the importance of cinema and art, a conversation that is resumed whenever we meet in various places, be it Rotterdam, Beirut, Florence, Geneva or Istanbul.

Over the course of the years I have shared many hours with the painter Marwan, who spent his life between Damascus and Berlin, discussing topics as varied as commitment in art, the meaning of home and our common love for Damascus and its light. Sadly, he left us before I finished my thesis and therefore will never get to see this book. I still miss our conversations.

I would like to thank Mouna Atassi for sharing some of her thoughts on Syrian art, from the early days of modern art till the most recent contemporary production with me. I thank Shireen Atassi of the Atassi Foundation for her help in locating and providing images, Sultan Al Qassimi and Suheyla Takesh of the Barjeel Foundation provided images from their collection, and Ead and Maya Samawi of Ayyam Gallery helped me access images from the Samawi Collection.

I thank Anneka Lenssen and Kirsten Scheid for their help in locating forgotten texts.

I am indebted to Delphine Leccas, with whom I have had the pleasure of working on a number of curatorial projects in Syria and Europe and who has shared with me aspects of her experience and knowledge of the art world in Syria.

Various aspects of my research have been presented at international conferences. Grants from the Swiss Academy of Humanities and Social Sciences and the Société académique de Genève allowed me to travel to and participate in WOCMES (World Congress of Middle Eastern Studies) in Ankara in 2014 and the AMCA/CIADA conference in Singapore in 2015 and to discuss my findings with international colleagues.

Salah Saouli supported this work from the beginning and offered much valuable advice. I thank him for his patience in discussing my ideas and the interest he always showed in my work.

I would also like to thank my mother for her support throughout the years. I only wish I could also have shared this book with my father.

Introduction

This book discusses the contemporary art scene in Syria during the first decade of the twenty-first century in its regional and art-historical context. It examines how young artists sought to re-think the role of artists in society and create a space to re-imagine the world through their work and thus inspire change in the socio-cultural and socio-political spheres. This coincided both with an expansion of the local art scene and the opening of new art spaces and galleries and a growing international interest in contemporary artistic production from the non-West, and with it from the Middle East, in the so-called "global turn" of the international art world.

Although artists from Syria might have been expected to have good prospects in this context, they were comparatively underrepresented on the circuit of biennials, festivals and large-scale exhibitions that proliferated during the 2000s and professed to offer an overview of the artistic production of this vast and diverse region. There are several reasons for this lack of visibility. Syria was, compared to neighbouring Lebanon, considerably less accessible for foreign curators. No contemporary art institutions existed at the beginning of the decade that were well connected to the international scene and immersed in contemporary artistic and cultural discourse, and Syrian artists were generally less mobile and often suffered from rigid visa rules when attempting to travel on an international scale. Furthermore, the country lacked a large artistic and intellectual diaspora, unlike Lebanon and Palestine, an important factor that often proved helpful in securing artists from these locations their place on the global art scene.

While international curators interested in visiting Syria might have faced an array of practical obstacles, many also appeared highly dismissive of artistic production in Syria. Therefore, their negative views were often based on short, superficial visits to the country (or in some cases, no visit at all). To give a telling example, the curator of the exhibition "DisOrientation" at the House of World Cultures in Berlin in 2003, Jack Persekian, visited Damascus briefly in the summer of 2002 to meet artists and what he termed "gallery people", and wrote the following in the catalogue of the afore-mentioned exhibition: "What I saw, …, did not go beyond self-indulgent orthographies and ana-chronistic development."[1] It was judgements such as these that triggered my initial interest in the contemporary art scene in Syria. These criticisms seemed odd in their harshness, particularly in light of the tradition of fine art and filmmaking in the country. And they made me curious to see for myself what the contemporary art scene in Syria was like. But although Syria was not unknown to me, as I had visited the country on numerous occasions before, I had to wait several years, before I was able to travel to Syria and undertake research on-site with a travel grant for an artistic project from the Danish Institute in Damascus. I travelled to Damascus in February 2007 to embark on a

project focusing on the young, experimental documentary video scene. Prior to leaving, I had succeeded in locating one contact online, Diana El-Jeiroudi of Proaction Film, and once I had arrived in Damascus, Diana and her partner Orwa were kind enough to introduce me to some of their contacts. This allowed me to begin building my own network through a snowball system and this was the beginning of a long informal research project that led to several film and video programmes, exhibitions, a PhD project and, ultimately, to this book.

Although I had expected to meet obstacles, even occasional distrust, among artists, I was pleased with the steady progress of my research. I met a group of young artists and filmmakers and videomakers, who had begun experimenting with contemporary artistic media and modes of expression. They came from a variety of educational backgrounds, many had received their training at the High Institute of Dramatic Arts and were now working with video, some had studied at the Faculty of Fine Arts at the University of Damascus, others came from the humanities or other academic disciplines, while still others described themselves as autodidactic artists. Only very few had studied film, because, as Syria did not have a film school, this would have meant going abroad to study, something that presented significant obstacles to young Syrians due to travel and visa restrictions. The majority of these artists were highly critical of what they called the "backwardness" of the University of Damascus' Faculty of Fine Arts and of the entire official, state-sponsored artistic and cultural scene, such as exhibitions, festivals and other events organized by the Ministry of Culture and the Faculty. They seemed keen on redefining their roles as artists in Syrian society, reaching new audiences, addressing critical social issues and even touching upon sensitive taboos or, in some cases, openly challenging conventions of Syrian society and politics. While constantly searching for new aesthetic approaches to address these themes and working their ways around censorship, many mentioned Omar Amiraly, a prominent Syrian documentary filmmaker, as an important inspiration for their own understanding of an engaged, aesthetically innovative art. In their radical search for a new aesthetic language and a redefinition of the role of art within Syrian society, they practised a kind of institutional critique, if we understand this as a critique of art and its institutions as a means to preserve a status quo perceived as stifling.

The 2000s were a period of numerous transitions. A number of my interview partners had placed high hopes in Bashar al-Assad's transition to power after the death of his father Hafiz al-Assad in 2000, hopes he had inspired during his first public appearances as president of the country, and these hopes were shared by large parts of Syrian society (and a considerable number of foreigners as well). Shortly after the death of Hafiz al-Assad, visual artists, filmmakers, writers, journalists and other intellectuals had joined forces in the "civil society movement", also known as the "Damascus Spring movement" and formulated calls for democratic reforms. It was a brief period which lasted until autumn 2001 and saw the organization of political salons in the private homes of the protagonists. Lively discussions took place about Syria's political future as a democratic state and free society, but sadly, such hopes were soon crushed and a large number of advocates for freedom were imprisoned or otherwise forced into silence. Although this was a significant setback, it did not mean an end to artists' advocacy for freedom and change in the country. Rather, the first decade of the twenty-first century witnessed a new generation of artists who took up the legacy of critical, socially committed art, even occasionally venturing onto the dangerous terrain of political critique. Just as former generations of fine artists, writers and filmmakers had used the means available to them, so all my interview partners seemed eager to use the limited opportunities at their disposal to work for social change.

However, like their older peers, these young artists were also subject to state censorship. Even though Syria seemed, on the surface, more open during the first decade under Bashar al-Assad, censorship remained in place and arbitrary rules of what was permitted and what was not were as fluctuating as they had been during the regime of Hafiz. There maybe was a slightly more permissive climate and more work might have passed the censors, but all artistic and cultural production continued to remain subject to censorship, while a lack of openness and clear rules added to a general feeling of uncertainty. Former generations of artists had often expressed critique through elaborate metaphors and symbols, but the young generation was longing for a more direct language. Yet, because of the severe restrictions they faced when they tried to push the boundaries of permitted speech, they often had to revert to old and well-tested solutions.

The atmosphere throughout the decade oscillated between hope and despair, between bustling energy and apathy: on the one hand, artists tried to see the signs of change positively, hoping that the long-term situation of the arts in Syria would improve; on the other hand, they were constantly faced with evidence that effective change was still far away and their own situation as artists as fragile as ever. Adding to this was a feeling of cultural isolation, from which many wished to break free. Former generations of artists had had the possibility of studying abroad, facilitated by a number of exchange programmes with socialist countries which had stopped with the fall of the Iron Curtain. New travel and visa restrictions now made such travel almost impossible. Young artists without connections to people close to the regime and without strong financial backing were largely prevented from travelling and thus felt they were being doubly punished for being Syrian.

My initial stay in February 2007 led to a series of longer periods of sojourn in the following years, during which I expanded my network and met numerous artists and cultural producers. I conducted a series of informal interviews and conversations with artists and collected an archive of videos, films, photos, and field notes in the process. It is this archive that forms the basis of the present work. My interaction with artists and cultural producers mostly happened in those Damascene cafés, where the artists used to meet regularly to discuss their ideas. Occasionally, I would meet the artists in their studios or workspaces and sometimes meetings would take the form of extended lunches and dinners, where the strict lines between professional and leisurely, personal conversation were blurred.

The material I collected in Syria was of quite an ephemeral character. Written sources related to the independent art scene in Syria were never abundant, and mostly were entirely absent. Some artists had portfolios that included texts and images of their work, and sometimes smaller publications, which they shared with me, but only very few artists had a website. This changed only with the uprising. Some exhibitions and events were accompanied by small catalogues. Most artists gave me copies of their films, videos and photos of their work and were happy to discuss their work with me but did not provide any written material. Press material was largely absent from the exhibitions and events, in which my contacts had participated, and, if present, tended to be superficial, largely descriptive, very basic, and, as I perceived it at the time, lacking in critical quality. At the time of my research, I therefore dismissed it as irrelevant and did not collect any of it. In hindsight, this is regrettable, as this material would also have been useful to retrospectively analyse the parameters of the contemporary art scene in Syria during the 2000s. The collected material gave rise to a series of public lectures and a number of film and video programmes which I have curated for institutions in Europe, an enjoyable

opportunity to present works that until then had received little international attention from interested audiences.[2]

The years 2007–2010 witnessed an important development in new artistic and cultural initiatives: in 2008, the festival for creative documentary film "Dox Box" was inaugurated, 2009 saw the first video art festival, organized by the contemporary art initiative All Art Now, and a festival for experimental dance was also initiated in 2009. New galleries opened which claimed an interest in a more conceptual, thematic approach and many more activities were initiated, all adding to the feeling of a vibrant art scene. The artists in my network were part of this emerging scene yet remained sceptical of many of its aspects. In particular, the rise of new, fashionable galleries with their subsequent commercialization of the art scene was criticized on numerous occasions, as it made it even harder for artists to pursue non-commercial interests and maintain a socially critical position. There was also a feeling among many that the economic opening of the country had led to a loss of social coherence and to a general alienation, that what was "genuinely Syrian" was being sold off and the fabric of Syrian society given a fake polish, in order to cover up for the lack of personal freedom and security. At the same time, and paradoxically, there was a strong desire to catch up with the international art scene, to claim a place on the regional scene and to be part of contemporary artistic and cultural practices.

The lack of exhibition space for non-commercial art and techniques other than painting and sculpture remained one of the major problems throughout the decade, despite the initiatives mentioned above. Foreign cultural centres offered a small space of relative freedom, often taking on the task of compensating for the lack of exhibition and screening opportunities for young, lesser-known artists, something which led to them being regarded as important venues by many of my interview partners. These centres (mainly the Centre Culturel Français and the Goethe Institute) were often able to show works of a more critical character than would have been possible at other venues, where they would have been deemed problematic for political reasons.

All these factors made the 2000s a fascinating, but brief episode in the history of art in Syria. It was a time of experimentation and important changes with young artists taking up new forms of expression and private initiatives that sought to expand ideas of suitable venues of viewing art and modes of representation. Beginning with tentative first steps, this young and dynamic movement grew in strength throughout the decade, only to be crushed after the beginning of the popular uprising in early 2011.

During the first year of the revolt, and after a period of hesitation that lasted some months, many artists began to use their work to express solidarity with the peaceful, popular movement for change and to condemn the violence perpetrated by the forces of order against the protestors on the streets. Many of the artists, who had been part of the video movement during the 2000s, were engaged in such activist work. They became involved as trainers, by lending out equipment, but they also used their artistic work for activist means. In general, the new post-2011 works were bolder and more direct than the work of the previous decade. However, the foundation laid for them during that period is undeniable and its importance is emphasized.

The significance of the artistic production between 2000 and 2010 thus lies in its transitional role. It represents a breaking free from certain rigid aesthetics that arguably had guided much of Syrian art up to that point. It was the period in which Syrian artists started working with contemporary artistic media, such as video, installation and performance, practices which have greatly gained in importance since the beginning of

the uprising. Thus, while the Syrian art scene was halted in its smooth development, the changes initiated during the 2000s paved the way for new practices that flourished after 2011 when the artistic environment once again changed substantially. Art in Syria has generally not received much scholarly attention, and this is especially true for the 2000s. It is therefore a period that easily risks falling into oblivion. Yet, I would argue that any attempt to reach an in-depth understanding of Syrian artistic production (or that of Syrian artists who relocated to other countries) since 2011 will need to consider the developments of the preceding ten years. The ease with which artists turned their attention to new technology and to the internet as a space for both dissemination and discussion of art after the beginning of the uprising is hard to imagine without the groundwork laid during the decade leading up to 2011.

Scholarly work on artistic production in Syria remains largely marginal within the wider field of modern and contemporary Middle Eastern art. This turns every new work into an almost "pioneering" endeavour, each piece adding to the body of knowledge and representing a re-thinking of some of its aspects. During the initial stages of my research, I was very interested in miriam cooke's notion of "commissioned critique".[3] It has proved helpful when considering critical works of earlier generations of artists, but less applicable in the context of the young artists working in the 2000s, who produced their work outside state-sponsored institutions. cooke uses the term to describe practices of permitting and even funding the production of critical artworks, works that the state would later use for its own aims, while keeping the artists, filmmakers or writers unsure of the reasons behind this leniency and always afraid of a later crackdown. One particularly striking example of this is the auteur films of the 1980s and 1990s, that were produced by the state film institution, *Al-mu'assassa al-'amma li-l-sinema* (mostly referred to as National Film Organization, NFO in English). These films were of a high artistic standard and were often sent to international film festivals, but were censored at home and never released in Syrian cinemas. Lisa Wedeen's concept of "as if" is useful when understanding the necessity to perform political conformity without the necessity of actual belief. As she argues, it is not the conviction of the truthfulness of claims made by the regime which was essential, but rather the pretence of believing them.[4] This necessity of keeping up a façade of conformity is known from other authoritarian contexts, as is the withdrawal of critique into the realm of private jokes and metaphorical language. In my wish to understand the official culture industry in Syria with its system of censorship, coercion and favours, Cecile Boëx's dissertation on the state-sponsored film industry was invaluable, as it offers an idea of the structures that young artists were criticizing and rebelling against.[5] For a historical perspective of how the art and culture scene in Syria had developed since national independence in 1946 up to the crisis of 1967, following the Six Days' War with Israel, Anneka Lenssen's dissertation offered a wealth of first-hand sources with an in-depth analysis of the social and political context.[6]

The official art scene will not figure prominently in this book. It did not interest me at the time of my stays in Syria and I did not include it in my field research. I was more interested in how the independent art scene organized itself and how young artists managed to get the training they wanted in media not included in the art school curriculum, as well as the channels through which they made their works available to their audiences. The independent and informal character of my research and my status as an independent, unaffiliated researcher might possibly also have complicated any attempts to be more involved with the official art scene. Lacking an institutional affiliation certainly did close some doors, but it might have opened others.[7] I wanted to understand how

young artists defined their practice as oppositional to the official art scene and state authoritarianism. That these artists were willing to discuss such critical issues with me might be partially explained by my unofficial status, in other words, that I was not seen as posing a threat. The resulting informality of my contacts had a substantial influence on the style of my research. I made the deliberate choice not to force a rigid, standardized scheme onto my interviews, but chose to conduct them in a friendly, informal climate, meeting the artists regularly and also remaining in contact with them when I was in Europe. I only rarely recorded the interviews. I soon realized that a recording device created a tense atmosphere that ran counter to my self-understanding as a researcher and that artists would not be comfortable sharing their concerns with me if their words were caught on tape. Keeping my informal method allowed me to develop lasting friendships with many of my contacts, friendships that are still intact, even now that most of them have relocated to other cities in the Middle East or Europe.

Supplementing my initial findings with further research on the state-controlled art scene would surely have been of great value. Besides constituting the structures that the independent initiatives sought to position themselves against, its importance also lies in the fact that it involved those teaching the young generations of artists as well as those guaranteeing exhibition opportunities within the recognized artistic circles of Syria. So, while its importance for such a study as mine is undeniable, the steadily deteriorating situation in Syria since I began turning my initial research into a dissertation project unfortunately crushed any hope of returning to the country for additional research. For this reason, I have to leave this aspect aside here and hope that future researchers might get a chance to fill in these gaps.

Another aspect of art production that I did not include in my initial research was those artists involved in the production of the official celebratory paintings and sculptures of the Syrian president and his family that populated the streets and buildings of the country. While certainly also an interesting subject of study, this was very far from my personal interests at the time.

The Syrian artists whose works I will discuss in this book, all produced their art from an engaged, critical position, believing in the power of art to inspire change. I have found ideas of art as a way of "worldmaking" useful when thinking about this social project of Syrian artists and the effects that the artists hoped their works would have. As discussed by the art historian Marsha Meskimmon and the artist and theorist Dan S. Wang, art can function as "an active constituent of meaning production, rather than a mute 'mirror' onto the world" and a location for the world to be imagined differently.[8] Under constraining conditions, whether economic or political, art might even be the only space in which such imagination is possible when all other options might be stifled.[9] Under conditions that differ strongly from those of Western democracies, artists sometimes take on the role of articulating not only social, but also political alternatives. Thus, during the Pahlavi era in Iran, what is known as Iranian New Wave Cinema offered a space to articulate political and social grievances and discuss alternative arrangements.[10] Similarly, the criticality of Syrian art is very different from that of Western art. It was (and is) produced from a highly precarious position with constant risks for the artist, and the works produced are often much less outspoken than those of Western "committed" or "critical" artists. The restrictive conditions, under which they were produced, necessitated a veiled, metaphorical language, a language that called upon the audience to enter the mind of the artist and read between the lines. Syrian artists produced their critical works driven by a wish to engage their contemporary reality and to get their audience

directly involved in their project of reimagining and remaking the world. When using the terms "committed" or "critical" for these works, it is important to keep this in mind, since all these aspects flow into the particular worldmaking project of Syrian artists.

Despite their misgivings about the way censorship infringed upon their freedom to produce, the young generation of artists was generally careful to avoid overly open confrontations with censors, though there are some important exceptions. But they were also eager to push the boundaries of what was permitted to talk about by using a subtle approach and applying what one might call a "strategy of small steps".[11] Their project was an attempt to work for change from within society, not through open opposition and provocation. The anthropologist and writer Saddeka Arebi described a similar approach she called "measured challenge and response", as used by Saudi Arabian women writers: "resistance, if too organized and apparent, may spark alarm and lead to increasing opposition",[12] but, she goes on to write, "if resistance is too masked or hidden, it may be incorporated as a means by which the dominant discourse displays its tolerance for opposite views and [one] may confuse this tolerance with participation".[13] This neatly sums up the difficult working situation of artists working in authoritarian contexts, regardless of their chosen medium. Artists living and working under such conditions are caught in a continuous and tiresome balancing act, relentlessly assessing and reassessing their work and the risks involved. Despite this, they continue to produce and often succeed in making strong and surprisingly outspoken works.

To write this book, I have relied on my notes from the days of my field research. While preparing my dissertation at the University of Geneva, I attempted to follow up with some artists of my network and talk about different aspects of the previous decade, but these talks were of only limited use, as the artists' memories of that period understandably were often coloured by the violent events that had followed since the uprising began in 2011. Interviews about the past are always challenging due to the selective nature of memory, but this is especially true in the context of political activity and repression, engaged and critical artistic practice included.[14]

When discussing art and artists in Syria, I am using these terms in a broad sense, including the fine arts with its different disciplines as well as cinema that does not fall into the category of mainstream entertainment cinema. Both practices, artistic and cinematic, are closely tied to one another in the context of my work, namely, the intellectual milieu of artists critical of the authoritarian Syrian state. These filmmakers and visual artists knew each other and participated in the same discussions. They were united by a common goal: to work for positive, social change in Syria. Though writers also formed part of these circles of critical, cultural producers, they will not be considered in depth here, I will, however, occasionally allude to works of literature.[15] The work of many young artists that I discuss here often had an interdisciplinary character; it was not uncommon for them to work with video, photography, installation and performance. Many looked to cinema for inspiration and, in particular, the documentary filmmaker Omar Amiralay was seen as an important influence because of his understanding of a cinema as at once personal but also engaged and critical. While a discussion of visual art and cinema as closely linked practices might not immediately offer itself in all contexts, it makes sense here in order to ensure an in-depth discussion of individual artists and their work.

In this book, I am using the term "culture" in the lay sense of "high culture", meaning the production of artists, writers, musicians, scholars, and not in the anthropological sense of the term. I am situating the works of artists in their particular socio-political

context. More than perhaps any other scholar of non-Western culture and art, Edward Said has been influential in stressing the need to look at a subject in connection with its contemporaneity and context and not address these cultures as eternal and unchanging, as the European Orientalist tradition had.[16] This principle has also guided me in my research and analysis of Syrian artists and their work in different periods of the history of modern and contemporary art. Due to the highly personal character of my research as it was fuelled by my curatorial interests and the manner in which my material was collected, I situate myself clearly within the text. Furthermore, I write from a position that regards art as a potentially powerful tool to articulate social and political concerns and to advocate for change of the status quo. In this, I follow the position of my inter-locutors quite closely.

The starting point of this study is the artistic infrastructure and its rapid development during the second half of the 2000s as well as the young generation of critical artists' role in it. I will look closely at artists working in contemporary artistic media such as video and installation, since it is these media which have been of the greatest importance for artists with a socially critical approach during the period covered by this study. While critical, painted works have played an important role in the history of modern art in Syria, they only played a minor role in this artistic approach in the 2000s. I will link the works of this recent generation to what I propose to call "moments of criticality" in the works of earlier generations, i.e. artworks (painting and auteur films) that have taken a critical stance vis-à-vis current issues. In contrast to neighbouring Lebanon, artists in Syria have mostly seen themselves as critical, active members of society and have used their art as a vehicle to express their political and social concerns. Since the union of Syria and Egypt in the short-lived United Arab Republic (1958–1961), the Syrian state has formulated a cultural policy which stresses the role of artists in national progress and, since the Ba'ath Party came to power in 1963, it has sought to actively influence artistic production. Many artists have, however, resisted where they could. That said, not all artists in Syria viewed themselves as oppositional or pursued a declaredly emancipatory or activist project. But, it would exceed the thematic scope of this study to consider those artists who have chosen to take an apolitical stance and concentrate on purely aesthetic questions.

The Structure of the Book

In Chapter 1, I focus on the historical, social and political context of artistic production in Syria. Beginning with a discussion of one of the first painters born in those Ottoman provinces that were later to become Syria, Tawfiq Tarek, and how he applied his art to articulate a critical stance on his contemporary society, I turn attention towards the political framework provided by the Syrian state throughout its history as well as how different state institutions, such as censors, have affected the working situation of artists. I conclude with a discussion of the changes in the art world and its infrastructure during the 2000s. Howard Becker's notion of the "art world" as networks of individuals, groups and institutions, all of whom contribute to the production, distribution, presentation and reception of art, has been useful when thinking about the Damascene art world and its participants. According to this understanding, an art world includes "workers" at every level involved in making works of art possible, from those offering different kinds of "support" work to the highly specialized artists themselves, as well as those involved in the presentation and reception of art.[17] While these ideas have helped me understand the

different modes of production and collaboration among artists and cultural producers, my main focus in this book is on the artists and their work. I do, however, acknowledge that they do not operate in a vacuum. The artistic infrastructure, as it existed and developed in the course of the decade, was formed by three elements: (1) the official art scene largely controlled by cultural and artistic state institutions; (2) the privately owned, commercial galleries; and (3) the new, independent and experimental initiatives, such as independent festivals and art spaces, workshop initiatives and other activities that do not fall into the first two categories. My work and research in Syria were strongly focused on the last category, occasionally entering into the field of commercial galleries when they claimed an interest in new artistic media and techniques – a claim not always substantiated. The interest of these galleries was clearly commercial and particularly in the case of one of the new galleries, mainly lay in the promotion of art as an investment.

Chapter 2 is focused on the artists and their perception of self as engaged social actors. I discuss the notions of "critical" and "committed" art as they were articulated by Western theorists and their translation into the Syrian context. Since the Arabic term for "committed art", *al-fann al-multazim*, has often been misused by authoritarian and dictatorial regimes, many artists have become wary of the term. This should always be kept in mind when discussing art of the Arab world in relation to this concept. The term "critical art" has been used in Western contexts in relation to contemporary artistic practices which include a great variety of media and often use performative and partici-patory approaches. While such practices have not played an important role in Syria (or in the wider Arab world), the idea of an art that challenges and questions the status quo and thereby suggests the possibility of a world with different social and political structures comes very close to the particular worldmaking project of Syrian artists. Central in much of Syrian art production, from the beginning of oil painting in the European modality to the video works of the younger generation, is a strong belief in the transformative powers of art as a space within which to imagine a different world and as a tool that can be applied to achieve change by installing a wish for this change in its audiences. I close the chapter with a brief discussion of the audiences of contemporary art works in Syria.

Chapter 3 is dedicated to the art works themselves, relating contemporary art works to works by previous generations of artists and filmmakers. I pursue four thematic lines, through which Syrian artists have voiced their criticism of social and political conditions and advocated for positive change: The first examines the issue of Palestine as caught between official ideology, the personal activism of artists and its use as a metaphor, the second takes a close look at works that address the presence of unseen threats in Syrian society through the use of metaphorical language, the third discusses works that critique particular forms of societal rigidity, such as reductive gender roles and normative beha-viour; and the fourth presents an analysis of works that challenge official discourse and taboos and venture into the terrain of political critique.

In Chapter 4, I focus on the complex relations of Syrian artists and the international art world. I begin with a discussion of the increased international interest in contemporary art from the Arab world or the Middle East in the context of the globa-lizing art world of the 1990s and 2000s and discuss some of the problematics at play, such as essentialist representations of Arab/Middle Eastern/Muslim artists. Since Syrian artists were largely absent from many large-scale exhibitions staged in the West during the 2000s, which sought to provide a comprehensive view of artistic production in the Middle East, I examine the possible reasons for this relative under-exposure. This lack of

visibility during the 2000s stands in stark contrast to the situation following the beginning of the uprising-turned-war in March 2011. The last section of Chapter 4 turns attention to artistic production after that date and its international reception. The uprising put an abrupt halt to the development of the art scene in Syria and prevented many promising initiatives from reaching their full potential, but also led to new forms of artistic practice that gained in importance as artists strove to articulate their positions on the political situation and advocate for peaceful change. One of the most notable was the role of the internet, which developed into a major space for artistic debates and the distribution of critical art works very soon after the beginning of the uprising. This led to an increased visibility of artists, whose works were widely shared among online communities and caught the attention of international curators and festival organizers. I close the chapter with a discussion of the complexities facing Syrian artists, who have been displaced and find themselves in environments that differ strongly from that in Syria, such as the risks of their works being fetishized as "war art" and presented through an essentializing lens. As artists attempt to come to terms with personal and collective traumas, this presents important challenges to their work and existence as artists.

This book is based on my PhD dissertation, which was written between 2012 and 2017. Sadly, the period of writing was also coincidental with Syria's descent into total disaster. Most artists who were part of my network in Syria, and whose work I discuss here, were forced to leave the country, some of them after experiences of imprisonment and violence. Those who stayed were facing extremely difficult living and working conditions. However, it would be a mistake to expect the artistic and cultural life in Damascus to have come to a complete halt, although it has lost the vibrancy that characterized it in the 2000s. The Faculty of Fine Arts at the University of Damascus remains open and each year sees new graduates. Exhibitions are still being held, but are mainly organized by people with close relations to the regime. One sad consequence of this is a certain disconnect between artists living in Syria and those outside, something that is particularly problematic for the young, recent graduates of the Faculty. As I write these words, in late 2019, Syria's future continues to appear dark. Even if fighting has decreased and the regime has celebrated the end of the war by re-opening the National Museum in Damascus in 2018, it does not change the fact that many Syrian cities are in rubble, and millions of Syrians are dead or displaced.[18] During my writing, it was not always easy for me to focus on a period that seems so innocent in retrospect and yet, throughout the entire process, I was driven by the wish to ensure that the work of the young artists discussed here, much of which was so ephemeral, is not forgotten. It is my firm conviction that the creative production since 2011, and the substantial attention it has received, owe much to the work of these young people, who, with a great sense of adventure, embarked on a practice in artistic media that was at that time new to the Syrian art scene and largely unseen in the country.

Notes on Transliteration and Titles

For the sake of readability, I have chosen to limit the transcription of diacritics to "ayns" and "hamzas" in Arabic technical terms, titles and certain personal names.

For the transcription of artists' and art world professionals' names, I adopt those favoured by the artists or art professionals themselves or the most common spelling as they appear in international art publications.[19] These do not always conform to standard linguistic rules, but have been chosen to facilitate further research and to make the study

more accessible to non-Arabists and to members of the global art history community. For the names of Arab institutions, I am using their English names, if they use one, since these are generally used in international literature and the common English transcriptions. When mentioning these institutions for the first time, I provide the Arabic names as well. In the case of titles of artworks, I give both the Arabic and the English title, if they have one. Some later art works, especially those produced after artists have left Syria, do not have Arabic titles.

Notes

1 Persekian (2003), p. 96.
2 Programmes include: *Positions: Experimental Short Films and Videos from Lebanon, Palestine and Syria* at Casino Luxembourg, Forum d'art contemporain, City of Luxembourg, in 2008; *A Silent Cinema: Highlights des syrischen Kinos* at Arsenal, Institute of Film and Video Art, Berlin, in 2009, *Sites of Memories: Experimental Film and Video from Syria* at the Museum of Contemporary Art, Roskilde, Denmark, in 2010; *So Close in the Distance: Young Arab Video Art* at the European Media Art Festival, Osnabrück, Germany, in 2011 and *Behind Walls: Recent Films from Syria* at Arsenal, Institute of Film and Video Art, Berlin, in 2011 and the Overgaden Institute of Contemporary Art, Copenhagen, in 2012.
3 cooke (2007).
4 Wedeen (1999).
5 Boëx (2011a).
6 Lenssen (2014).
7 See Lenssen (2011) for the access policies of official art institutions in Syria. It even proved difficult, though not impossible, for me to get permission to use the library of the IFPO (Institut Français du Proche Orient).
8 Meskimmon and Rowe (2013), p. 7; Wang (2003), p. 69.
9 For a similar development in another context, namely, in South Africa, see Arnold (2013), p. 127.
10 Egan (2011a), pp. 44, 46.
11 See Chapter 2, Section 1.2.
12 Saddeka Arabi, quoted in Nashashibi (1998), p. 180.
13 Saddeka Arabi, quoted in ibid., p. 180.
14 See Adams (2005), p. 534, for a discussion of a similar problematic when writing about politically engaged folk art in Chile under the Pinochet dictatorship.
15 See cooke (2007) for a study that includes visual artists, filmmakers and writers.
16 Said (1979), p. 15.
17 Becker (1982), pp. 2–4.
18 See www.theguardian.com/world/2018/oct/28/syria-national-museum-damascus-reopening-hailed-as-return-to-normal-life (accessed 10 December 2019).
19 Joanne Lisinski, former head of research at Mathaf Museum of Modern Art, discussed the issue of the "correct" spelling of Arab artists' names at the Global Art Forum in Kuwait in 2015. Available at: www.youtube.com/watch?v=4b-rE-nh_hI (accessed 10 December 2019).

1 "Culture Is Humanity's Highest Needs"
Art and Artists between Autonomy and Coercion

On 18 September 2015, an article was published in the Syrian pro-government newspaper *Tishreen*, in which Prime Minister Wael al-Halki was cited talking about the "vital role Arab artists have in enhancing the notion of belonging while immunizing the Arab society against radical *takfiri* thought".[1] According to the newspaper, in his speech, al-Halki further elaborated on the Syrian leadership's role in supporting the "creative and artistic movement" that had "boomed" thanks to its (i.e. the government's) support, despite efforts to "weaken and isolate its role".[2]

Coming amidst the country's embroilment in an extremely violent war, in the course of which the regime did not hesitate to arrest or pressure artists and cultural producers on several occasions, these statements seemed cynical, to say the very least. At the same time, this attempt by the state to co-opt artistic production and make artists work for its ends was nothing new in the country. Yet, the way the statement stood in stark contrast to the state's actual treatment of artists added a new and more sinister dimension to the complex relationship between the Syrian state and the artists living and working within its borders. Since the beginning of the uprising in March 2011, artists and cultural figures have been scrutinized by the security apparatus and subjected to coercion to a degree, which exceeds that of the already closely monitored artistic and cultural scene and the control of state censorship. Particularly prominent examples of this were the attack on caricaturist Ali Farzat in August 2011, during which the attackers (believed to be "thugs" close to the regime, so-called *shabiha*) crushed Farzat's hands,[3] the imprisonment of the painter and graphic artist Youssef Abdelké in July 2013,[4] the short detention of filmmaker Mohamad Malas in March 2014, when he attempted to travel to Beirut, en route to Geneva in order to present his new film at a festival,[5] and the arrest of the sculptor Wael Issa Kaston, who was tortured to death shortly after his detention in July 2012.[6] These artists were in no way involved in the more violent aspects of the Syrian uprising, nor had they joined any armed groups fighting the regime or expressed any support for such groups. And yet, they were treated as major enemies of the state. In a certain, perverse way, this testifies to the importance that the Syrian state accords to art and artists.[7]

While the Syrian state both has assigned and continues to assign art a particular power, Syrian artists themselves have also considered themselves to be active participants in the social and political sphere, for instance, lending their support to the state-building efforts after the country gained independence in 1946. Indeed, any notion of art as an autonomous phenomenon, moving between private galleries and non-profit art spaces, public museums, and independent journalistic criticism as is normal in liberal democracies and remote from any concerns related to social and political reality, is and was quite remote from the realities of the art scene in Syria.[8] Artists in Syria have always been

conscious of the context they were working within and have acted accordingly, keeping in mind the political ramifications of the stances reflected in their work, their lives as social participants, and of course their very subjective being-in-the-world. However, the gap between their self-perceived role and the one defined by the authorities has often given rise to conflictual situations.

Although the Syrian frame for artistic and cultural production might be considered less rigid than the one, for example, in Iraq,[9] artists in Syria have been subjected to ever-vigilant censorship. Official institutions made sure to let artists know that they and their activities were being monitored and that there were limits to their freedom.[10] As in other authoritarian contexts, the relationship between artists and the Syrian state was a troubled one. When discussing the unofficial art scene in the Soviet Union, the political sociologist Paul Sjeklocha and the artist Igor Mead have demonstrated how authoritarian states view the artist's gifts as their own, thus regarding the possession of artistic talent as the possession of material which rightly belongs to the state. The artist's demand for creative autonomy is thereby countered by the state's demand for political use of this creative energy.[11]

Since the Ba'ath Party came to power in Syria in 1963, officials and party-affiliated critics continuously have called upon artists to produce works that "reflected the contemporary conditions of living in Syria, in the Arab world while staying rooted in their heritage", thus making the message clear they expected "their" artists to convey through their work.[12] Artists, who did not wish to blindly follow the party line, became more and more involved in a difficult and energy-consuming balancing act, seeking to guard their freedom to produce the art they wished, while, at the same time, trying to circumvent the state's efforts to co-opt their often-critical works. As the Arabist and literary scholar miriam cooke writes, the authoritarian state relentlessly sought to appropriate messages that proposed an alternative to state ideology in order to create its own cultural capital. It thereby forced artists to find a way to produce their art so that it would avoid being appropriated while still challenging the state.[13] One way to do this was to have recourse to the use of metaphorical and allegorical language, a practice common in the fields of literature, theatre and film. The situation became particularly dire during the regime of Hafiz al-Assad (1970–2000) and, despite initial hopes for an improvement in the political climate in the country, barely changed under his son and successor, Bashar al-Assad. Though less rigorously enforced, censorship remained firmly in place, as did the general uncertainty regarding unwritten rules of what was permitted and what was not.

The preceding remarks make clear that any study of art in Syria will have to take into account the country's shifting political and social conditions, the role accorded to artists by the authorities and, with this role, all the written and unwritten rules which any artist or cultural player had to consider when acting. In this chapter I will discuss the relationship between artists and the state, along with the framework provided by the Syrian state and its institutions involved in organizing, encouraging and supervising artistic life in the country. Since the practice and appreciation of art in the European modality were closely linked to projects of modernization, progress and state-building, I will begin with a brief outline of some aspects of the relationship between fine art, especially painting, and projects of modernization of the late nineteenth and early twentieth centuries. The pioneering artist Tawfiq Tarek will serve as an example to discuss how art became a site within which to express critique of the status quo and negotiate social and political change.

I will then outline the developments of the post-independence era and, in particular, the period under the rule of the Ba'ath Party. I will end by focusing on my main period of interest, i.e. the first decade of the twenty-first century. I will discuss the social and political changes of that time, how a young generation of artists and cultural producers attempted to push the boundaries of permitted speech and create new spaces for the representation of art and its related discourses.

1.1 Art as an Index of Modernity and Progress: The Syrian "Pioneer" Tawfiq Tarek

Faced with European colonialist expansion, Arab intellectuals of the late nineteenth and early twentieth centuries had largely become convinced that the Arabs had fallen into a state of stagnation and believed that only a radical break with traditional culture would enable the region to move on and achieve true modernity.[14] In a process referred to as *tathqif*, "enculturation", norms of social behaviour and interaction were to be reassessed, and those regarded as harmful discarded.[15] Modern discourses, as they developed in the imperial capitals of Istanbul and Paris, were eagerly followed by the Arab elites, who also adopted Western styles in both dress and interior design, paralleling a substantial change of outdoor spaces in cities throughout the Ottoman Empire during the nineteenth century, where new quarters modelled on European urbanization were built and public monuments were erected on central squares.[16]

Fine art, its practice and its appreciation were granted an important role in this process and intellectuals and civic leaders were intent on nurturing the understanding of art among the elite, those upper- and middle-class strata of society whose resources allowed them to participate in the process of *tathqif*.[17] It became common practice to decorate indoor spaces with painted frescoes, oil paintings and photographs and to commission oil portraits and murals for the walls of the formal rooms in private houses. Patrons sought to manifest their modernity in their choice of motifs, which often presented modern inventions like steamboats, factories and railways or even referred to dramatic, current events, such as the Paris Commune or natural disasters.[18]

Artists understood themselves as playing a crucial role in this civilizing mission. From the late nineteenth century onwards, Arab artists had begun to travel to Europe or Istanbul to study art or, alternatively, sought tuition from European painters who were living in the region.[19] The first artists from the Arab world who studied art in Europe are generally referred to as the generation of *ruwwad*, "pioneers", in Arabic. The *ruwwad* painters have often been treated somewhat harshly by later Arab art historians and critics. Their work has been criticized as derivative, as following the works of European artists too closely. While Egyptian art historians have been particularly severe in their criticism of the early painters as "bourgeois" and failing to display "Egyptianness" in their work,[20] Syrian art historians have been less severe, although they have also stressed the imitative character of Syrian *ruwwad* artists' work and deplored the lack of interest among the artists in radical, international modern art movements.[21] In general, later Syrian art historical writing on the *ruwwad* artists tends to focus on a few, canonical artists, whose work is treated descriptively rather than analytically, while the socio-cultural and political context of their work is almost entirely ignored. Likewise, any individual motivation in thematic choices is hardly considered.

In recent scholarship of painters of the Late Ottoman Empire and the states created on its territory after its demise, a re-reading of the works of these artists has begun to take place, which takes their particular socio-cultural environment into consideration and

acknowledges the social agency of these artists and their commitment to change of the political and societal status quo.[22] If their work had previously been described as out of touch with artistic debates happening in avant-garde circles in Europe, recent scholarship has shown the particular agency of these artists, as intellectuals and active members of their societies. Even if their works adhered to the rules of academic painting, they appear to have based their stylistic and thematic choices on very conscious choices, often applying their skills to comment on current issues and advocate for social and political change. The art historian Nadia Radwan has discussed how Egyptian artists, such as the painter Mohamed Naghi and the sculptor Mahmoud Mukhtar, consciously chose not to follow avant-garde European artistic movements as a form of cultural resistance and as a way to keep close connections to their home country.[23] Another example is the early-modern painters in Lebanon and the Nude as a sign of modernity. The anthropologist Kirsten Scheid has demonstrated how the painter Moustapha Farroukh deployed the trope of the Orientalist odalisque as a way to comment on the marginalized social role of women in his contemporary society by drawing a parallel between women living in luxurious seclusion and caged birds.[24]

In what follows, I would like to discuss some aspects of the work of the Syrian *ruwwad* painter Tawfiq Tarek, thereby approaching my subject along a similar line of thought. But before I begin, I would like to mention a number of caveats. Tawfiq Tarek has been described as the first major Syrian artist by later Syrian and Arab art historians. But he was born in Damascus as a subject of the Ottoman Empire in 1875, and, following in the footsteps of his father and grandfather, both of whom had been Ottoman officers, entered the Military Academy of Istanbul in 1893 after having completed his secondary schooling in that city.[25] It was probably in Istanbul that he began his training as an artist, which he later completed in Paris.[26] He is described as having been influenced by Ottoman artists and their carefully constructed, "documentary" style, but not much is known as to how his time in Istanbul may have influenced his decision to pursue a career in art.[27] Tarek's time at the Military Academy was only short. In 1893, he was arrested for his involvement with a nationalist group and released on condition that he leave the city. He was granted asylum in Paris in 1895, where he studied drawing, land surveying and urbanism at the École des Beaux Arts. He graduated in 1901 and returned to his city of birth to work as an architect and topographer and was involved in restoration work on several historic buildings in the city, while continuing to paint. How does the "Syrian" artist Tawfiq Tarek fit into this biography? For a large part of his career, Tarek was an Ottoman subject, after the fall of the Ottoman Empire, Syria (together with Lebanon) came under French mandate rule and, as I will discuss further, Tarek was an outspoken critic of the French presence. But he died in 1940, six years before Syria gained its independence as a sovereign state. As discussed by the art historian Vazken Khatchig Davidian, in relation to Late Ottoman Armenian artists, the rigid frame of nationalist art history is greatly problematic and risks obliterating crucial details that would help our understanding of such artists' oeuvre. This aspect is echoed by Nadia Radwan's discussion of how Egyptian art historiography has frequently failed to acknowledge the cosmopolitan character of the Egyptian art scene of the first decades of the twentieth century and its influences on artists. In Istanbul and in France, Tawfiq Tarek came into contact with international artists, in Istanbul, he might have studied briefly with the Russian-Armenian artist Ivan Aivazovsky and at the time of his sojourn in Paris, the city was attracting artists from the entire world.[28] An artist like Tarek, who through his activities appears to have been

keenly interested in the world around him, is sure to have engaged with the different ideas and aesthetic approaches circulating in these artistic environment and have been well equipped to form ideas of his own. The narrow view of a nationalistic artist who was unable to develop an artistic language of his own and therefore stuck with his French, academic training does not seem to do him justice. I would therefore rather suggest that he very consciously chose the artistic formats he worked with, because they appeared as the most useful ones for his particular project.

For Tawfiq Tarek, the strictly academic style he had learned in Paris became a vehicle through which to express his critique of contemporary Arab society and call on his compatriots to reflect on the lessons offered by Arab history and their relation to the present.[29] He seems to have consciously adapted modes and genres of European painting, such as Orientalism and history painting. In an early work, created a few years after graduating, Tarek offered a historical allegory that may be seen as a "wake-up call" to his contemporaries. The painting, *Abu 'Abd Allah as-Saghir* (1322 AH /1903–1904 AD, Figure 1.1) appears at first sight to be a classical, Orientalist painting. In fact, it is a simplified copy of details of a painting by the French Orientalist Paul-Louis Bouchard (1853–1937), *Les almées* (c.1893), showing a so-called "harem scene" of an "Oriental pasha" watching two women dancing.[30] But Tarek did not wish to show a titillating image of "Oriental debauchery", as was common in European imagination. By way of the painting's title, he sought to convey a different meaning: Referring to the last Muslim ruler of al-Andalus, the very person who lost his realm to the Christian conquerors, he seemed to suggest that it was the idleness and decadence of the prince that had cost him his kingdom. And by extension, it was the inability of Arab notables of his own time, that was the reason for the sad state of contemporary Arab societies.[31] In this way, the painting was to serve as a lesson to Tarek's contemporaries, to learn and draw parallels from history and take a critical view of contemporary leaders.

The use of history to draw parallels and learn lessons for the present and future was an idea commonly advocated by Arab and Muslim intellectuals of the late nineteenth and early twentieth centuries. It included gaining knowledge of important moments of Arab history and its heroes and was regarded as an important step towards regaining national pride, overcoming foreign domination and becoming the equals of modern Europeans. Particularly the youth should be encouraged in this pursuit of knowledge and through it prepare themselves to rebuild their societies.[32] History as a well from which to draw lessons is also powerfully illustrated in a much later work by Tawfiq Tarek: *Ma'rakat Hittin* (*The Battle of Hittin*), painted in 1940, the year of his death. The painting appears as a classical history painting, of seemingly monumental dimensions,[33] showing the decisive victory of Salah al-Din al-Ayyubi (Saladin in European sources) over the Crusaders with the confrontation between Saladin and his Crusader adversary at its centre. Tarek remains firmly within the conventions of the genre in his focus on the actions of heroic individuals, favouring the drama of the moment over historical exactitude. As the genre developed in the eighteenth century, it "attempted to weave together the heroism of individuals with universal moral messages embodied by those individuals at particular moments – specific scenes illustrating eternal truths", thereby it should not just "record on canvas important historical moments for their own sake", but use "particular kinds of events to express 'truth'".[34]

The choice of Saladin and his victory as the subject of this painting is of interest for several reasons: the figure of Saladin had a particular significance as an important symbol of anti-imperialist resistance after the First World War and during the French Mandate.

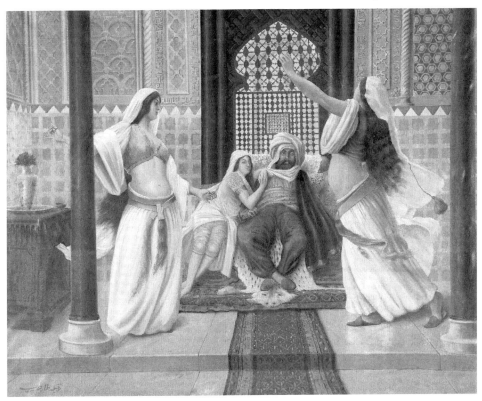

Figure 1.1 Tawfiq Tarek, *Abu ʿAbd Allah as-Saghir*, oil on canvas, 100 x 80 cm, 1322 AH / 1903–1904
AD, Damascus National Museum
Source: Photo credit: catalogue DACC 2008.

A commonly told anecdote, which even found its way into a novel by ʿAbd al-Rahman
al-Basha, tells how the French High Commissioner General Gouraud visited the tomb of
Saladin upon entering Damascus, declaring: "Saladin, nous voilà!"[35] This incident served
to underline the arrogance of the colonialists and the need to oppose them. And even
though traditional Shiite historiography saw Saladin as an enemy of Islam due to his
conquest of the Shiite Fatimid caliphate in Egypt and his oppression of the Shiʿa, also
Arab Shiite writers of the twentieth century, like their Sunni and Christian counterparts,
saw in him a symbol of anti-imperialism. Thus, to protest against the French Mandate in
Syria, the Lebanese Shiite writer Muhammad ʿAli al-Haumani (1896–1964) wrote a poem
entitled "At the Grave of Saladin" in 1925/26.[36] So, when Tawfiq Tarek evoked the
Ayyubid hero and his victory in 1940, at a time where Europe was at war and France
under considerable pressure, it appears as if he wanted to remind his fellow Syrians that
history can change and that just like the Crusaders had been defeated, so might France
and the dream of independence for Syria could become reality. Tarek wanted to create a
parallel between the historical event and contemporary reality, the outcome of which was
still uncertain.[37]

Tawfiq Tarek's work remained within classical academic genres that were not
commonly associated with critique and therefore they appear conventional at first glance.

However, I would argue that his stylistic choices were deliberate and consciously made with the definite intention of subverting them and giving them a new purpose. They were rooted in a wish to offer an accessible critique of social and political conditions, in a style of painting to which his educated audience was beginning to become accustomed to. As with other painters of the *ruwwad* generation, this innovative aspect of Tarek's work was overlooked by later Arab art historians. For them, an important point of criticism was the lack of interest in the radical, modernist art movements among the *ruwwad* artists, although these coincided with their stays in Europe and shook the art world there. But the concern of the early Arab artists was clearly a different one than that of the revolutionary avant-garde in Europe, it was not modernist "in the sense of fitting with art movements that aimed to destroy artistic traditions and radically reconfigure perception".[38] For Arab *ruwwad* painters, artistic modernism meant oil painting, mostly in academic genres.

Fine art in the Arab context was closely linked to national, societal and cultural concerns and the idea of an art that was disinterested and detached from these questions was remote from the artists. Thus, the notions of artistic autonomy and "l'art pour l'art", ideas discussed in Europe at the time, had almost no importance for Arab artists, as it rarely had for other non-Western artists working in the contexts of late colonialism and de-colonization.[39] Their project was a different one; it was a project of modernization, of "overcoming" a perceived backwardness, of "catching up" with the European development, a project of empowerment and social transformation. Linked to these concerns was the wish to prove that Arab artists could master the new medium and, thus confirm their ability to participate in the modern project. This was also meant to prove the high civilizational standard of Arab societies and that they were ready for political autonomy and national independence.[40] Tawfiq Tarek and his Arab peers appear to have felt that the classical academic style, with its carefully composed and skilfully executed, realist images was the style best suited for this task.

Tawfiq Tarek offers a good example of how Arab artists consciously employed academic genres to comment on current issues in their societies. If the work of these early painters has mostly been regarded as derivative or at least as expressions of a still immature period of "learning", taking a new look at this artistic production can bring forth new and interesting details and help us gain a better understanding of the beginnings of modern art practice in the Middle East. It has long been the habit to regard the transition of the Arab countries to independence as constituting a more or less categorical break, separating the practice of artists of the post-independence era from that of earlier *ruwwad* artists. Thus, Silvia Naef distinguishes two major periods of modern art in the Arab world, one of "adoption" corresponding to the *ruwwad* generation and one of "adaptation", roughly corresponding to the generations of post-independence artists.[41] During the period of "adoption", mastering the skills and technique of oil painting would have been at the centre of artists' efforts, whereas the period of "adaptation" would have been characterized by a greater maturity and artists' increasing capability to apply their skills to projects of their own and develop independent artistic languages. But as the examples of Tawfiq Tarek and Moustapha Farroukh show, a different reading of the early *ruwwad* painters and their relationship to later generations of artists is possible, namely, that of commitment to social renewal as a project that runs through the history of modern art in the Arab world. The *ruwwad* artists were not only active as artists, and as critics of their contemporary social and political status quo, they were also intent on educating future generations of artists and were highly influential in fostering modern art

scenes in the cities of the Arab world. After returning home from their studies in Europe, they took up teaching positions and helped build up art academies and thus laid the important ground for later developments. Tawfik Tareq contributed significantly to the establishment of the art scene in Damascus, one of his activities was the establishment of an art association called *Nadi al-funun al-jamila* (The Fine Arts Club) with a group of artists from different fields, in the 1930s.[42]

1.2 The Artist and the State: Navigating Artistic Freedom, Censorship and Threats of Co-Optation

In 1940, the Egyptian artist Mohamed Naghi wrote in his text, *Art et dictature* (Art and Dictatorship):

> Art symbolizes the freedom of the individual, of which it is the last refuge: the dictator has also brought his inquisitorial sight into this domain. Here the individual can still avail himself of the lot of his natural abilities and transgress even the laws that a necessarily limited rationalism draws up for us, and this is where the tyrant wants to exercise his powers. Art is subject to his direct assessment; it is reduced to the level of zealous propagandist; it is servant of whatever social philosophy an individual man fancies imposing on his fellow men …[43]

Naghi, who was then Director of the Museum of Modern Art in Cairo, wrote this text before the background of European fascism and heated discussions in Egypt pertaining to the role of art and artists in society and called on the Egyptian state to ensure the freedom of artistic expression.[44] The freedom of artists was one of the key demands of the group known as *Al-fann wa-al-hurriya* (Art and Liberty), which was founded by a number of Egyptian writers and artists around the poet Georges Henein in the late 1930s. The group called for freedom to create and for an engaged and progressive stance towards current political and social developments, for the "correlation between art and social engagement".[45] In their manifesto, *Long Live Degenerate Art* (1938), they declared their solidarity with their European colleagues who were under attack from the fascists and positioned themselves against similar ideas in Egypt.[46] The group aligned itself with the FIARI platform (Fédération Internationale de l'Art Révolutionnaire Indépendant, or International Federation of Independent Revolutionary Art), an initiative by André Breton, Diego Rivera and Leon Trotsky which was to be a synthesis of intellectuals and creative workers worldwide and agitate for freedom of expression and creativity. The Egyptian Art and Liberty group, among whose members were many Surrealist artists, was active on various fronts, supporting women's liberation and workers' rights as well as organizing art exhibitions and lectures and publishing books and pamphlets with the aim of educating the public and calling for social renewal. Ramsis Yunan, a Surrealist painter and a prominent member of the group, expressed this commitment with the following words: "Belief that the social order needs to be changed has led the surrealists to declare war on the acceptance of the status quo."[47]

As this example shows, for many artists in the Arab world, engaging in societal debates and using their art to advocate for change of the status quo appears to have been a natural part of their self-perception as artists, as active social agents. Above, I discussed how Tawfiq Tarek combined modernizing and anti-colonialist commitment with aesthetic pursuits and educational efforts. But as committed social participants, artists

also often paid a price, that of being subjected to different measures of coercion. For Arab artists, as for artists in other authoritarian contexts, the possibility that state officials would interfere with artistic production was a recognized reality. Artists and political players alike ascribed a particular power to art, the power to influence and direct a society's thinking. This stands in stark contrast to ideas of "l'art pour l'art" or "art for art's sake", as well as the modernist notion of the autonomous artist, working in a sphere separate from the concerns of the world, ideas that are also often dominant among people outside the art world in the European context. In this view, art is seen as a sphere separate from society and its more mundane issues. Not so in authoritarian states. Here, art is generally regarded as a powerful tool, a tool that can and should be used to disseminate certain ideas and ideologies, and which at the same time needs to be strictly controlled, lest its influence on society run counter to the wishes of those in power. Thus, in their study of the unofficial art scene in the Soviet Union referred to above, Sjeklocha and Mead discuss how authoritarian states insist on viewing the artist's gifts as their own, thus regarding the possession of artistic talent as the possession of material which rightly belongs to the state. The artist's demand for creative autonomy is countered by the state's demand for political use of this creative energy. In this way, the artistic community remains the professional group most resistant to integration into the totalitarian structure and, consequently, one that is observed with particular distrust.[48]

Seen in this way, art is regarded as imminently powerful by all who participate in its production, distribution and control. For those artists who choose to position themselves against the official ideology of a country, there is in general a strong conviction that art can be a powerful tool for dissent; for those in power, art holds a potential danger in need of close monitoring. The artists' demands for freedom to create without restrictions from ruling ideologies is confronted with a state that insists on having the last word, regarding what artists can produce and present, but also concerning the discourses related to the production and dissemination of art.[49] Consequently, artists find themselves in a precarious situation, in which being able to work and steer clear of persecution requires a constant balancing act between their aesthetic concerns and interests as citizens and cultural agents, on one hand, and the regime's system of control and coercion, on the other. The resulting relationship is a deeply fraught one and is characterized by a constant back and forth between instances of freedom, censorship and repression. In what follows, I will examine how artists in Syria have navigated this complex terrain, by which means they have succeeded in staying free of attempts of control and what the reaction by state authorities has been.

For the early *ruwwad* painters, art was both an aesthetic and a societal project and they saw themselves as active members of their society. Aided by their affluent backgrounds, those who had the possibility to do so, travelled to Europe to study fine art and used the acquired knowledge to advocate for change in the social and political fields.[50] In order to do so, they had to create their own opportunities to exhibit their work and present it to their audiences, even if the authorities of the French Mandate (1920–1946) implemented certain rudimentary measures. Thus, the French restructured the educational system and state-sponsored schools were established, where art and art history were added to the curriculum, offering artists work opportunities as teachers.[51] An educational and cultural centre, the *Institut français d'archéologie et d'art musulman* was established in 1922 as a place that offered education in traditional crafts, staged exhibitions and also served as host for visiting artists and scholars from France.[52] These activities served the clear propagandistic goal of creating a favourable image of the

French among the local populations, but seems to have remained at a distance from the activities of the small, but growing art scene in Damascus, which was largely driven by private, artist-led initiatives.[53] However, although information on the interaction between visiting painters and the local scene is scarce, several authors mention the invigorating effect of the influx of foreign artists on the local art scene.[54]

Of the private initiatives that were leading the way towards the establishment of a genuine art scene in Damascus, one was of particular importance: the "Studio Veronese". Established in 1941 by a small group of artists,[55] it was conceived as a new venue for debates and presentations of art. While Syrian artists mostly had to rely on less organized training, working in the studios of older artists and relying on peer exchange, this initiative seems to have offered somewhat more structured opportunities, as its activities consisted of painting with live models as well as meetings and discussions focused on various issues related to art, philosophy and modernism. In the heated climate of the late French Mandate and the Second World War, the Studio became more and more involved with national issues and developed into the "Arab Association for the Fine Arts" (*Al-jam'iyya al-'arabiyya li-l-funun al-jamila*) with the declared mission to promote a distinct role for art and artists in a future independent Syrian state. For this organization, art was an important civic instrument, and not merely an intellectual, aesthetic pursuit, something that is also illustrated in an exhibition of history painting organized in August 1945 to celebrate the Troupes Spéciales' rescinding of control over Syria as an important step towards Syrian independence.[56]

For most Syrian Ba'thist art historians and critics, the independence of Syria marks the starting point of a real "Syrian" art. Thus, Afif Bahnasi defines it as "the rebirth of a nation, whose origins date far back in history".[57] And although it still remains an understudied subject, it does seem that the art scene of the early independence era was vibrant and active and offered a variety of opportunities for artists. But for many younger artists, it was also a period of struggle to claim a presence for radical artistic movements against what the painter Adham Ismail defined as the "bourgeois character" of the art world and its institutions.[58]

In 1958, Syria united with Egypt under the leadership of the latter in the United Arab Republic (UAR) and during this period, a serious institutionalization of Syrian art began with the establishment in 1958 of a Ministry of Culture (*wizarat al-thaqafa wa-l-irshad al-qawmi*, Ministry of Culture and National Orientation), with an affiliated Directorate of Plastic Arts. The first art school in the country, the Institute of Plastic Art, was established in 1959. In 1963, it became a degree-granting faculty and was re-named *Kulliyyat al-funun al-jamila* (Faculty of Fine Arts).[59] At that time, the UAR had been dissolved and the Ba'ath Party had taken power in one of the many coups the country witnessed in the first decades of its existence as an independent state.[60]

In 1964, a state-run organization for the production and distribution of films was created, *Al-mu'assassa al-'amma li-l-sinema* (National Film Organization, NFO).[61] Professional film-makers who had received their training abroad (Syria never had a film school itself) could become members of the organization and gain the status of employees with the right to apply for funding for film projects. The NFO took decisions as to who was granted the rights to direct a film and what the content could be. It was the NFO which undertook the censorship of all submitted material and which also had the last word regarding which films would be released and shown in national cinemas. Since the cinemas also were in the hands of the organization, the NFO more or less had a monopoly on all aspects of film production and distribution. While the NFO had its own offices, staff, and budget, it was and is answerable to the Ministry of Culture and its director is appointed by the Minister of Culture.[62]

During its initial period from 1964 to 1973, the NFO enjoyed a large degree of autonomy and, thanks to the involvement of some dedicated functionaries, several innovative and high-quality films by Syrian and Arab directors were produced under its auspices.[63] Examples of this new, engaged Arab cinema are films such as *Al-sikin* (*The Knife*, 1971) by the Syrian director Khaled Hamada as well as films by non-Syrian directors such as the Egyptian Tawfik Saleh's *Al-makhdu'un* (*The Dupes*, 1972), based on the Palestinian author Ghassan Kanafani's novel *Rijal taht al-shams* (*Men in the Sun*), the Lebanese director Bourhane Alaouié's *Kafr Kassem* (1974), which recounts the events surrounding the 1956 massacre of the Palestinian village Kafr Qasim, and the Iraqi filmmaker Qais al-Zubeidi's *Al-yazerli* (*The Yazerli*, 1974), a tragic story of the problems facing immigrants from rural Syria as they struggle to adapt to the city. These early years of the NFO were characterized by an intense search for innovate imagery and excitement, but also by a certain lack of organization. As the documentary filmmaker Omar Amiralay recalled:

> It was chaotic. Syrian cinema had nothing, no infrastructure, no past. We established the foundations of Syrian cinema. We managed with the means we had at our disposal. The beginning of the 1970s was a true golden age. There was an incredible excitement. They [the people in charge of the NFO] not only gave the Syrians a chance, it was extraordinary, there was openness, they also gave other Arab film-makers a chance. If it had continued like that, we could have created interesting things. There was a variety of experiments, of projects.[64]

But this brief period of experimentation soon ended. After 1973, the autonomy of the NFO was increasingly restricted and attempts were made to bring the interests of the filmmakers in line with those of the regime. A number of filmmakers surrounding Nabil Maleh and Omar Amiralay, who did not wish to align themselves with the new leadership and its more rigid rules, left the organization and stopped producing films for quite some time, preferring to concentrate their efforts in the "Ciné-Club de Damas", which itself became a place for critical discussions about cinema, art and society.[65] The activities of the club included screenings of (mainly European) art house films, discussions after the screenings and encounters with filmmakers. With the political climate becoming increasingly tense, the Ciné-Club became a space for political activism against the regime and was closed down by the authorities in 1982.[66]

It was only with a new wave of auteur cinema in the 1980s that film production regained importance as a medium for artistic critique, albeit in a much more conflictual political climate. And although the space for creativity narrowed considerably from the 1990s onwards, Syrian films of great artistic quality continued to be produced, despite the tight control of the censors and administrative staff. This was largely thanks to the uncompromising idealism of its filmmakers who were willing to accept prolonged fights for their projects rather than give up or compromise on the aesthetic quality. The relations between the administrative staff and filmmakers were based on a complex system of flexible rules, individual arrangements and compromises, all of which were subject to constant review and renegotiation.[67] Rather than accepting the NFO and its politically appointed administrators as legitimate holders of power, Syrian filmmakers entered this "game" with the clear aim of finding ways to produce their films and remain as free as possible from state censorship, while keeping the final product as close to its original ideas as they could.

Censorship and Attempts at Co-optation

For artists in Syria, working around and against restrictions and censorship was and is a defining part of their practice. In her study of the Syrian art world of the mid-twentieth century, the art historian Anneka Lenssen has written: "Syrian artists conducted their negotiations in the art world from locations outside the tripartite system of private galleries, public museums, and independent journalistic criticism that is familiar from the liberal democracies that have set the norm for the modern."[68] Syrian artists always had to include the state and its interference in this equation. Writing about the history of art in Syria is always also writing a history of circumventing censorship and the fight of the artists for their freedom of expression. While Syrian artists might not necessarily ascribe to the Western ideal of artistic autonomy and remained firmly committed to their society and its current issues, they took it upon themselves to carve out a sphere within which to articulate their vision of a better future, to pursue their world-making project.[69] I will discuss this in greater detail in Chapter 2. Here I will concentrate on the functioning of the Syrian state's censorship and some examples of ways to counter it.

When a military coup in 1963 brought the Ba'ath Party to power, attempts to control artistic production by the state and its authorities intensified. Since the days of the UAR, the official cultural policy of the Ministry of Culture had called upon artists to commit themselves to the national project. Art and culture should "popularize knowledge and culture, present Arab culture and disseminate its message" and

> develop Pan-Arab awareness and help citizens to improve their social standing, boost their morale and strengthen their sense of responsibility, and motivate them to cooperate, make sacrifices and intensify efforts to serve their country and humanity.[70]

How artists chose to work towards these goals was largely left up to them. Unlike other authoritarian states such as the USSR and the socialist states of Eastern Europe, the ministry did not express a preference for a particular style of painting.

Under the Ba'ath Party, this began to change gradually. While the instructors at the Faculty of Fine Arts were expected to provide education that corresponded to contemporary curricula, the Directorate of Plastic Arts, under the leadership of Afif Bahnassi, sought to exert direct control over the work of artists. In 1965, artists were asked to submit works on the theme "national art" to the Directorate's Autumn Exhibition. When some artists protested against such restrictions, Bahnassi responded by asserting that rather than putting restrictions on artists, it allowed them to work outside the gallery and market system, freed them from commercial needs and therefore represented increased support. But in the end, the protesting artists succeeded in forcing the Directorate to retreat from its rigid position and thus keep the thematic scope for future autumn exhibitions open.[71] While the artists were able to celebrate the reversal of the policy, they had also been reminded of the fact that the state saw itself fit to intervene in the field of artistic production wherever it felt compelled to do so, and that it held the view that art should stand in the service of the state and its goals. More and more, just as in other authoritarian contexts, Syrian artists saw themselves embroiled in a perpetual, unhealthy struggle to maintain their autonomy from state structures, while simultaneously relying on them for vital infrastructure.[72]

While the Ministry of Culture had promoted the country's abstract painters on the international circuit of biennials and exhibitions during the early years of Ba'ath Party

rule in the 1960s, and even sought to bring their work into harmony with Syria's particular socialist model, the year 1967 changed everything. Following the defeat in the Arab-Israeli War and the loss of the Golan Heights to Israel, artists gathered at the Yusuf Al-Azmeh Square in central Damascus in a spontaneous demonstration to express their horror at the war. Based on this experience, a reconsideration of the role of art and artists in society took place in artistic circles. It was felt that art and artists needed to communicate more directly with the public and that this necessitated a more outspoken visual language. Consequently, many artists came to favour figurative work over abstraction.[73] The Ministry of Culture was quick to take up this new activist impulse and, in addition to organizing the annual autumn exhibition, it also sponsored several other exhibitions in 1967 with titles such as "Aggression" and "Mobilization".[74] This ideological stance set the standard within the context of state-sponsored artistic events in the years to follow. In their writings, officials and critics affiliated with the Ba'ath Party in Syria highlighted the works of artists whose focus lay mainly on content rather than form and style and who sought to highlight the "difficult reality, social problems and the threat of the imperialist aggression".[75] Likewise, in a statement by the Arab Writers Union from 1978, the role of artists and writers was described in the following terms: "[Individual commitment] cannot be separated from commitment to one's country and society ... the writers and artists who produce the greatest works are those who realize this link in its highest form. They are at once free and committed."[76] The constant emphasis placed on these aspects of Syrian art effectively implied that this was what the state expected from artists. Art was expected to "reflect the contemporary living conditions of Syrians and Arabs, while staying rooted in their heritage" and artists were encouraged to consider themselves a group with a particular mission to give aesthetic values a moral dimension.[77]

As outlined here, artists and the state are closely tied to one another in Syria and their relations have often been conflictual in nature. The state has frequently tried to intervene in artists' production and forced them into the defensive position of having to protect themselves from what they perceived as an illegitimate interference.

The censorship laws of Syria, which have been in effect since nineteenth-century Ottoman rule and continued under the French Mandate, were strengthened under the Ba'ath Party. They accorded the state "absolute control over the production of culture and the dissemination of information".[78] All material destined for publication and distribution, i.e. newspapers, periodicals, drawings and caricatures, book manuscripts as well as film scripts must be approved by the censorship committees of the Ministry of Information.[79] Likewise, exhibitions and other artistic events needed to get official approval before opening to the public. Institutions in charge of an event would write a letter to the Ministry of Culture stating the name(s) of participating artist(s), the title of the event, the location and date. Any event involving moving images would have to hand in copies of these together with the letter, something that was not required of photography and painting. Events for which permissions had been granted would be viewed by a ministry representative shortly before the opening to ensure that no works on show violated the official rules.[80]

All negotiation with censors, whether in relation to cultural and artistic events, film scripts or literary works often took on the form of an absurd "game", in which images or, in the case of films, frames were "traded in" to prevent another image or frame from being removed.[81] The literary scholar Ann Komaromi has adopted Pierre Bourdieu's metaphor of a "game" to describe cultural activity in the unofficial art scene of the post-

Stalin Soviet Union, particularly the forging of rules by powerful players and attempts to circumvent them by their antagonists.[82] Similarly, the negotiations between censors and cultural producers in authoritarian Syria can be described as a "game", where both players knew the rules and each tried to benefit the most of it. The skill with which artists negotiated, their "feel for the game", guaranteed their success in producing their works as they envisioned them. Faced with the fluctuating regulations of censorship, artists needed to "act and react … in a manner that [was] not always calculated and that [was] not simply a question of conscious obedience to rules".[83] In Syria, the state's right to control artistic and intellectual life was granted by the State of Emergency Law, but in fact contradicted the right to a free press and free expression as guaranteed to all citizens by the Syrian Constitution.[84]

State censorship places artists in a complex situation of multiple paradoxes. While it poses severe restrictions on the work of artists and cultural producers, it does not entirely curb critical artistic production. Out of sheer necessity, artists living under conditions of restricted freedom reframe their work according to these circumstances and develop elaborate systems of metaphors and allegories in order to address critical issues. In his discussion of writers working in authoritarian states, the philosopher and critic Andrei Plesu notes that censorship leads to the "elaboration of ingenious subtexts, allusions, and camouflage, techniques practiced with great virtuosity by writers and assimilated promptly by the mass of readers".[85] In Syria, artists and particularly filmmakers often had recourse to this solution in their attempts to voice critique or even "speak truth to power" and "represent all those people and issues that are routinely forgotten or swept under the rug", as Edward Said has described the role of intellectuals.[86] Censorship may even be embraced in a certain way, rather than lamented. By consciously engaging with the limitations, it may be possible to turn them against the system and use them as a tool. This is an idea that the Syrian filmmaker Mohamad Malas has expressed on several occasions: "Censorship is a gift because it forces one to look for new and more interesting structures through which to speak."[87]

Historical reframing is another way out of this dilemma. Sensitive topics may be transported to another historical time, leaving it up to the viewers and readers to draw the necessary parallels between past and present. It offered a way out of the impossibility of political expression and became "a popular way of discussing genuinely political topics in a less conspicuous way in order to circumvent the well-known limitations of free speech and general censorship".[88] For a number of Syrian artists, writers and filmmakers, history became the preferred frame within which to place social and political critique. Thus, the playwright Saadallah Wannous chose to set his play *Tuqus al-isharat wa al-tahawwulat* (*The Rites of Signs and Transformations*, published in 1994) in Ottoman Damascus of the 1880s. Through this historical setting, he offered a parable of how the complicity of the elites precludes lower-class emancipation and how corruption renders individual life projects impossible.[89] Similarly, Mohamad Malas chose two different eras for his denouncement of facile ideas about the nation and the nationalist and Pan-Arabic project in the fiction feature films, *Ahlam al-madina* (*Dreams of the City*, 1983) and *Al-Layl* (*The Night*, 1992). *Dreams of the City* is set in the 1950s and shows a society increasingly torn apart by distrust and cruelty. While this film focuses on inter-personal relations seen through the eyes of a young boy who is forced to take on an adult role much too early and is confronted with the hypocrisy and brutality of the adults, *The Night* is a disillusioned denouncement of the political ideologies that gave rise to high hopes among Arabs in the twentieth century, but in the end led to a disastrous political and social impasse.

A particularly vexing aspect for any creative action is that the rules defining the permissible and the forbidden are never revealed; rather, they are kept unclear, even deliberately left undefined. This is the case in Syria, as in other authoritarian contexts.[90] As a result, artists and cultural producers are forced to live in a constant atmosphere of uncertainty and fear, ultimately bringing them to practise self-censorship in an attempt to decipher the border between what is permitted and what is not. They are obliged to anticipate objections and to act as their "own secret police".[91] Not only are rules never clear, they can also change over time; What is permitted one year might be punished the following year, or vice versa. Furthermore, exceptions are frequent and rules do not apply equally to all art forms; what might be accepted in painting might not be tolerated in literature, what is tolerated in literature might be subject to censorship in film, etc.[92] While this arbitrariness might on the surface seem to weaken the official system of power, in practice, it rather strengthens it by adding what Andrei Plesu calls a "confusing coefficient of unpredictability".[93] In this way, artists often find themselves engaged in a tiresome and time-consuming process of negotiating single words and images with censors, forced into unwanted compromises if they want their works to be published or exhibited.

Another threat facing artists in Ba'thist Syria was the risk of seeing their critical works being co-opted and manipulated by the authorities. The title of this chapter, "Culture Is Humanity's Highest Need", refers to a motto used by the Ba'ath Party in the mid-1990s, a time, in which artists, whatever their field, suffered particularly from the stifling climate in Syria.[94] As discussed by miriam cooke, the state needed art and culture to legitimize and extend its power and never stopped underlining its fundamental necessity, yet it systematically repressed it and its producers. And since art and culture needed the state for support and distribution, they became vulnerable and prone to co-optation by the state.[95] The regime of Hafiz al-Assad invested considerable effort in attempts to use and co-opt art and artists for its own purpose and turn them into ideological tools. cooke has referred to this as "commissioned critique". She defines this as permitting and even funding the production of critical artworks that the state would later use for its own aims:

> an official and paradoxical project to create a democratic façade … situated at the nexus of the permitted and the transgressive … not merely the toleration of transgressive practices that bridge the cognitive gap between the lies of government pronouncements and the reality of everyday life … the regime's Machiavellian manipulation of dissidence.

The regime would let dissident artists produce their critical works, while at the same time making sure they never forgot that they were being closely monitored and kept in a state of uncertainty regarding the risks they were running. It thereby created an atmosphere, in which "dissidents do not know whether what they write or paint or sculpt or turn into moving images corresponds to an inner drive or is part of a disguised, Mephistophelean pact".[96]

The NFO offers a poignant example of this practice. For many years, it produced films of a high artistic standard and sent these films to international film festivals, where they often received wide acclaim. At home, however, these films would be censored and remain largely inaccessible to the public and only screened on special rare occasions.[97] The film scholar Cecile Boëx has referred to this practice of limiting the circulation of

these films as "selective distribution".[98] When the films were screened, they were received with great interest by the Syrian public, something that belies the official position that the Syrian public is not interested in Syrian films. For example, Mohamad Malas' *The Night* was shown during the Damascus International Film Festival in 1995, and people seem to have stood in long lines in order to attend.[99] These films were never officially banned. That might have offered a possibility for filmmakers to use their connections and have their works released. Instead, the NFO remained vague. Whenever filmmakers enquired about delays in releasing their films in Syrian cinemas, they were told that no cinema was interested in screening them (ironically, as mentioned above, the NFO controlled most cinemas), that the copy of the film could not be found, that it had not yet returned from a festival, or provided with other peculiar explanations. Such practices gave the NFO the nickname "the grave of films and filmmakers" among film professionals in Syria.[100]

A particularly striking case is Oussama Mohammad's *Nujum al-nahar* (*Stars in Broad Daylight*, 1988). The film has only been screened on very rare occasions in Syria and is effectively banned. Yet, it has been presented at film festivals abroad (e.g., at the *Quinzaine des Réalisateurs* section of the Cannes Film Festival in 1988) and received much attention. It is one of the best-known Syrian auteur films and has been screened at special programmes with a focus on Syrian cinema throughout Europe. The film is perhaps the most openly critical work of Syrian cinema, a biting satire with plenty of hints at the Ba'th regime's personality cult, ruthless authoritarianism and hollow slogans. The film tells the story of the tumults surrounding a double wedding of almost dynastic dimensions that is to unite two rural families. The oldest brother, played by the actor Abdullatif Abdul-Hamid, who in this film bears a strong physical resemblance to President Hafiz al-Assad, controls the lives of his siblings with an iron fist, while relentlessly telling them how much he loves them. The dramatic events unfold when one of the two brides decides to escape and the other refuses to go on with the marriage. The brother feels the need to restore order and does so, alternating between coaxing and violence.

The film satirizes several aspects of the Syrian state and its ideology, propaganda and power structures: during the sumptuous wedding celebration, the twin sons of the protagonist recite a poem that brings together several aspects of official speech, but here appear entirely out of context: "Papa gave us a present, a tank and a rifle, my brother and myself have joined the Liberation Army and we have learned how to defend our nation. Down with Israel. Long live the Arab Nation!"[101] By letting the slogans be expressed by the mouths of two children who appear completely intimidated and have clearly memorized them without understanding their meaning, Oussama Mohammad denounces their hollowness and the empty rhetoric of Arab nationalism. In her discussion of the Syrian poet Muhammad Maghut's *Sa-akhunu watani* (I shall betray my homeland, 1987), miriam cooke notes that the mindless repetition of hollow slogans only confirms the system, creating an atmosphere where everybody "repeat[s] slogans because they feel they are being watched, and in order to prove their patriotism they watch others. That is how the system works; each person watches and is watched."[102] The film also ridicules the personality cult practised by the regime. In the final scenes, the deaf brother, whose suffering at the hand of his father and his elder brother the spectator has witnessed throughout the film, travels to Damascus to join a cousin and find some degree of kindness and liberty. He finds himself getting lost in the city with all its traffic and hustle and bustle. The streets are filled with banners celebrating a famous singer that are placed on strategic locations. They bear a striking resemblance to those posters and banners that used to fill the streets of Syrian cities celebrating the president and the ruling party (Figure 1.2).[103]

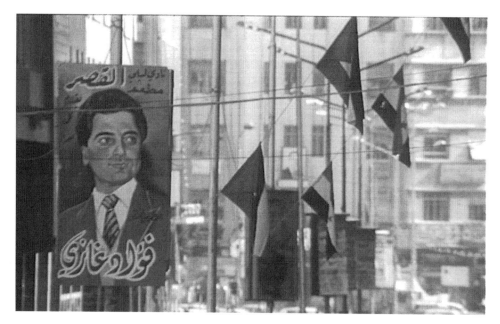

Figure 1.2 Oussama Mohammad, *Nujum al-nahar (Stars in Broad Daylight)*, 1988, 33 mm film
Source: Courtesy of the artist.

Stars in Broad Daylight employs a remarkably direct language, while still respecting some taboos and conventions. The film does not mention the state but lets the extended family stand in for the Syrian state and society, while the elder brother represents the president. This barely veiled parallel would not have been lost on Syrian audiences, even without the physical resemblance of the main character to the president, if they had been given the chance to see the film. In fact, the family was also invoked as a metaphor by official ideology, likening al-Assad to the family patriarch who seeks obedience from his citizen-children and who in turn provides for their material need.[104] By invoking a familiar metaphor, yet turning it *ad absurdum*, Oussama Mohammad subverts its efficacy and thereby undermines the ruling party's claim to absolute power. *Stars in Broad Daylight* provides a powerful example of the Syrian regime's treatment of critical artists, of the regime's "Machiavellian manipulation of dissidence" referred to above. The film was produced by the NFO and the filmmaker was allowed to finish it, only to see it disappear in the storage rooms of the NFO after its completion. It was sent to international film festivals, in order to project the image of a liberal, open-minded regime by emphasizing the state-sponsored production of a film so critical of that very state. But it was never released in Syrian cinemas. Thus, a film so clearly made for a Syrian audience was doomed to circulate exclusively in the international festival circuit and remain largely inaccessible to domestic audiences.

But not only living artists were co-opted by the Syrian regime, as the case of the long-deceased Tawfiq Tarek shows. His painting *The Battle of Hittin*, which I discussed above, was created in 1940, long before the Ba'ath Party came to power and in an entirely different political context, namely, as a statement of resistance to the French presence in Syria. In Ba'ath Party ideology, Hafiz al-Assad and the historical figure of

Salah ad-Din al-Ayyubi (Saladin) became closely linked, with Saladin's victory at Hittin being used as a historical parallel to al-Assad's "victory" in the October 1973 War.[105] As a consequence of this retrospective re-appropriation of Saladin and the Battle of Hittin, the painting was hung at a prominent place in the Presidential Palace in Damascus, where it possibly still remains.[106]

1.3 Hopes for Change: Artists and the Artistic Infrastructure in the 2000s under Bashar al-Assad

When Hafiz al-Assad died in June 2000 and his son Bashar succeeded him as president of Syria one month later, many Syrians held high hopes that the young president would lead the country on a path of much-needed reform. Artists and intellectuals in particular hoped for greater freedom to create and express diverse opinions. And indeed, Bashar al-Assad's inauguration speech seemed full of promises. He spoke of "democratic thinking", of the "principle of accepting the opinion of the other" and of a "democratic experience which is special to us", citing the Progressive National Front, a group of Arab nationalist and leftist parties united under the leadership of the Ba'ath Party as a "democratic example". The speech was quite vague in its content, but impressed Syrians and foreigners alike and was widely interpreted as a will to reform. And certain immediate, practical steps that followed seemed to corroborate such an interpretation. The ban on satellite dish receivers was lifted (it had never been very effective, nor had it ever been truly enforced), officially allowing Syrians to access information through international media and no longer be dependent on state-controlled channels, and the notorious prisons of Tadmur (Palmyra) and Mezze, located in a Damascene suburb, in which large numbers of political prisoners had been held, were closed.[107]

Furthermore, the "civil society movement" (also referred to as the "Damascus Spring" movement), formed within weeks after Bashar al-Assad's takeover, led to a dynamic culture of widespread political debates with discussion groups or salons set up in private homes.[108] Syrian intellectuals began publishing open letters and opinion pieces in the Lebanese press calling for political reform. In September 2000, 99 intellectuals, artists and professionals signed and published a declaration calling for an end to the emergency law that had been in place since the Ba'thist coup in 1963, the public pardoning of all political prisoners and the return of deportees and exiles, as well as the establishment of the rule of law and a free public life.[109] The signatories were at first left undisturbed by the authorities, for many, this was another important sign of change. Even state-controlled media in Syria started to participate in the debates. For a while, political change seemed possible. But, the climate of optimism lasted for only a short period. In February 2001, the regime seemed to become nervous and started to crack down on salons and forums, and prominent members of the civil society movement were arrested and sentenced to imprisonment.[110] The "Damascus Spring" was quickly followed by a "Damascus Winter".

This back and forth between cautious relaxation and increased rigidity, between modest hopes and disappointment came to characterize the decade. For artistic and cultural producers, this meant that initial hopes for greater freedom of expression were disappointed and many reverted to means of expression that were similar to those of former generations: veiling critique by using metaphors and symbols. This will be discussed in further detail in the following chapters. Since outright political activity remained severely restricted, art and cultural production remained a field for civic activism. That political

resistance moves into alternative spaces when direct political engagement is impossible has been noted by the political scientist Lisa Wedeen, who in 1999 described political resistance in Syria as a diverse constellation of "mundane transgressions, via films, cartoons [and] satire".[111] As the anthropologist Christa Salamandra and Islamic studies scholar Leif Stenberg have written, the expectations of the "Damascus Spring", with its "reformist discussion and debate" and "promise of greater expressive freedom and political participation", were never forgotten, but rather "lingered through the decade" and fuelled the hopes of Syrians of all classes, regions, and religious and ethnic affiliations.[112]

Art came to be seen as a way to address social and political issues, e.g., women's rights, and the number of artistic and cultural initiatives increased particularly in the second half of the decade, offering artists more opportunities to present their work. Due to its subtle language, civil society activists hoped that art would arouse less suspicion among the authorities and allow them to approach a greater variety of critical issues.[113] TV series, which began to flourish during this decade, offered another space of cultural production which permitted the articulation of cautious critique. However, as has been pointed out by several scholars of Syria, the danger of co-optation of critical producers as figures connected to the regime attempted to influence the content of these series made this a particularly fraught terrain.[114]

On the surface, the climate seemed somewhat more lenient towards creative production especially during the second part of the decade. However, censorship was still firmly in place. Privately owned media had to model their discourse on that of the regime, if they wished to remain functional, giving the impression of an "outsourced propaganda", now disseminated by non-state producers.[115] For artists attempting to produce work of a more outspoken kind, the situation remained fraught with difficulties, just as it had been for former generations. As I will discuss later in more detail, several young artists and filmmakers experienced incidents of censorship, which, in one case, even involved an attempt to prevent the screening of a Syrian film at a foreign festival. For many artists and intellectuals, the situation seemed just as bleak as ever. In 2006, the actor Fares Helou complained that

> We had the same amount of freedom or more in Hafiz' time … Hafiz at least was clear – with any position, you knew exactly the space that was allowed. But after the son came in, the freedom given us was not real; it was a trap. When voices started to be heard presenting new and modern ideas, they arrested those voices.[116]

New Spaces for New Art

Despite the undoubted difficulties linked to critical art production, for the Syrian art world in general, and especially in Damascus, the 2000s was a dynamic decade that saw the rise of a new generation of artists and new artistic media. But these new media needed new venues of presentation, as the traditional spaces guaranteed by the state seemed insufficient. Art exhibitions were regularly organized by various state institutions. These included an annual show organized by the University of Damascus' Faculty of Fine Arts, featuring works by its graduates and an annual exhibition of works by Syrian artists organized by the Ministry of Culture at the Khan Assad Pasha in the Old City of Damascus. The works on show entered the collection of the Ministry of Culture after the exhibition and remain in its possession. Exhibitions of works from this collection would occasionally be presented at the National Museum and occasional art

exhibitions also took place at the Damascus Opera House (officially *Dar al-Assad li-l-funun wa-l-thaqafa*, Al-Assad Institution for Arts and Culture). In order to take part in such shows (and any official event), artists needed to be members of the artists' syndicate, a Ba'thist institution.[117]

Many young artists longed to break free from these structures that they perceived as overly rigid, where connections to influential art professors and regime figures appeared more important than artistic merit.[118] Another problem was the lack of willingness of the official art world to include works in new media. Private galleries did not really represent an alternative, as they were intent on selling works and tended to cater to a somewhat conservative collectors' community. Foreign cultural centres, first and foremost the Centre Culturel Français (CCF) and the Goethe Institute, offered some opportunities, and events there were usually well attended and allowed artists to exhibit and interact in a generally open-minded, friendly atmosphere. The CCF introduced a festival for photography in 2001, the *Journées de la photographie* under the head of programming Delphine Leccas, which became a valuable contribution to the artistic infrastructure of the city by bringing together artists from Syria, the Middle East and Europe.[119]

But local spaces were largely missing until the second part of the decade. Within a few years, several new, private initiatives were established, such as independent festivals and art spaces, workshop initiatives and other activities. Non-commercial and experimental in character, they had the aim of creating an alternative circuit for the training of artists as well as the production, presentation and discussion of art. Before I move on to discuss some of these initiatives in more detail, some remarks on the notion of "official" versus "unofficial" art are appropriate.

While the official and independent art scenes in Syria might at first appear to be distinctly two clearly separated realms, this was not the case, as the boundaries between what might be termed "official" and "independent" artistic activity should not be seen as static. In this study, the term "independent" does not necessarily mean dissident. I use the term "independent" for structures set up by private persons with the aim of enabling aspects of artistic activity that were not given a space on the circuit of the state-sponsored, official art world. While these aspects might include expressions that were critical of the social or political status quo, this is not necessarily the primary *raison d'être* of these structures. It is important here not to fall into the trap of seeing independent artistic and cultural activity as *per se* diametrically opposed to official culture. The existence of such independent or "unofficial" counter-spaces might lead one to think of the opposition between the "official" and "unofficial" art scenes in the Soviet Union and the socialist countries of Eastern Europe. However, one should be careful not to draw facile conclusions. Syria and communist Eastern Europe were two very different contexts, whose systems of social organization reveal important differences. The Syrian authoritarian system did not attempt to build a society according to one ideology, as was the case in the totalitarian states of the Eastern Bloc.[120] Nor did the Syrian state impose an official ideology upon the art world, as was the case with the official promotion of Socialist Realism in Eastern Europe and the Soviet Union between 1934 and the mid-1980s.[121] But in spite of these differences it is equally important to remember that, even in the Soviet Union "unofficial" culture did not necessarily exist in total isolation from the official sphere. The two realms existed parallel to one another within extended networks of art and culture and agents could well participate in both of them.[122]

For the young Syrians who set up new artistic structures, the main objective was to introduce alternative views on the nature of art and bring greater diversity to the Syrian art scene. Most of them did not see themselves as declaredly oppositional to the official circuit, but rather maintained that the main reason for starting their initiative was the official art circuit's lack of diversity, the absence of contemporary techniques and media, and the general lack of opportunities for young artists. Thus, these projects should not be seen as antagonistic towards the official art scene in the sense that cooperation was excluded at all levels. The alternative character of these projects arose from the lack of opportunities for artists working in media that were not recognized by the official circuit. This was felt as particularly dire in view of the increased international interest in contemporary artistic production of the region, a development in which Syrian artists were largely ignored. This will be the subject of the discussion in Chapter 4.

All independent artists and cultural operators, to whom I spoke, stressed the limitations and "backwardness" of the official art activities as one of the major reasons for their own work. Thus, Abir Boukhari, founder and co-director of the initiative "All Art Now", often used the example of her sister, the artist Nisrine Boukhari, to explain the necessity of her activities. Being mainly interested in video art, Nisrine had faced significant opposition from her teachers at university and had to struggle with the almost total lack of exhibition opportunities for this art medium.[123] This had led the two sisters to initiate "All Art Now", defined by its initiators as a "cultural, artistic and social initiative", dedicated to the promotion of contemporary artistic techniques.[124] During the first years of its existence, All Art Now organized workshops and minor exhibitions at different venues and in 2008, the sisters acquired a house in the Old City of Damascus to set up an independent art space of the same name (Figure 1.3). The space was oriented towards the young artistic community and its location in the Old City and easy accessibility by foot guaranteed a steady audience which kept growing as the space became known to Syrians and foreigners alike. Among the organized activities were collaborative exhibitions held throughout the year, which showed works of affiliated artists, often together with young, visiting international artists. This was supplemented by activities such as talks, performances, and workshops sometimes involving collaboration with foreign cultural institutes and organizations. While the number of foreign artists visiting Syria on a professional basis was modest, it was, however, enough to secure a steady programme of events involving Syrian and foreign visiting artists. Larger activities such as a video art festival (the first of its kind in Syria) in 2009 and a media art festival in 2010, which were considerably well attended led to hopes that the art scene in Damascus would continue to expand and become more inclusive towards new forms of expression.[125]

Another, important new initiative was the festival for creative documentary, "Dox Box", which was inaugurated in 2008 with a cautiously political activist agenda and a programme focusing on engaged, socially critical documentary films from around the world. It included both a section reserved for Syrian filmmaking as well as one dedicated to films related to gender issues. The co-director of the festival, Diana El-Jeiroudi, was herself one of the first artists in Syria who produced independent films and videos. She produced two video documentaries with a feminist theme in the middle of the decade, which I will discuss in Chapter 3. El-Jeiroudi and her husband Orwa Nyrabia also were directors of Proaction Film, an independent film production and distribution company for critical and innovative documentary filmmaking.[126] Through the festival and production company, El-Jeiroudi and Nyrabia declared themselves intent on laying the foundations

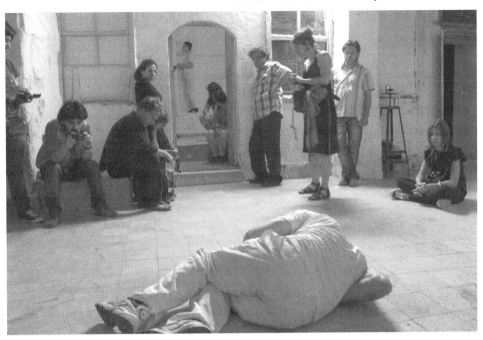

Figure 1.3 All Art Now, Performance *Fatigue Fracture* by Markus Keim and Beate Hecher, 2010
Source: Photo credit: Nisrine Boukhari.

for a high-quality documentary cinema in Syria and creating training and production opportunities for young Syrian filmmakers. Although the festival's main activities were in Damascus, it also hosted events in other cities, with the aim of reaching new audiences and working against the tendency to concentrate all cultural life in Damascus.[127] The festival took place only four times from 2008 to 2011, with the final one ending just a few days before the first large protests in Syria. It did, however, succeed in creating a space for experimental documentary filmmaking and videomaking in Syria during the years of its existence.

Dox Box offers an interesting example of the conditions under which independent art and culture could exist and be exhibited in authoritarian Syria. The festival offered a space to screen documentary videos with a mildly critical character, such as Hazem Alhamwi's *Asfur hajar* (*Stone Bird*, 2006), screened in 2009, and Ammar Al-Beik's *Samia* (2008, 40 mins), screened in 2010. I will discuss these works and their significance as critical art works in Chapter 3. However, one video was deemed too controversial, Rami Farah's *Samt* (*Silence*, 2006), an openly critical work that denounced official historiography related to the loss of the Golan in 1967. The festival organizers often seem to have had to step through a minefield of different considerations, balancing the desire to push the boundaries for cinematic discourse and criticality with the necessity to avoid open confrontation with the authorities. When the festival collaborated with the National Film Organization and the Ministry of Culture for the 2010 festival, El-Jeiroudi and Nyrabia received some criticism for this in Syria as well as in Lebanon.[128] It was apparently interpreted as selling out the original ideas of social activism and oppositionality and "collaborating with the regime", but should probably rather be seen as an indication of

the fraught terrain that artists and cultural producers need to navigate in authoritarian contexts, constantly needing to revise their positions in order to negotiate a space for free artistic practice. As discussed by political scientists Sonja Hegasy and Lisa Wedeen, such harsh criticism might not always be appropriate, as it may do injustice to people, who have potential as participants in the political and social scene who might be able to influence policies.[129]

The final years of the 2000s saw increased activity. A non-profit cultural association, AIN, was established by Delphine Leccas, who left the CCF in 2007 to concentrate on independent projects. Its first major activity, the Visual Art Festival, was held in Damascus in the autumn of 2010.[130] The festival was organized in collaboration with some of the foreign cultural institutes, such as the CCF, the Goethe Institute and the Finnish Institute. The venues were all located centrally, many of them in the Old City and the events were well attended (Figure 1.4).

A private gallery, Rafia Gallery, was established in a new building complex in central Damascus, which also hosted luxury fashion boutiques. The gallery had the aim of combining exhibitions of new art (including new media work) with a public program of discussions. Rafia Kodmani, the owner and manager of the gallery, wanted to organize a series of conferences that would bring international scholars and art experts together to open critical and academic debates about contemporary art in Syria. The first such event, entitled "Arab Art in a Changing World" took place in 2010 (Figure 1.5).[131] Kodmani's motivation was based on the desire to make an active contribution to the art scene in Damascus. Forced to relocate to Dubai due to the war, she is now organizing occasional exhibitions for Syrian artists to support them.[132]

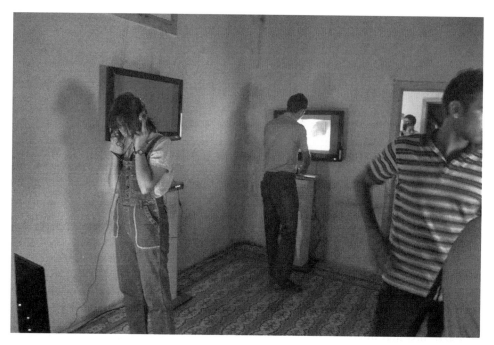

Figure 1.4 Visual Art Festival, Damascus 2010, exhibition of video art
Source: Photo credit: Salah Saouli.

Figure 1.5 Conference, "Arab Art in a Changing World", 2010, organized by Rafia Gallery
Source: Courtesy of Rafia Kodmani.

The independent initiatives were welcomed by the Damascene art public, especially the younger age groups, and openings generally attracted large crowds of people. Thereby, keeping them functioning with regular programming was no easy task. The non-commercial initiatives and spaces operated on a project-related basis with modest financial resources and would not have existed were it not for their founders' will to dedicate time and personal resources to the continuing existence of these initiatives. Outside funding, e.g., by foreign cultural institutions was possible and did happen, but never reached the same level as in other places in the region, first and foremost neighbouring Lebanon. At the end of the decade, it looked as if this was all going to change, as the international art world was beginning to become interested in Syria. But unfortunately, the uprising cut this short and all the mentioned initiatives – while having significant potential – were halted and thus not allowed to develop their full potential.

Aside from the above-mentioned organizations, several larger private galleries played a role in the expanding Syrian art scene. The Atassi Gallery, one of the oldest, genuine art galleries in Syria, displayed an interest in new forms of artistic expression and organized exhibitions of works in new media by foreign artists in cooperation with foreign cultural centres on some occasions (Figure 1.6). The owner, Mouna Atassi, remained sceptical of many of the new artistic developments in the country, especially those which she perceived as the over-commercialization of the scene and the "lack of skill and passion" among the majority of young artists.[133]

This "over-commercialization" that Mouna Atassi spoke of might refer to developments sparked by some of the new galleries that were established during the latter part of the 2000s, first and foremost, Gallery Ayyam. This space, opened in the autumn of 2006 and located in the affluent Mezze suburb of Damascus, sought to promote young, local

Figure 1.6 Atassi Gallery, exhibition view. Works by Marwan.
Source: Courtesy of the Atassi Foundation for Arts and Culture.

artists at an international level. Their promotional practices were deemed aggressive by a number of artists and other art professionals, however, they succeeded in creating an international demand for works by young, often highly inexperienced Syrian artists, whose works have since been sold at high prices at international auctions, especially on the market in the Gulf countries.[134] Curiously, the marketing efforts aimed at the international cultural media paid off and articles, in which journalists uncritically repeated the gallery's claims and praised Damascus as a "hub of Mideast art" began to appear in papers such as the *New York Times* in 2010.[135] The views expressed in these articles are quite problematic, as they entirely fail to differentiate between commercial and non-commercial art spheres and confuse success at auctions with practices engaged in contemporary artistic discourse.

The artists represented by the Ayyam Gallery were mostly young, some of them recent graduates, although also some older, established artists were found among them for some time, such as Youssef Abdelké, Mouneer Al-Shaarani and Asaad Arabi. To these were added some non-Syrian, Arab artists, e.g., the Palestinian painter Samia Halaby. Ayyam's self-presentation was a curious mixture of old-fashioned insistence on "the thousands of years of history and culture that the region has to offer", reminiscent of Ba'ath Party propaganda, and promotional language closer to the world of advertising than that of art. Thus, Khaled Samawi, the founder and owner of the gallery, spoke of the "Ayyam vision" and of artists, who have "leaped to become well known internationally", are "sought after by astute collectors worldwide" and whose work had "attained record breaking prices at the major auction houses".[136] Together with their programme of

regular exhibitions, the gallery also offered prizes for emerging artists as part of the "Shabab Ayyam Project", described on the gallery's website as "an incubator program that has catapulted the careers of nearly a dozen young painters since 2007".[137] The gallery also expressed an interest in "educating" the Syrian audience by showing new art.[138] However, while they included some photographers in their programme (e.g., Ammar Al-Beik, whose videos I will discuss in Chapter 3, and Nassouh Zaghlouleh), the focus of the gallery was on sellable art in a classical format and art as a business investment.

The Ayyam Gallery was controversial for bringing a new form of commercialism to the Syrian art scene, something Youssef Abdelké, echoing the concerns voiced by Mouna Atassi referred to above, criticized in an article for the Lebanese newspaper *al-Safir* in 2009, after ending his collaboration with the gallery. While artists of earlier generations managed to keep their autonomy in the face of the dictatorships' power, they might not, he wrote, be able to withstand the power of capital.[139] But, for all the criticism one might direct at the Ayyam Gallery, they did bring a new dynamic to the Syrian art scene, something that could have had positive effects, had it been allowed to develop naturally towards greater diversity in galleries, non-profit spaces and small-scale independent institutions.[140] This, however, remains a matter of speculation.

Most independent initiatives were found in Damascus. Outside of the capital, two non-commercial art spaces are worth mentioning: the Center for New Art in Al-Hassakeh, run by the visual artist Fassih Keiso, and the Le Pont Gallery in Aleppo, run by the photographer Issa Touma. Keiso established the Center for New Art in an old shop owned by his family upon his return to Syria from Australia. Located in the provincial town of Al-Hassakeh, it opened in 2008 as a community art space with a programme of exhibitions and informal gatherings and sought to bring contemporary art and its discourses to communities that were not usually exposed to new art. The outlook of Issa Touma's Le Pont Organization and Gallery in Aleppo was very different. Touma's focus was on bringing international art and artists to Syria and much less on the local scene. In fact, Touma tended to be highly critical of the quality of art produced in Syria and on several occasions even proclaimed that he did not think anybody was producing any work of interest. Most of his critique, however, was directed at the older generation of Syrian artists.[141] But although he claimed an interest in "young and emerging talent" in Syria, only few young Syrian artists actually exhibited at his gallery or took part in his festivals and many young artists expressed their disappointment of Touma's perceived total lack of interest in their work and the local scene.[142] As a result, Issa Touma's activities remained marginal within the Syrian art scene, despite them being among the best known internationally.

As we have seen, the 2000s witnessed a number of newcomers to the art scene in Syria, something that added a particular dynamic to it and seemed to have great potential for the future. However, these newcomers did not always receive a warm welcome from the members of the established art world. Howard S. Becker has pointed out that new art worlds will be actively developed, if established art worlds and their institutions do not recognize certain works, produced by members of these art worlds, as "art".[143] Becker explains the often heated resistance against innovations in the world of art as rooted in perceived threats to the position of established art world members. New aesthetics might mean a falling behind current practices and thus becoming irrelevant.[144] According to Pierre Bourdieu, such conflicts are an integral part of the "field of artistic production" and the attempt to "impose the dominant definition of the [artist]" serves to "delimit the population of those entitled to take part in the struggle to define the [artist]".[145] In Syria,

members of the established art scene and many older artists often expressed strong criticism of new artistic media as they perceived them as "alien". The painter Youssef Abdelké described video and installation art as such at the conference organized by the Damascene Rafia Gallery in 2010 mentioned above and stated that they "reflect European and American values, desires and modes of expression".[146] But "polemics imply a form of recognition", to quote Bourdieu again,[147] and so, by entering a discussion about the legitimacy of new practices, older art professionals, involuntarily perhaps, acknowledged their existence within the Syrian art world. For young artists, however, the situation appeared more conflictual. They felt that it was their interests which were being attacked by older, established artists, who sought to assert the superiority of their positions. This led one young artist in the audience at the above-mentioned conference to emotionally burst out: "If I hear one more time about how great Fateh Moudarres was, I think I will die."[148] But not all older artists were so negative about the new artistic practices. Omar Amiralay, the well-known documentary filmmaker, who had a lasting influence on younger videomakers, and in particular those focused on documentary practices, recognized a new force in the very personal approach of the younger generation.[149]

To the outsider, these fights might have seemed surprising and unnecessary. For a city with several million inhabitants like Damascus, the number of venues to present art and, in particular, non-commercial, experimental art was very small, despite the undoubted improvements throughout the decade. The city could easily have accommodated more. And audience attendance at events also seemed to suggest an interest in new forms of art experiences. In many ways, the difficulties arising from the scarcity of available exhibition spaces might have been further complicated by an unfortunate lack of cooperation between many of the initiatives and art spaces mentioned. Although all art-scene agents habitually visited each other's exhibitions and seemed on good, even friendly, terms, there was a strong sense of competition. Most people I talked to, whether gallerists, curators or programmers, were eager to stress the uniqueness of their particular initiative, sometimes expressing criticism of other initiatives. This state of affairs recalls what Christa Salamandra has termed a "poetics of accusation", a certain mode of sociability common among elite groups in Syria and as "part of the competitive fray among cultural producers".[150] In the case of the non-commercial initiatives, this competitiveness could perhaps be explained by their restricted access to external funding. With more competitors for the already limited grants of foreign institutions, the individual applicants might have felt their chances to receive such grants were decreasing. The general climate of distrust in a heavily controlled and monitored environment probably also played a role in this.

Conclusion

In this chapter I have, through the example of the "pioneer" painter Tawfiq Tarek, discussed how modern art came to be seen as a space for commentary and critique of the social and political status quo. This engaged stance was followed by subsequent generations of artists, through those modes of expression they found most suitable. The state, particularly under the Ba'th regime, generally viewed artists and their activities with suspicion, attempting to control their production through censorship or attempt to co-opt it when it saw fit, for example, when it sought to present a favourable image of itself to the outside world. As a result, artists were forced into a "game" of devising ways to continue their work, while steering free of control measures.

When Bashar al-Assad assumed power after his father in 2000, hopes were high among artists and intellectuals, that he would lead Syria to a path of reform and that cultural production would become less subject to coercion. However, in terms of freedom of expression, the changes remained limited. But as a new generation of artists came to fore, among whom many showed an interest in new artistic media, such as video and installation art and a will to re-think the role of the artist in society, there was a certain hope that art and culture could succeed where political activism had failed, namely, in creating more favourable conditions for critique and individual expressions of opinion.

Over the course of the decade, new initiatives were established to represent the production of this young generation of artists and at the end of the decade, the future seemed quite bright. When I left Syria in November 2010 for an intended break of some months, it was only a few months before the beginning of the uprising that turned into such a disastrous war. But at that time, the independent art scene had developed into a small, but dynamic and diverse field that seemed promising for the years to come. At the same time, it was also a very fragile field in constant need of redefinition and to defend itself, both against a society that often did not see its purpose as well as against certain young artists' steadily growing expectations of financial gain, which had been fuelled by the immense success of some young painters at international auctions. In Chapter 2, I will discuss this aspect as part of that difficult balancing act, which artists in Syria needed to perform. Their desire was to apply their art as a way to articulate critique and inspire change, rooted in what I would like to call the particular "world-making" project of Syrian artists.

Notes

1 See www.syrianobserver.com/EN/News/29839/PM_Hails_Arab_Artists_Role_War_Against_Ter rorism (accessed 10 May 2019). This is a translated, possibly abbreviated, version of the article.
2 See www.syrianobserver.com/EN/News/29839/PM_Hails_Arab_Artists_Role_War_Against_Ter rorism (accessed 10 May 2019).
3 See www.theguardian.com/world/2011/aug/25/syria-cartoonist-ali-ferzat-beaten (accessed 10 May 2019).
4 See http://syrie.blog.lemonde.fr/2013/08/23/lartiste-yousef-abdelki-relache-apres-5-semaines-de-sequestration/ (accessed 10 May 2019).
5 See https://syrianobserver.com/EN/news/33340/director_mohammad_malas_detained_for_seve ral_hours.html (accessed 10 May 2019).
6 See https://hyperallergic.com/54968/syrian-sculptor-wael-kaston-killed/, www.alhayat.com/Det ails/421110 (accessed 10 May 2019).
7 There are numerous examples of how authoritarian states display their belief in the power of art. To give just one example: commenting on the censorship of one of her works by Chinese authorities, the American artist Sarah Sze said: "It was amazing to me that the Chinese government actually paid such attention. It suggests a belief that art has a major influence on society." See www.theguardian.com/artanddesign/2016/sep/11/protest-art-miro-elmgreen-dragset-isaac-juli en-sarah-sze-doug-aitken-interview?CMP=share_btn_fb (accessed 10 May 2019).
8 Lenssen (2014), p. 17.
9 For a discussion of the dilemmas of poets and writers in Ba'thist Iraq, see Tramontini (2013).
10 Lenssen (2014), p. 283.
11 Sjeklocha and Mead (1967), p. 61.
12 This ideological take on artistic production is reflected in numerous writings by Syrian critics and officials of the Ministry of Culture, see e.g. Al-Sharif (1984–1985), pp. 4–7. See also several forewords to cultural events by the Minister of Culture, Najah Al-Attar in the Syrian art journal *Al-ḥayat al-tashkiliyya*, e.g. Al-Attar (1986–1987).
13 cooke (2007), p. 30.
14 Naef (2003), p. 192; Scheid (2010), p. 211; Massad (2007), p. 16.

15 For a discussion of the term *tathqif*, see Scheid (2010), p. 203. See Naef (2001), p. 56, for a discussion of ideas of reforms in the social domain.

16 See Naef (2003), pp. 189–190, for a brief outline of the general changes in the visual realm of modernizing cities.

17 Scheid (2010), pp. 209–210, 218.

18 See Weber (2002), pp. 146–147, for a discussion of mural paintings in Damascene houses of depictions relating to the Paris Commune and volcanic eruptions, see pp. 65–166 and pp. 168–169 for depictions of symbols of modern life. Tariq Al-Sharif mentions that framed paintings came to replace traditional ornamentation in private homes. See Al-Sharif (1984–1985), p. 8. For a discussion of practices of wall and ceiling paintings with similar motifs in Beirut and the Levant, see Barakat (2003), p. 133.

19 Naef (2003), p. 202. Maari (2006), pp. 94–95 provides a list of early painters in Syria.

20 Naef (1996), pp. 75–76.

21 Bahnassi (1974), pp. 10, 11; Al-Sharif (1984–1985), pp. 7, 8, 13.

22 See Davidian (2014) for a discussion of Late Ottoman Armenian artists and their treatment by later Turkish and Armenian art historians. See Scheid (2010) for a discussion of early twentieth-century Lebanese painters. For a re-reading of the Egyptian *ruwwad* sculptor, Mahmoud Mukhtar, and his cosmopolitan social environment, as opposed to a purely nationalistic interpretation, see Radwan (2011). In relation to other non-Western artists, recent scholarship has likewise presented new interpretations of their work and highlighted hitherto neglected aspects. See e.g. Juneja (2011) and Mathur (2011) for a discussion of the Indian-Hungarian modernist artist, Amrita Sher-Gil.

23 Radwan (2011), p. 60.

24 Scheid (2010), pp. 216–218.

25 Qashlan (2006), p. 18. The biographical data available for this painter is scarce, often conflicting and largely anecdotal. See Bank (2016b) for a discussion of this research problem and a discussion of some of his works. For biographical data, see Qashlan (2006), pp. 14–20; Al-Sharif (1984–1985), pp. 14–16; Atassi (1998), p. 65; Ali (1997), p. 87.

26 Al-Sharif (1984–1985), p. 14. Oil painting was taught in Ottoman military primary and secondary schools for military purposes, but despite this utilitarian aspect, it seems that some well-known Ottoman artists taught in such schools See Shaw (2011), p. 31 for information on art education in Ottoman schools.

27 Tareq Al-Sharif mentions this "influence" but does not further elaborate on how this is manifested, see Al-Sharif (1984–1985), p. 14.

28 Lenssen (2014), p. 24; Hussam al-Din and Abu Ayash (1991), p. 44. Aivazovsky appears to have been invited to Istanbul on several occasions between 1857 and 1890. Unfortunately, not much is known about these early years of Tawfiq Tarek's training and much remains subject to speculation.

29 See Bank (2016b), for a discussion of the element of critique in the works of Tawfiq Tarek.

30 The painting is now in the Musée d'Orsay in Paris: See www.musee-orsay.fr/fr/collections/ca talogue-des-oeuvres/notice.html?no_cache=1&nnumid=001462&cHash=e54f2d6635 (accessed 10 May 2019). Unfortunately, the exact circumstances of how and when Tarek had access to Bouchard's painting are not known.

31 See Bank (2016b). See also Naef (2002), pp. 225–226, for a brief discussion of the painting.

32 One proponent of these ideas was the Syrian intellectual and activist Muhammad Kurd Ali (1876–1953), who participated in several of the International Congresses of Orientalists and was a fervent critic of much European Orientalist scholarship, see Escovitz (1983), pp. 97, 106. See also Ende (1984), p. 70. In Arab painting, such ideas are reflected in what is occasionally referred to as "classicist" art by Arab art historians. The term "classicist" is somewhat misleading here, since it does not, as in European art history, designate an intellectual, cultural and artistic movement that turned towards Graeco-Roman antiquity for inspiration. However, the turn towards the past for inspiration and examples of moral grandness is common to both movements. See Al-Sharif (1984–1985), p. 10.

33 Unfortunately, the exact dimensions of the painting are not known and it remains entirely inaccessible, as it is located in the Presidential Palace in Damascus. Likewise, images of this painting are extremely rare. A reproduction of poor quality is depicted in Hussam al-Din and Abu Ayash (1988), Figure 6.

34 For a discussion of history painting as moral lessons, see e.g. Conn (2002), pp. 23–25.

35 "Saladin, here we are!"

36 Ende (1984), p. 89.

37 Saladin and the motif of Hittin have undergone a number of ideological transformations in the course of Syrian history. Under the rule of the Ba'ath Party and after Hafiz al-Assad had established his authoritarian regime, Saladin and the motif of Hittin gained in importance as a symbol of Arab victory over the imperialist forces and, interestingly, Hafiz al-Assad became closely linked to the person of Saladin. A parallel was even drawn between the latter's victory at Hittin and al-Assad "victory" in the October 1973 war. During a symposium in Damascus in July 1987, held to celebrate the 800th anniversary of Saladin's victory over the Crusaders at Hittin, Najah al-'Attar, then Minister of Culture, said: "The soil which has born Saladin is the same soil that has produced Jamal 'Abd al-Nasir and Hafiz al-Asad, who came to complete the mission of 'Abd al-Nasir by liberating, unifying and awakening the Arabs to prepare them for the battle" (cited in Freitag 1999, p. 11). The importance of the figure of Saladin for the Syrian regime can also be seen in the recent statue of Saladin by 'Abdallah al-Sayyid, erected in front of the citadel in Damascus in 1992. See also Wedeen (1999), p. 3.

38 For a discussion of a similar phenomenon in Ottoman modern painting, see Shaw (2011), p. 3.

39 For a discussion of the political dimensions of modern painting in Syria in its international context, see Lenssen (2014), pp. 38–49.

40 Ibid., p. 13.

41 See, for instance, Naef (2003), p. 189; Naef (1996), pp. 13–15.

42 Qashlan (2006), p. 17. Unfortunately, information on such activities are very scarce and the few available sources only provide very few details. However, they are generally viewed as being particularly important for the development of modern art in the Arab world, see Zayat (2008), p. 19, for a statement about this aspect of artists' activities.

43 Lenssen, Rogers, and Shabout (2018), pp. 104–106. Translation from French by Kareem James Abu-Zeid.

44 Ibid., p. 88.

45 Bardaouil (2016), p. 18. For a discussion of the group, see also Naef (1996), p. 82.

46 Lenssen, Rogers, and Shabout (2018), pp. 94–95. See also Bardaouil (2016), pp. 34–35.

47 LaCoss (2010), p. 103, see pp. 83–84, for a discussion of the group's activities.

48 Sjeklocha and Mead (1967), p. 61.

49 Sjeklocha and Mead (1967), p. 61

50 In the case of Tawfiq Tarek, his choice of Paris was less voluntary, but rather prompted by the necessity to seek asylum in France in 1895, after having been briefly imprisoned in Istanbul. While Syrian artists needed to rely on their own financial resources to study in Europe, students at the School of Fine Arts in Cairo profited from a system of scholarships that sent selected ones to Europe, see Radwan (2011).

51 Lenssen (2014), p. 23.

52 For a discussion of the training opportunities for artists in Syria in the twentieth century, see Bank (2019b). For a history of the institute, see Avez (1993).

53 Ibid., p. 27.

54 Shabout (2007), p. 20; Al-Sharif (1984–1985), p. 10; Avez (1993), p. 38; Dussaud (1927), pp. 248–253.

55 Members included Mahmoud Hammad, Adham Ismail, Adnan Jabasini, Nasir Shoura, Salah al-Nashef, Rashad Qusaibati, and Mahmoud Jalal. See Lenssen (2014), p. 30.

56 Ibid., pp. 30–35.

57 Bahnassi (1974), p. 1 (my translation).

58 Lenssen (2017), p. 223.

59 Lenssen (2014), pp. 218, 286.

60 The UAR lasted from 1958–1961.

61 On the website of the organization, the name given in English is "National Film Organization". However, the article on the page "Organization History" gives the name as "General Cinema Organization", which is closer to the Arabic. In the English language literature, however, "National Film Organization" is more commonly used and, for this reason, I am using this term here.

62 For a history of the NFO, see Boëx (2011a), p. 113.

63 Ibid., pp. 78–79.

64 Ibid., pp. 115–116. My translation.
65 Ibid., p. 85.
66 Ibid., p. 36.
67 Ibid., pp. 110–111.
68 Lenssen (2014), p. 17.
69 See Winegar (2006), pp. 187–188, for a discussion of the need not to assume that all art worlds necessarily aspire for autonomy as defined by European Modernism.
70 Al Khatib and Yazaji (2010), p. 182. See also Boëx (2006), §4.
71 Lenssen (2014), pp. 282–283, 302.
72 cooke (2007), p. 29.
73 Lenssen (2014), pp. 314–320.
74 Ibid., p. 321.
75 Bahnassi (1974), p. 21. See Boëx (2011b), pp. 141–142, for similar views on the role of cinema.
76 *Hafiz al-Asad wa waqadaya al-kitaba wa al-kuttab* (Hafiz al-Assad and issues concerning writing and writers), Damascus: Arab Writers Union Publications 1978, cited in cooke (2007), p. 25.
77 Boëx (2011a), p. 74.
78 cooke (2007), p. 8.
79 Ibid., pp. 8–9. For a discussion of censorship in the *musalsal* (TV drama series) industry, see Salamandra (2015), p. 43.
80 Delphine Leccas, former head of cultural programming at the Centre Culturel Français. Conversation with author, Damascus, April 2010, email correspondence January 2013. See also Lenssen (2011), p. 2.
81 Several artists, particularly filmmakers, to whom I spoke, could tell such stories, if not from their own experiences then from those of other artist friends.
82 Komaromi (2007), pp. 614–615.
83 Johnson (1993), p. 5.
84 Ghadbian (2001), p. 76.
85 Plesu (1995), p. 62.
86 Said (1994), p. 11.
87 Cited in Porteous (1995), p. 209. Similar thoughts were also often expressed in personal conversations I had with Malas.
88 Freitag (1999), p. 10.
89 Massad (2007), pp. 351–354, 373–375.
90 Most literature on art production in authoritarian contexts touches upon this central topic; for examples, see Calirman (2012), pp. 2–3; Wallach (1991), p. 76; cooke (2007), p. 20; Wedeen (1999), p. 110.
91 Wallach (1991), p. 76. See Sjeklocha and Mead (1967), p. 45 on the law of "kritika i samokritika" (criticism and self-criticism), which should guide an artist to know what to paint and what not to paint. See also Devictor (2002), pp. 67–68, for a discussion of the lack of clear rules of censorship in relation to cinema in early post-revolutionary Iran.
92 cooke (2007), p. 26; Devictor (2002), p. 70; Komaromi (2007), p. 614; Naficy (2002), p. 50; Salamandra (2015), p. 43; Wallach (1991), p. 76.
93 Plesu (1995), p. 64.
94 cooke (2007), pp. 19–20.
95 Ibid., pp. 29–30.
96 Ibid., pp. 72–74.
97 Similar practices can be found in Iran. See Egan (2011a), p. 44, for examples from the Pahlavi era and pp. 52–53 for the post-revolutionary era.
98 Boëx (2011b), p. 149.
99 cooke (2007), pp. 102, 106. Such screenings were, however, rare and most of the time Syrian films of this kind remained firmly locked up in the archives of the National Film Organization.
100 I heard such stories from a great number of people involved in film production, both filmmakers and independent producers.
101 Cited and translated in Boëx (2011a), p. 290.
102 cooke (2007), p. 31.

103 Filming these scenes involved taking some substantial risks, since Syrian films (and TV series) are normally filmed on location rather than in a studio. Thus, filming these scenes necessitated taking down actual posters of Hafiz al-Assad and replacing them with the fictional ones. In the case of this particular film, the film crew working on the set was also employed by the *Mukhabarat* (intelligence service), but appear to have been sympathetic to the filmmaker's project. This may explain why it was possible to take down official posters and banners in the first place, but it also illustrates the conflict-laden climate, within which filmmakers were working. Oussama Mohammad was obliged to rely on the whims of the regime in order to produce a film that was critical of that very regime. See Wedeen (1999), p. 115.
104 For a discussion of the family as a metaphor in official ideology, see ibid., pp. 49–66.
105 Ibid., p. 3.
106 I have not been able to gain any information concerning the transfer of this painting to the present location in the presidential palace, nor whether it is actually still located there.
107 Perthes (2004a), p. 13; Perthes (2004b), p. 103.
108 Literature that discusses different aspects of the "Damascus Spring" movement is quite abundant. See e.g. Pace and Landis (2012), pp. 120–122.
109 "Statement by 99 Syrian Intellectuals", originally published in *Al-Hayat* on 27 September 2000, translation from the original Arabic by Suha Mawlawi Kayal. Available at: www.meforum.org/meib/articles/0010_sdoc0927.htm (accessed 15 May 2019).
110 For a timetable of events of the "Damascus Spring", see Perthes (2004a), pp. 15–19.
111 Wedeen (1999), p. 87.
112 Salamandra and Stenberg (2015), p. 2.
113 Personal communication by an anonymous activist, Damascus, June 2009.
114 Hinnebusch (2012), p. 104; Salamandra and Stenberg (2015), pp. 8–9.
115 Ibid., p. 6.
116 Cited in Salti (2006), p. 51.
117 I thank Delphine Leccas for pointing out these aspects of the official art scene to me.
118 This was deplored by several younger artists with whom I spoke.
119 For an idea of the activities of the *Journées de la photographie*, see www.delphineleccas.org/section300500.html
120 Perthes (2004a), p. 11.
121 See Efimova (1997), pp. 76–77, for a description of the philosophical and aesthetic discussions surrounding the adaptation of Socialist Realism. It is commonly understood that Socialist Realism was adopted as the official style of Soviet art and literature at the First Congress of Soviet Writers in 1934 and prevailed as the governing principle of art and literature until the mid-1980s. However, it was not formulated as a monolithic set of rules for artists and writers to apply in their practice and left room for individual interpretation, something that also made artists vulnerable to accusations of deviation from official ideology. This vulnerability has certain parallels with the lack of clear rules imposed by censorship discussed above.
122 Komaromi (2007), p. 626.
123 Abir and Nisrine Boukhari, conversation with author, Damascus, April 2009.
124 All Art Now (2008), p. 5.
125 To get an idea of these festivals, see www.allartnow.com/living-spaces-festival.php (accessed 10 December 2019).
126 The company relocated to Cairo after the arrest of Nyrabia in 2012 and subsequently to Berlin, where it is now based.
127 Diana El-Jeiroudi and Orwa Nyrabia, conversation with author, Damascus, June 2009.
128 This critique was voiced by several people in Beirut as well as in Damascus.
129 Hegasy (2010), pp. 23, 31. See also Wedeen (1999), p. 87.
130 See www.delphineleccas.org/section442397_475618.html (accessed 10 September, 2019). I participated in the programming as curator of an exhibition of video installations. What was originally planned to become an annual or bi-annual event was re-planned as an itinerant festival by Delphine Leccas and myself and went on to be hosted by different institutions in the Netherlands (International Film Festival Rotterdam in 2012), Turkey (DEPO in Istanbul in 2013) and Germany (ZKM, Centre for Art and Media in Karlsruhe in 2014). The 2014 festival was the final one.

131 See Takieddine (2010) for a summary of this conference and some of the discussions it opened.

132 Rafia Kodmani, conversation via Skype, 12 December 2017. Kodmani expressed her sadness at having lost the centre of her professional activities and the difficulties of continuing her work in Dubai.

133 For an interview with the gallery owner, see Maghribi (2011), pp. 74–77.

134 Important critique was expressed by Youssef Abdelké upon ending his collaboration with the gallery. Available at: www.reuters.com/article/syria-art-idAFLDE6961JG20101013 (accessed 10 October 2019).

135 See www.nytimes.com/2010/11/27/arts/27iht-scdamascus.html (accessed 10 October 2019).

136 Khaled Samawi in Ayyam (2008), p. 5.

137 See www.ayyamgallery.com/news/39/info (accessed 10 October 2019).

138 Conversation with Myriam Jakiche, then the manager of Ayyam Gallery Damascus, October 2007.

139 Lenssen (2014), p. 40. See also www.reuters.com/article/syria-art-idAFLDE6961JG20101013 (accessed 10 October 2019).

140 The gallery and its practices generated much talk in artistic circles in Damascus and certain rumours of financial dishonesty, such as money laundering, were circulating about Ayyam and another, commercial gallery, Art House. See Boëx (2011a), p. 104.

141 Issa Touma, conversation with author, Aleppo, November 2007. Harsh critique of the established art scene in Syria was voiced by Issa Touma in several conversations.

142 For claims of interest in young talent, mostly expressed to international media, see www.dailystar.com.lb//Culture/Art/2006/Sep-15/114023-issa-touma-vs-the-syrian-state.ashx#axzz2Hlw rP2Qb (accessed 10 October 2019). Several young artists with whom I spoke in Damascus expressed their disappointment at Issa Touma's neglect of their work.

143 Becker (1982), p. 162.

144 Ibid., p. 304.

145 Bourdieu (1993), p. 42.

146 See Takieddine (2010), pp. 60–61 for a summary of this critique. See Keiso (2006) (unpaginated) for mention of similar views among Arab audiences. See Winegar (2006), pp. 158–172, for a discussion of similar debates going on in Cairo.

147 Bourdieu (1993), p. 42.

148 Anonymous audience member, cited in Takieddine (2010), p. 60.

149 Amiralay (2009). Despite the somewhat patronizing views expressed in this filmed interview, Amiralay was one of the most active people in Syria in his encouragement of the young independent film and video scene.

150 Salamandra (2004), p. 147 and Salamandra (2008), p. 188. See also Winegar (2006), p. 295, for a discussion of a climate of competition among Egyptian artists seeking exhibition opportunities in the expanding private gallery scene of Cairo in the early 2000s.

2 Commitment, Critique and the Power of Imagination

In his film *Sullam ila Dimashq* (*Ladder to Damascus*), released in 2013, the Syrian film-maker Mohamad Malas openly denounced the regime of Bashar al-Assad and its crack-down on the youthful revolutionary movement that had begun in March 2011.This critical stance led to a difficult situation for Malas at the Syrian-Lebanese border in March 2014, when he was arrested while travelling to Beirut, en route to Geneva, where he was to present his film at the FIFDH festival (*Festival du film et forum international sur les droits humains*) a few days later. He was released after several hours of questioning and permitted to return to his home in Damascus, but was banned from travelling to the festival in Geneva.

The arrest of Mohamad Malas is just one example of the risks that Syrian artists run when attempting to criticize the regime and its politics in their work. It was not the first case of an artist being banned from travelling abroad; in fact, like many others, Malas himself has been banned from all travel several times during his career.[1] And yet, artists in Syria have repeatedly found ways to question the status quo and voice critique through their works, even if this has brought them into open conflict with the authorities or separated them from the cultural mainstream. Indeed, one might say that this has been the case since the very first artists started to practise Western-style painting in Syria under political systems entirely different from the al-Assads' authoritarian Ba'ath Party regime.

This chapter will focus on how Syrian artists have sought to engage with social and political realities, voice critique, or even attempt open dissent, how they have used their voices and work to reimagine the world and call for a different, possible world. In her discussion of artistic production in modern dictatorships in Eastern Europe and Latin America, the political scientist Caterina Preda has highlighted the task of art in such states as turning the "possible" into an aesthetic category. Drawing on the theories of Jacques Rancière and Gilles Deleuze, as well as the writers of the Frankfurt School, she affirms the critical role inherent in artistic production and its capacity to offer alternative visions of realities.[2] The subversive and emancipatory potential of art was also recognized by Pierre Bourdieu, who stated that art could function as a "technical advisor for all subversive movements".[3]

The caution with which authorities viewed art and artists in Syria and which was discussed in Chapter 1 is related to these inherent qualities. Syrian artists have, throughout the history of modern art in Syria, seen their work in similar ways. They have regarded themselves and their works as being clearly situated within the lived reality of the world as they experienced it and, for a number of artists, this embeddedness went hand in hand with a critical commitment to advocate for a change in the status quo. For the art historian Terry Smith, this particular relationship of art to its contemporaneous reality is central to

contemporary art: "contemporary art ... is essentially, definitively and distinctively *worldly*", i.e., deeply involved with the particular moment and location in which it was created and therefore different from the modernist ideal of a universal, transcendental art.[4] I suggest that this close link between art and its socio-political situation has been manifest in the works of Syrian artists since the early days of oil painting in the European modality. But together with this connection to the moment of its creation, much Syrian art also shares an interest in inspiring a different world. As noted by the art historian Marsha Meskimmon in her response to the cited essay by Terry Smith, the embeddedness of art in its contemporary reality gives it a "significant role to play in imagining the world other-wise – in becoming 'for the world', not just as it is, but 'as it might be'", offering "the potential to *make* the world otherwise in future".[5] The latter notion is of particular interest here. In this chapter and Chapter 3, I will discuss the world-making project of Syrian artists and the legacy of criticality in their works. I will discuss critique as it has appeared at distinct moments within the history of Syrian art, when artists found ways to combine their aesthetic pursuit with the will to step outside the comfortable frame of mainstream artistic production. These are moments in which artists have taken a progressive stance on social and political issues and used their art to call for a reimagining of the world as they and their audiences knew it.

In what follows, I will discuss the role of the artist in Syrian society, their particular situatedness in their social and political environment and their advocacy for social and political transformation. I begin in Section 2.1 by discussing the different notions of "committed art" and "critical art", how they are construed within international artistic discourse and how they can be defined or redefined in the particular context of the authoritarian Syrian state. I will then move on in Section 2.2 to discuss how artists in Syria have viewed their role within the broader context of Syrian society and the role new artistic media played in the 2000s. In the final Section 2.3, I will briefly discuss the audience(s) of critical art production, as far as this is possible without any empirical research having been done in this field. I will here draw on my own observations and those of my interlocutors.

2.1 Artist-Citizen: Commitment and Critique in Syrian Art

In Chapter 1, I discussed how the frame of the Syrian state with its different regimes defined the ways artists viewed their roles as artists and the meaning of their work. Throughout the history of art in Syria, art has mostly been regarded as an important civic instrument, while also constituting an intellectual, aesthetic pursuit. For the *ruwwad* painters like Tawfiq Tarek, learning and practising oil painting were a way to assert their modernity, and for artists of the early independence era, art represented an important instrument in society-building and to articulate critique of its wrongs. And even when the state grew increasingly authoritarian and sought to intervene in more and more aspects of civic life, artists asserted their freedom to address current issues in the way they saw fit. They even occasionally ventured into the dangerous terrain of critiquing the structures and figures of the Syrian state, something that filmmakers in particular were attempting and which represented a considerable risk under Baʿath Party rule. For Lisa Wedeen, cultural production was where Syrian political action could take place, direct political action being too dangerous: "political parodies, feature films and jokes are where Syrian political vitality resides and where critique and oppositional consciousness thrive".[6]

While most artists I spoke to in Syria were hesitant to use the term "political" when speaking about their work and usually did not define their practice as "critical" either, they rarely seemed to question the potential of art to inspire and eventually achieve societal change. For historical reasons particular to the Arab world, the term "committed" was also usually avoided and even downright rejected. This poses the question as to how we as scholars should address their practice, which terms are best suited to the particular Syrian situation. In what follows, I will discuss what I have chosen to call the "world-making" project of Syrian artists. I will begin by a brief discussion of the terms "critical" and "committed" as they were defined by European theorists and their significance in the Syrian and broader Arab context. I will then outline how the production of the younger generation of Syrian artists can be described as "critical". In doing so, I align myself with contemporary notions of art as a space through which to challenge the status quo, inspire change, to "re-imagine the world" or "re-make the world", as they appear in the writings of art historians and theorists like Marsha Meskimmon and Dan S. Wang.

As noted in Chapter 1, art in Syria, as in other authoritarian contexts, was and is regarded as a powerful tool, which, in the view of the state, needs to be closely monitored in order to ensure that its messages do not run counter to official ideology. This belief in the power of art was mirrored by statements of the artists with whom I spoke, and has been noted by the anthropologist Christa Salamandra as a common opinion among all cultural producers in Syria with a socially committed attitude.[7] The installation artist and art faculty teacher Buthayna Ali used the following words to express this connection between art and social reality:

> An artist cannot exist apart from society, from his or her space. I am part of this region and my work is concerned with the issues of my country. While I do not consider myself a political artist, I cannot produce a work that is entirely devoid of political significance. I take an interest in my surroundings, my society, its concerns, its inconsistencies. And all this shows in my work. My art mirrors my surroundings – I present a visual expression of my society.[8]

This view was echoed by most of the artists with whom I spoke. Refraining from defining their practice as distinctly "critical", they usually preferred to describe it in somewhat vague terms, referring to the social change they hoped to inspire. There are several possible reasons for the hesitancy of artists to use terms such as "critical", "political" or "committed". As discussed in Chapter 1, using an overly blunt visual language when addressing critical issues was not without risks for artists. But to a large degree, it is probably also grounded in the intellectual history of these terms in the Arab world. And due to their connection to official ideology, artists would often have been reluctant to engage in discourses that might be seen as ideologically tainted and be wary of getting too close to easy, didactic messages similar to those conveyed through much of the officially sanctioned art. Therefore, they often expressed opinions close to those formulated in European contexts about the social responsibility of cultural producers and intellectuals. Despite this seeming closeness, a certain amount of caution is necessary, as the living and working conditions of artists differ greatly between Europe and the Arab world, and from one Arab country to another as well. In what follows I will discuss the notions of artistic commitment and critique with their different implications and how they can be meaningfully used in the Arab and particularly in the Syrian context.

Artists have at various periods commented critically on their contemporary society and/or political situation.[9] However, political engagement and commitment as a conscious stance of artists are largely a product of nineteenth-century modernity, and particularly France. As noted by the art historian T.J. Clark, the mid-nineteenth century was a time where "the State, the public and the critics agreed that art had a political sense and intention".[10] In a study of French intellectuals and their public role from the Dreyfus affair to the 1980s, the historians Pascal Ory and Jean-François Sirinelli defined the term "committed" (in French, *engagé*) as a particular political positioning of the artist (in this case, the writer), expressed in his or her artistic work and public utterances. It appears not as the occasional expression of an opinion on current affairs in a single work, but rather as inseparable from the person of the writer, who through this action becomes not only an observer of his or her time, but an active participant: "la literature est insérée dans son temps, elle est donc mémoire; le litterateur est engagé, il est donc acteur".[11]

Most writers and artists of the nineteenth and early twentieth century wrote from the position of concerned outsiders, as members of the middle class. In contrast, Jean-Paul Sartre stated the need to write from within the community under pressure in his narration of his own and other writers' involvement with the underground newspapers of the French Resistance during the Second World War: "from within oppression itself we depicted to the oppressed community of which we were part its anger and its hopes".[12] In his understanding of the role of the writer, the aim of writing should be to "reveal to the reader his power, in each concrete case, of doing and undoing, in short, of acting".[13] Strongly emphasizing the freedom of the writer, for Sartre, the refusal to adhere to a given political agenda as dictated by parties or regimes was an important aspect of his understanding of artistic commitment.[14]

In the Arab world, Sartre's ideas were of great importance. The term "commitment", Arabic *iltizam*, entered the field of cultural production in the Arab world via discussions of Sartre's ideas by the Egyptian critic Taha Hussein. But the idea that artists had a social obligation towards their societies and should work towards its improvement had been around for some time, as the example of the Surrealist group *Al-fann wa-l-hurriya* (Art and Liberty), founded in 1939 in Egypt shows. Firmly rooted within international leftist discourse, the artists affiliated with the group declared their solidarity with European artists who were threatened and persecuted by the fascists and affirmed the social and political responsibility of artists.[15]

But it was Taha Hussein who helped theorize these ideas in his literary journal *Al-katib al-misri* (*The Egyptian Writer*). In 1947, he discussed a series of essays published by Sartre in the journal *Les Temps Modernes*, arguing that Sartre's notion of *literature engagée* was very useful for the Arab readers.[16] In the Arab context, the notion of "commitment" seems to have been quite flexible and soon came to cover a variety of different readings, from strictly Marxist understandings to more open concepts of commitment growing out of the writer's individual sense of responsibility.[17] The latter appears close to Ory's and Sirinelli's definition of artistic and intellectual commitment. For example, in 1956, the Egyptian secularist, socialist and feminist writer Salamah Musa wrote in his *Al-'adab lil-sha'b* (*Literature for the People*):

> a literature that is engaged or committed makes it imperative that we take on social problems. A belletrist is responsible; and his responsibility is to society and humanity. He should always stand against war, colonialism, exploitation, against the denigration of women, against inequality between the sexes in civil, constitutional, and economic rights, and he must call for justice to the workers and for love between the two sexes.[18]

The demand for artistic production to apply itself for the improvement of the society became even more outspoken following the defeat of the Arab armies in the Six Day War of June 1967. Thus, the Syrian artists Nazir Nabaa (1938–2016) and Burhan Karkutli (1932–2003) called for a realist, committed art, that responded to issues of political and social urgency. Termed "expressive realism", Nabaa saw this approach as the only appropriate means of contributing to the Arab struggle after the defeat of 1967. In an article published in the *Al-Ba'th* newspaper, he saw this kind of art as the only appropriate means to react to the threats to the Arab cause and support it. For Nabaa, the role of the artist was to express the reality of his society and works of art should therefore respond to the bitterness of concrete reality. For him, the events of the war of 1967 obliged artists to turn to an expressionist reality in their literature, poetry and visual forms. They should give a voice to their community's experiences, its joys and its sorrows, its victories as well as its defeats, and to capture what he termed "real, unformed emotions and unarticulated sensibilities as well as desire, hope and development as a truer embodiment of revolutionary resistance".[19]

However, while the notion of artistic commitment and art as a close representation of people's sentiment in a changing social and political environment could have had great subversive potential, they were soon taken over by the ideologists of the Arab regimes and subsequently turned into a parody of itself. Authoritarian regimes called upon "their" artists to "educate the masses", thereby following not their (i.e. the artists') own convictions, but rather the regulations of the respective Ministries of Culture. The conditions under which this art was given a place varied from one country to another. In Egypt, for example, artists were driven towards political themes by the intellectual climate of the time and painted in a variety of figurative styles, in preference to abstraction. Particularly the artists who exhibited with the "Contemporary Art Group" (such as Abdel Hadi El-Gazzar, Hamid Nada, Maher Ra'ef, Samir Rafi) sought to ground their art in popular life and heritage, while also addressing social inequalities in their paintings. The state did not prescribe a particular style the way the socialist countries of Eastern Europe did with the doctrine of socialist realism.[20] In Syria, as discussed in Chapter 1, authorities had, since the late 1950s, offered well-defined guidance as to what their view of the role of artists in society was, even though artists did not always follow official expectations and often chose to define commitment according to their own understandings, and offered deviant or nuanced views, even when superficially adhering to certain aspects of official policy.

Critical engagement with social and political realities often necessitated difficult negotiations with political and social conventions and always meant careful consideration of what one could say and how one could say it. Thus, the Syrian playwright Mamdouh Adwan saw the revolutionary potential of art as closely linked to the commitment to humanity:

> [Art] can resist the normalisation of oppression. It can focus on human beings and their deep humanity, reminding them constantly that they are human. Artists must create works that will help others to understand what is going on and why and what is the possible outcome.[21]

Similar views were often expressed by older artists in Syria, who invoked broader, humanistic terms when speaking about the social and political commitment of artists and intellectuals, thereby stressing the right to express themselves as something they possess

qua human beings.[22] The young artists I spoke to in Syria often expressed ideas of art needing to address current concerns of society and work for change, using expressions like "taking an active position in society" and as "work for things to change", yet they mostly rejected the labels "political" and "committed" and rarely mentioned notions of "critique". So while artists in Ba'th-ruled Syria needed to carefully tread their way through a multitude of (un)spoken rules, they did, as had been the case for previous generations under different regimes, seek to carve out a space, however limited, for their own, personal vision of the world. In doing so, they had to reckon with multiple constraints and forces which had an impact on their artistic production: it was not only official ideology that sought to influence or even censor the character of the art being produced and the themes narrated.

The painter Louay Kayali (1934–1978) held a firm conviction that the commitment of an artist should be "his commitment as a human being first, and as a producer second", that "commitment comes from deep within him" and that it should be "a real reflection of his positions". For this reason, artists should not be asked by outsiders to be committed to the act of artistic production, but should be expected to be "committed as a human being who takes positions in life".[23] Echoing this view, Youssef Abdelké (born 1951), some of whose works will be discussed in Chapter 3 and Chapter 4 stated that his commitment came from his deep inner convictions, from his nature as a political being, but was reluctant to use the word "committed" to describe his art.[24] And yet, Abdelké was and is an artist, whose work is closely related to the social and political realities of Syria and his wariness of the term "committed art" should probably be seen as a rejection of the ideological implications of the term rather than a downright rejection of the idea of the artistic expression of commitment as such.

For artists in the Arab world, the social, political and cultural environment was and is different from that in Western societies. Committed European intellectuals, such as those discussed by Ory and Sirinelli, had several outlets at their disposal to make their voices heard: a (more or less) free press, public speeches and demonstrations, all of which might not exist elsewhere. And the history of Arab artists' involvement with their contemporary realities reflects this difference, "critical" art is not always easily recognizable as such. For this reason, some caution is needed when transferring terms such as "commitment" and "critique" from the Western context to that of Syria and the Arab world. Each particular case should be carefully considered.[25]

Artists in Syria had since at least the defeat of 1967 been guided by an increasing sense of loss and discomfort with the present condition, something which found its way into their production. A bright and promising vision of the present and future, as can be found in much of socialist realist art from the former Eastern Bloc, is lacking in the works of Syrian artists, including those following mainstream trends. They did not offer a way out of the present conditions, but instead, by insisting on its dysfunctionality, called on their audiences to realize the need for change and to re-imagine a different world. It is not the grand utopias of Socialism, nor the universalism of Western high Modernism that we find in the Syrian works of art from the mid- and late twentieth century, but rather the fragile tracings of a world that is relentlessly deteriorating, the disappointments of the failings of de-colonization and a sorrowful chronicling of the wrongs inflicted by internal and external powers upon human beings in the Arab region. And while the artistic media might change, these preoccupations have followed Syrian artists up to the moment when I am writing these words.

The critical potential of art in a context like that of Syria lies in creating moments for a rethinking of the status quo and reimagining of the world. The difficulties of working for change from within the Syrian system and trying to achieve what little improvement might seem possible was at one point compared to "swimming in honey" by the Director of the Goethe Institute during a conversation.[26] It involved a painstaking process of seeking alliances among moderate and slightly open-minded members of the official system,[27] of constantly assessing which language might be most appropriate, when to push the limits and when to refrain from doing so, when to speak up and when to remain silent. At the same time, art remained a rare opportunity for transgressive practices and for political articulation, which should be acknowledged as such. Lisa Wedeen has pointed out the danger of ignoring this, as it "may mean neglecting the lived circumstances in which collective action is generated and sustained; quotidian struggles can and do grow into large-scale and conscious challenges to the political order".[28] Thereby, the absence of freedom did not prevent artists from speaking their mind and the audiences they reached in turn became skilled at reading between the lines. "intellectuals ... find ways of coping with fear and of communicating alternative ideas to receptive audiences who can imagine remaking their world even if they do not act politically".[29] One young artist, with whom I spoke, used the metaphor of a wall to express how he perceived the efforts of his generation to advocate for change. Former generations, he claimed, had tried to bring down the wall in its entirety, all at once. His generation preferred to scratch at strategic places in the hope of eventually making the wall crumble. In other words, he saw his own generation's attempts to achieve change through small steps as more promising.[30] Christa Salamandra and Leif Stenberg described efforts by human rights activists, socially critical artists and political critics in a similar vein, as "chipping away at that wall, moving it incrementally to widen the range of public discourse".[31]

To understand the work of young Syrian artists experimenting with contemporary expressive formats and seeking to inspire change in their society, Terry Smith's notion of contemporary art, as characterized by artists' engagement with the world as it is and as it might be, is helpful.[32] The art of today, so his argument runs, mirrors the changing shape, multiplicity, contingency and arbitrariness of contemporaneity itself.[33] Young Syrian artists were reckoning with the fluctuating social and political climate of the 2000s, trying to push for the changes, they regarded as essential. But while Smith sees such contingency as belonging to the contemporary era and opposed to the idealism and universalism of Modernism, for artists in Syria and the Arab world, such uncertain and fluctuating conditions have prevailed since the days of colonialism and have shaped the world, with which these artists have been confronted. The embeddedness of the works of Syrian artists in their contemporary reality arose from a necessity they felt to name the wrongs of the present world and imagine it differently. This "imagining of possible worlds", to which Terry Smith refers as a "hope-filled enterprise",[34] is what Marsha Meskimmon expands upon in her discussion of "art's agency in worldmaking" and which she sees in the "interconnection between ethics and aesthetics ... within the registers of imagination, affect ... where the future can be made anew and opened to difference".[35] Meskimmon goes on to say that "art compels, but it does so at the level of the subject and through the power of the cultural imaginary".[36] It is in this way that the works of critical Syrian artists, both of the present and past generations, should be seen. Their unease with their present conditions led them to create works that were meant to instil a wish in their viewers to imagine the future as different from the past and present and to actively work to bring about this change. While they did not frame their work as

"critical", it comes close to a definition offered by the writer and artist Dan S. Wang, who sees critical artistic practice as multi-disciplinary, involving object- or display-oriented, interactive or performative approaches and having the aim of presenting "questions and challenges about the way the world is, the way we perceive it, and the ways in which we can act in it", thereby implying that "a world with different social arrangements, behaviours, or both is possible".[37]

2.2 Balancing on the Edges: Being an Artist in Twenty-First-Century Syria

In 1997, the filmmaker Nabil Maleh (1936–2016) wrote an essay in which he presented a very bleak image of the state of art and culture in Syria and, more generally, in the Arab world:

> In this country, it is pointless to speak of a 'cultural scene'. Culture is like politics: it suffers from lack of vision and a program, and has stood still on the sidewalk of the world, participating only like an outsider would, by applauding, crying, wailing, protesting, reactive, never with any initiative and prospect.

He also stated his belief in what he called an "explosion", which was due to happen because "it is not possible for human beings to accept these living conditions for much longer".[38] At first, it seemed that the twenty-first century could bring, if not exactly an "explosion", then at least the "light that will emerge from beneath the clutter" which Maleh had hoped for.[39]

Such hopes were largely crushed through the 2000s, yet the youthful contemporary art movement offered some glimmer of hope, despite undeniable, ongoing problems. Young artists sought not only to redefine the artist's role in society, but were also immersed in a search for new artistic languages and media and some began to experiment with video, digital photography, installation and performance art. These art forms were not taught in art schools as these kept their traditionally oriented curricula and teachers often remained sceptical of any new artistic medium or form of expression.[40] As several young artists complained, new artistic modes of expression were often denied the status of "art" by art professors and critics alike.[41] Many young artists experienced the climate at art schools as "backward minded and out of touch with contemporary life", "hostile towards contemporary artistic media" and only concerned with "the pursuit of beauty".[42] The failure of art school teachers to recognize significant recent developments in international art and to acknowledge as legitimate the wish of young artists to participate in ongoing artistic dialogues with their peers outside the country led to a strong feeling of frustration among younger artists and a strong urge to leave behind what they felt were outdated aesthetics. They were eager to apply new artistic media in their practice and catch up with international developments, but they were also intent on keeping themselves grounded in Syrian social reality. Like earlier generations of artists, they saw themselves as members of Syrian society, as active social agents who used their art to work for positive change in society and who managed to balance the pursuit of aesthetic concerns with strong social commitment. Older generations of artists had expressed their political and social commitment through oil painting and drawing and still continued to do so in the new millennium. But for some artists of the younger generation, these practices seemed either antiquated or a terrain firmly in the hands of their teachers, and thus, exploring new artistic media was seen as a viable solution. Commitment and critique

came to be expressed largely through new media, mostly video, but also installation, and to some extent performance art. Thus, while the formats through which commitment and critique were expressed might change, the dedication to critical artistic production remained, echoing the words of the cultural studies scholar Hanan Toukan: "What commitment is and how it manifests as a counter-hegemonic act depends on how politics is practiced, conceived, understood and resisted in any respective historical era."[43]

However, the marginal status of their practices led, together with their (understandable, but largely self-imposed) estrangement from the Syrian official art scene, to a kind of isolation, that was exasperated by the lack of coherent connection to artistic developments outside the country.[44] Young artists who worked with contemporary media were largely left to fend for themselves and pursue their own experiments without assistance in this quest. They often had to rely on a combination of self-education, mutual assistance and feedback for their training, combined with occasional workshops, such as those offered by the foreign cultural institutes.[45] During my research in Syria, I found the young, independent art scene in Syria to be dynamic and teeming with energy. Discussions among artists were frequent, lively and imaginative, but I could not entirely avoid feeling that artists were also often at a loss as to how they could focus this abundant energy in a meaningful way. Given the lack of continuous training opportunities in contemporary artistic media, a certain degree of incoherence was occasionally traceable in some works I got to see. Many experiments remained unfinished and were never allowed to mature, due to the informal character of the artists' education and because workshops ended and with them the necessary feedback from teachers and lecturers. Occasionally, I noticed some degree of impatience among young aspiring artists and, at times, little willingness to pursue long-term studies to achieve results. Some young would-be artists tended to regard contemporary art as "easy" to learn, and thereby failed to recognize that video and installation art both have a history and are embedded in art historical discourse, just as painting and sculpture are. While eagerly seeking to apply these practices, but lacking the necessary knowledge and skills, these young people risked involuntarily confirming the prejudices their professors might have had about contemporary art. But despite such difficulties, the first decade of the millennium did produce some remarkable examples of art and marked the beginning of the practice of video and installation art in Syria. I will discuss some of these in Chapter 3.

For many young artists and filmmakers, the documentary filmmaker Omar Amiralay (1944–2011) became a leading inspiration. His uncompromising stance towards the Ba'th regime (facilitated to a large extent through his international reputation and residence in France, which put him beyond the reach of the regime's repressive measures) and his innovative approach towards documentary filmmaking served as an important model. Amiralay held a firm belief in the power of documentary film, a "deep conviction" based on "contact and exchange with people as well as engagement with reality", which led him to believe "that a mere mortal such as myself could not imagine a fiction with characters and a plot more enchanting and powerful than that which happens in the crucible of the everyday".[46] This fascination with everyday, lived reality was accompanied by a strong scepticism which informed his work, and led him to state:

> Truth in every fact or postulate is suspicious, ambivalent, relative, and ought to be subjected to the test of investigation, history, and accountability. This is one of the reasons my films lie in the liminal space betwixt documentary and fiction; they are crafted with the compulsion to coax ambivalence and titillate doubt.[47]

Despite the bitter sarcasm found in many of Amiralay's films, he kept his belief in cinema's power to change: "Were it not for cinema, I would not have let myself, for all these years, drift with abandon in the illusion that it has the ability to bring change or make a difference in art and life around us."[48] Though Amiralay's films cover a broad scope of subjects, he kept coming back to a bitter critique of ideology and the stagnation it caused in society several times in the course of his career, whether in Syria or more generally in the Arab world.

His practice was deeply informed by a concern for the lived reality of ordinary Syrians, something that resonates in his two early films *Al-hayat al-yawmiyya fi qarya suriyya* (*Everyday Life in a Syrian Village*, 1974, 90 min.) and *Al-dajaj* (*The Chicken*, 1977, 40 min.). Amiralay criticizes the measures initiated by the Ba'ath Party to fight poverty in rural areas and presents the party officials as entirely disconnected from the social reality, with which they claim to be concerned. Both films were banned in Syria, leading to the filmmaker's return to France, where he had studied and taken up filmmaking during the protests of 1968. Leaving Syria meant abandoning the long-term project he had been planning together with his friend, the playwright Saadallah Wannous, to "film the everyday life".[49] In *Il y a tant de choses encore à raconter* (*There Are Still So Many Things Left to Say*, 1997, 50 min.), Amiralay and Saadallah Wannous discuss the failure of the political projects of their youth and their lost ideals. Filmed during the final stage of Wannous' cancer treatment, it is a disturbing work filled with a bitter self-critique that seems to leave no way out of the perceived impasse. This sense of disillusionment is also prevalent in the film *Tufan fi bilad al-Ba'th* (*A Flood in Baath Country*, 2003, 47 min.), a reflection on the effects of the Ba'th's ideological apparatus on society, in which Amiralay shows how alignment with official ideology is disseminated through schools and party structures. But despite Amiralay's general disenchantment with the current situation in the Arab world, he appeared to have seen some hope in the young generation of documentary film- and videomakers, something which clearly played an important role in his co-founding of the Arab Institute of Film (AIF) in Amman in 2005.[50]

While the AIF certainly offered some opportunities for learning, it necessitated interested students travelling to Amman, something not every young would-be filmmaker could easily do. With the lack of training opportunities in contemporary artistic media inside Syria, artists needed to look elsewhere to learn the necessary skills for their chosen medium. Despite the basic courses in film and video technique offered by the Institute of Dramatic Art in Damascus, the field of TV production, which gained considerably in importance throughout the 2000s, became both an important employer and a space to learn useful technical skills in film and/or video production. The market for Syrian TV drama series was growing fast throughout the Arab world with Syrian drama overtaking Egyptian productions in popularity.[51] An increasing number of artists found employment in this field, many seeking to use their jobs in television to support more "serious", independent artistic projects that they would work on in their spare time.[52] Depending on their skills, some artists also worked as graphic designers, trying to keep a balance between the need to earn a living by doing a job they felt artistically unrewarding and their commitment to their own artistic endeavours.

In other contexts, occasional funding from public or private institutions could have offered some relief. But unlike countries, such as Lebanon and Egypt, where a certain rudimentary artistic infrastructure (however insufficient it might have been) of mostly internationally well-connected institutions, festivals, non-profit art spaces, and other similar initiatives, had developed since the turn of the millennium, Syria suffered from an

almost complete lack of similar institutions. Only extremely limited possibilities for private or non-governmental funding for the arts existed in Syria,[53] making selling art the only possible way for artists to earn a living through their artistic work. And while the foreign cultural institutes offered some funding opportunities, access to these depended on the artists' skills in mastering foreign languages and a building up good personal relationships to these institutes.[54] Therefore, to produce independent, experimental projects involving unsellable art, artists and cultural producers were largely left to themselves and had to rely on their own communities. While this puts severe limitations on artists' possibilities for development, the dynamic atmosphere of discussions, mutual criticism and feedback among peers did create a climate of experimentation as a fertile ground for a young, active contemporary art scene.

2.3 Searching for Renewal: Video and Installation Art as Locations of Critique

Painting was and still is by far the most important artistic medium among Syrian artists. The appearance of a young generation of artists who began to experiment with contemporary media during the first decade of the twenty-first century did not change this, nor has the change in production and distribution practices of the last decade meant a substantial turn away from painting as the dominant medium. Not even the fact that a large part of organized artistic life in Syria has come to a halt due to the ongoing conflict or that many artists now live in exile in Europe or the countries surrounding Syria has changed the situation that the vast majority of Syrian artists still continue to paint. And in the eyes of the Syrian public, the notion "fine artist" never ceased to signify "painter".

In Chapter 1, I outlined how young artists in the 2000s came to see contemporary artistic media – especially video and installation art – as the most effective vehicle for social critique and to advocate for change. Painting, the dominant medium, which had hitherto also served to articulate critique, seemed to have lost its effectiveness. Thereby, the art scene in Syria appeared geared towards a different trajectory. With the increase in upscale, private galleries in Damascus and the new focus of large auction houses on "Middle Eastern" and "Arab art", a number of Syrian painters, some of them quite young, achieved prices on a hitherto unimagined scale.[55] This further underlined the importance of painting and encouraged the choice of painting as a medium among young artists. As a consequence, towards the end of the decade, artists choosing to work with video or installation saw themselves faced with a widespread lack of understanding from their surroundings, possibly even greater than in the early years of the decade. "Why would a young artist shy away from material success and work with media that nobody understood and that could not be sold?" seemed to be the attitude among large sections of the cultural field. But for those young artists who sought not just financial success, but also a way to express themselves on matters of personal significance and to address current issues of social importance, painting had largely lost its attraction and new media, video, installation and performance was their choice.

Installation was, compared to video, much less frequent among young artists. One reason could be the greater requirements in terms of studio space necessary for this art form. Another reason could be its remoteness from art forms that were familiar to artists in Syria. As I will discuss below, video practice in Syria was closely related to documentary and auteur cinema, but installation art proved difficult to link to known artistic practices. One of the first artists in Syria to work with large-scale installations was Buthayna Ali, who had studied in France and lived in Canada and through her

international experiences was familiar with global contemporary artistic discourse. Buthayna Ali's work was even presented at such prominent locations as the Umayyad roundabout in central Damascus and the Damascus National Museum.[56] Later in the decade, the artists affiliated with the space All Art Now increasingly started experimenting with installation art, although video remained the central medium.

When speaking about "video", I am referring to moving image works created through the use of different digital video formats and which do not follow conventional narrative models as is common in mainstream cinema. Here I am following Laura U. Marks' definition of video as "independent work using the video medium that cannot be entirely subsumed under theatrical cinema, commercial television, or visual art".[57] I have chosen not to use the term "cinema", as this was often used to indicate moving images shot on 35 mm film in Syria.[58] There is, however, no general rule for classifying the work of young videomakers. Much of the work produced in Syria after 2000 could be situated at the intersection of fine art and film and many artists used the terms "video" and "film" more or less interchangeably, talking about "video art", when they wanted to specify an aesthetic closer to fine art. In general, the Syrian video scene was strongly informed by cinema, in particular critical, experimental cinema. This is not unique to Syria, but has been defined as a characteristic of much of the video production in the Arab world, which, according to the Canadian-Lebanese filmmaker Jayce Salloum, "attempt to find an appropriate form of representation for the issues being tackled".[59] Many of the video works I will discuss in Chapter 3 have a strong relation to documentary practices or are explicitly defined by their makers as documentary works. They also share an experimental approach to videomaking, in the sense defined by Laura U. Marks:

> [Experimental media art] includes experiments, drawn from critiques of cinema and TV, with sound, montage, structure, reflexivity, and other means. It experiments with the relationship between fiction and documentary, in questions about truth, presence, index, and performance … Experimentation also regards content: experimental narrative, essay films, experimental documentary, certain political work. Most experimental cinema is doing philosophy: dealing with epistemology, what we can know; ontology, what is real or true; and phenomenology, what our perceptions can tell us about the world.[60]

One of the pioneers of the "video movement" in Syria was Ammar Al-Beik, who made his first video, *Light Harvest*, in 1997 without any prior professional training in film or media art and embarked on a long path of experimentation, as he liked to stress, as resistance to the aesthetics common in Syrian cultural production, be it cinema, fine art or mainstream TV drama.[61] Similar concerns, although mostly less radically stated, were central to the protagonists of the video movement that developed from the middle of the following decade and it is also echoed by artists in other Arab countries. Thus, the film scholar and filmmaker Samirah Alkassim describes the use of video in Cairo as a "strategic tool" against the orthodox artistic tastes of the upper strata of society and its use for experimentation as "a form of resistance against empirical, ideological and cultural normativity".[62]

In the context of Syria, the relation between film and video was of great importance and possibly even greater than in other countries of the region. I have already mentioned the documentary filmmaker Omar Amiralay as a major influence with his understanding of a personal and engaged cinema grounded in lived reality. In addition, the widespread

practice of watching international films on cheap, pirated DVD copies also permitted a certain clandestine accessibility of often rare films and had a substantial influence on the visual language of young videomakers.[63] They often displayed a remarkable knowledge of international auteur cinema, something that might have appeared unexpected, given that few such films found their way into Syrian cinemas. Foreign cultural institutes also played a significant role in familiarizing the interested Syrian public with international cinemas through their regular screening programmes.

In many ways, young Syrian videomakers largely followed in the footsteps of their older critical artist peers. An important, recurring theme in their works is the conflicts between society at large and the political system with its rigid rules and tight control. A dominant theme in auteur films since the 1980s, the individual's quest for freedom and self-expression was taken up by the young generation of videomakers, who often chose to examine the subject through intimate narratives. Video as a medium of choice can thereby be related to several factors: it offered a more direct visual language with the potential to reach broader audiences and was a way to address the current issues of contemporary society. The artists set about this with a great innovative spirit and zest for experimentation regarding forms and techniques, supported by a courageous will to push the boundaries of permissible speech. Video also seemed a way for the artists to position themselves against what they perceived as redundant aesthetics and outdated artistic languages and, thus, to distinguish themselves from the works of their art school professors.

In this way, the Syrian video "movement" reminds us of the early days of video art in the West and its critique of the institutions of art and mainstream technological culture.[64] The young video practitioners in Syria wanted to give art a public role, to make it the space, within which to discuss social issues of general concern, a role that established art institutions did not (or no longer could) guarantee. This places them close to the artistic practices of "institutional critique", as developed in the Western art world in the late 1960s and 1970s. Artists involved in this movement were intent on bringing the declared self-understanding of art institutions as spaces for the "production of public exchange, of a public sphere, of a public subject" with its Enlightenment ideals closer to the actual workings of the art world. It was believed that this could be brought about by critical practices that revealed the discrepancies between ideal and reality in the functioning of museums and other institutions.[65] But, while the institutional critique in Western video art was articulated as such, Syrian videomakers did not express themselves in such direct ways, and mostly did not seem to be familiar with the concept. But even without con- sciously relating their practices to such notions, the iconoclastic wish to distance them- selves not only from the visual languages and aesthetics of the officially recognized art establishment, but also from officially sanctioned views on local and regional history as presented by mainstream media makes it possible to view Syrian video practice of the 2000s as a form of institutional critique.

A number of the video works that I discuss here have not been shown in Syria, either because they have been more or less officially banned or because artists and/or programmers and curators have deemed them too controversial to even attempt to get permission to present them in Syria. In a few cases, they have been shown inter- nationally at festivals and exhibitions or been circulated among private networks made up of the artists' friends and their extended networks and foreign researchers and curators. This was often a quite common way to get independent film and video productions into circulation.[66] The extent of these informal networks should not be

underestimated and works often made it surprisingly far. But the inaccessibility of independent work remained one of the biggest problems and stands in stark contrast to the declared wish of many practitioners to create works that moved audiences and called for changes in society.

One question that comes up in almost every discussion of artistic production in the Arab world is that of funding, especially that of foreign or international funding and the funding bodies' preferences in terms of subject matter. In contrast to Lebanon, foreign funding for artistic projects was still quite rare in Syria at the time of my research. Artists were intent on looking for the best possible ways to realize their projects, but in Syria this mainly meant producing on an independent basis with the help of extended personal networks. Most young videomakers would have some equipment of their own and borrow more from friends and their extended artistic network. Digital video equipment became increasingly affordable in the course of the decade and at least in the early phases of an artist's process of experimenting with the medium, investing in basic equipment was manageable.[67] Video offered another advantage which made it preferable to other media: it did not require large studios and could easily be transported and sent to festivals and exhibitions. Furthermore, its position between fine art and film gave it a potentially large audience. Laura U. Marks has related video to the activist tradition of Arab writers and poets because of its qualities as an "agile, portable and if necessary, disposable medium that condenses and expresses political situations in a personal voice".[68] So, for an artistic community on the margins of the established art scene and with only limited access to funds, video seems to have been a flexible medium that allowed relatively uncomplicated modes of production. In the very last years of the 2000s, there were some indications that structures were developing, which could help young artists in producing their work by making more outside funding available.[69] However, this development was halted with the beginning of the uprising.

2.4 Whose Art? The Audiences and Reception of Critical Art in Syria

As we have seen, the risks connected with the production of controversial artworks did not prevent Syrian artists from creating them. But one question, however, might puzzle outsiders. Faced with censorship and unable to earn a decent living from their art, what might the motivation for Syrian artists be to continue producing art that might not be seen by many people, that might be banned, that might even cause them severe troubles, to produce films that might disappear into storage at the NFO or be pulled out of film festivals abroad? Is this naiveté on the part of the artist or is it a desperate act of defiance? One might ask, why bother? If we accept the notion that a work of art is not an autonomous entity, but is also made through its audience's reception and interaction with it, that the viewers give meaning to the work, and that each viewing expands the meaning of a work,[70] then how should we view work that does not reach its intended audience or whose audience is severely limited? In the case of several Syrian works, these questions need to be asked. Rami Farah's *Silence* and Reem Ali's *Foam*, to give some examples that I will discuss in more detail in Chapter 3, were made with Syrian audiences in mind, while the videomakers were well aware of the controversial nature of the themes addressed in these videos. The works sought to tackle current socio-political issues in Syria, yet they were doomed to remain unavailable to Syrian audiences, as they would not get past the censors.

For the makers of these works, it seems a central issue was the mere fact of producing them. As Rami Farah once stated, producing critical films had the function of a "diary". They helped keep track of the artist's thoughts and mood at a particular moment and in specific circumstances and helped him "keep his sanity as a human being".[71] Other Syrian artists and writers have expressed similar ideas of art as a means of survival and keeping one's mental well-being, such as the writer WafiqYusuf: "We write and write and nothing leaves the country. I don't know why it is that we keep on, but we do. Maybe that's all we can do. Maybe that's how we survive."[72] Another important and related aspect lies in the function of such critical work as a means of resistance. When discussing the practice of Romanian artist Ion Grigorescu, whose critical works produced during Ceauşescu's regime were never shown publicly, but rather only in small circles of friends and collea-gues, the art historian and curator Iris Dressler has argued for seeing such work as instances of resistance, whose significance does not lie in public protest, but rather "in the creation of a parallel world that made it possible to evade the psychological and physical encroachment of the regime's power", i.e., in the "creation of free spaces of thinking and agency".[73] In the case of quasi-banned films in Syria, the knowledge that some artists were actually resisting political power could have a considerable effect on the public, even if the works themselves remain inaccessible:

> The key for potential Syrian audiences was not the film itself, in other words, its availability for screening. It was enough to know that filmmakers like Malas had been commissioned to make a film. His reputation guaranteed that the film would venture into forbidden territory. The mere fact that such a film was being made was more important than actually seeing it, since everyone knew that these films were unlikely to be screened.[74]

Despite not having access to such films, the mere knowledge of their existence would thus have given Syrian audiences a sense of hope and a feeling of dissident conspiracy with the artists.[75] cooke's argument is related to well-known filmmakers like Oussama Mohammad and Mohamad Malas. But in the case of young and only little-known videomakers, the situation was different. Here, Iris Dressler's argument seems useful. For many artists, pro-ducing critical works ensured that they did not lose touch with their convictions and granted them a space to re-think the world as different from the surrounding, "official" reality.

But despite the interest in productions by Syrian filmmakers that local audiences displayed, they often felt puzzled by them. As Cecile Boëx has pointed out, on those rare occasions when Syrian auteur films were shown in Syria, they found it difficult to access the complex and possibly obscure narrative techniques of the films. Speaking of a "real crisis", she identified this "abyss" separating Syrian cinema from its audience as grounded in the structures and production practices of the National Film Organization. While auteur cinema became a site to articulate dissent that could not be expressed in the public space, the hope of seeing their films screened in Syrian cinemas made filmmakers opt for a visual language that became increasingly veiled and thereby made their productions inaccessible to ordinary Syrians.[76] The gap separating ordinary audiences from works of modern and contemporary art and art house cinema is a problem well known in other Arab contexts (and indeed, also in the West). It has been identified as a lack of "authenticity", something that would be resolved by getting rid of "foreign" elements and developing an "Arab aesthetic".[77] By trying to develop new, more direct visual languages, young artists attempted to find a way out of this impasse.

Conclusion

In this chapter, I have discussed how Syrian artists strove to navigate the fraught terrain of critical art production in the context of the authoritarian state and how they sought to carve out a space to speak up about social wrongs and advocate for change, how they attempted to reimagine and remake the world through art. The term "committed art" which has been widely used in art history is only useful to a certain extent. In general, the term seems rooted in its own particular history, and while it has largely fallen out of use to describe contemporary practices since the second half of the twentieth century, in the Arab world, the corresponding term, *iltizam*, has a much more loaded history. Initially introduced in 1947 by the Egyptian writer and critic Taha Hussein to translate Jean-Paul Sartre's notion of "engagement", it was soon taken over by authoritarian, self-declared socialist Arab regimes to designate their (i.e., the regime's) view of art "for the masses". This might explain the hesitancy of many Syrian artists to use the term when speaking about their work.

Of a more recent date is the term "critical art", which in the Western context was preferred alongside the adoption of conceptual, performative and participatory artistic practices. It appears in reference to a variety of practices that involve an active stance on the part of the artist in order to inspire a change in the political, social or cultural environment, within which they are working. "Critical art" can thus appear in a multitude of forms; it can (but does not necessarily have to) involve the active participation of members of the public outside the artistic community and it often seeks to subvert existing rules. Although Syrian artists rarely framed their work as "critical", the wish to engage with contemporary reality and advocate for change places their practice close to this notion. In the way, their work was deeply invested in their social and political reality, they offer good examples of the belief in "art agency in worldmaking" that Marsha Meskimmon has discussed. This belief was shared by artists of all generations and will be the focus of Chapter 3.

Notes

1 cooke (2007), p. 115. See also a report by the UN Refugee Agency, dating from 18 June 2009: Available at: www.refworld.org/docid/4a5f30272d.html (accessed 10 October 2019).
2 Cited in Preda (2012), p. 900.
3 Cited in Danko (2011), p. 49.
4 Smith (2011), pp. 174–175. Italics in original.
5 Meskimmon (2011), pp. 191–192. Italics in original.
6 Wedeen (1999), p. 89.
7 She made this observation during her fieldwork among Syrian TV makers. See Salamandra (2008), p. 180.
8 Buthayna Ali, conversation with author, Damascus, October 2010.
9 Artists such as Francisco Goya and Hans Holbein come to mind with their strong outspokenness against the brutality of war.
10 Clark (1973), p. 9. Despite this, art history has often been reluctant to discuss the political dimension of art works. A striking example is Gustave Courbet, who was deeply involved with socialist politics, recognized by critics as a socialist artist and served as the position of director of art affairs during the Paris Commune of 1870–1871, yet underwent a posthumous process of "de-politicization" to make his art more palatable for the art market and its conservative public. See Nochlin (1982). For a discussion of Courbet's political affiliation, especially to the socialist philosopher Pierre-Joseph Proudhon, see Crapo (1991).
11 "The literature is embedded in its era, thus it is a mirror; the writer is committed, thus he is an active player", Ory and Sirinelli (1986), pp. 147, 149. See also Bourdieu (1993), p. 54.

12 Sartre (1993), p. 177.
13 Ibid., p. 224.
14 Ibid., pp. 220–221.
15 For a summary of the activities of the group and the discussions their work and writing inspired, see LaCoss (2010). For translations of the articles and critiques as well as the group's manifesto "Long Live Degenerate Art", see Lenssen, Rogers and Shabout (2018), pp. 87–105.
16 Klemm (2000), p. 51.
17 Ibid., p. 57.
18 Quoted in Massad (2007), p. 139.
19 See Lenssen (2013), p. 64 and Lenssen (2014), pp. 327–329.
20 See Naef (1996), pp. 100–106. See also Bardaouil and Fellrath (2016), pp. 149–167.
21 Mamdouh Adwan, cited in cooke (2007), p. 91.
22 Boëx (2006), §16.
23 See Kayali (2008). Unfortunately, the text I refer to here is reprinted from a non-disclosed source and is undated. Therefore, the original context of this opinion remains unknown.
24 Youssef Abdelké, conversation with author, April 2014.
25 See also Bank (2018b) for a discussion of the problematic of translating terms related to the social engagement of artists.
26 Björn Luley, conversation with author, September 2009.
27 Such negotiations are sometimes dismissed as a "selling out" of one's ideals. But I would argue that it is important not to condemn all cases of working with certain elements of the state, as it might occasionally represent an important way to achieve valuable results, however small they might be. See also Hegasy (2010), p. 31.
28 Wedeen (1999), p. 87. See also Scott (1990), p. 212. In a similar vein, referring to the GDR, Ulrich Dormröse noted that photography, like literature, film, theatre, fine art and rock music, "took over a substitute-function for a missing discourse about the increasingly obvious difference between social reality and political pseudo reality", Dormröse (2012), p. 16.
29 Wedeen (1999), p. 150.
30 Anonymous artist, conversation with author, July 2007. It is interesting that this artist chose to see former generations of artists as more radical in their advocacy for change and disregard the careful weighing of means of expression in the works of older artists.
31 Salamandra and Stenberg (2015), p. 3.
32 Smith (2011), pp. 174–175. Smith places this concern in opposition to the art of the Modernist era.
33 Ibid., p. 176.
34 Ibid., pp. 184–185.
35 Meskimmon (2011), p. 192.
36 Ibid., p. 192.
37 Wang (2003), p. 69.
38 Maleh (2006), pp. 92, 94. The text is a translation of the earlier text that appeared under the title *Mashahed min al-hayat wa al-sinema*, published in '*Alam al-Fikr*, a journal of the Kuwait National Council for Culture, Arts and Literature in 1997.
39 Ibid., p. 94.
40 The remark "art history as we learn it stops with Picasso" was a kind of standard joke among the young artists I talked to.
41 Even those professors, who were open to contemporary media, emphasized that, since such practices were not part of the curriculum, there was hardly any time for serious treatment of them. Buthayna Ali, an artist and professor at the Faculty of Fine Arts of Damascus University, whose own artistic practice often included large-scale installations, told me that she made a point of mentioning contemporary methods and suggesting further individual research to her students, but that the tight schedule of her courses did not allow any detailed discussion of aesthetics and approaches, Buthayna Ali, conversation with author, Damascus, April 2010. Concerning the general lack of support for new modes of expression, I should note that I did not conduct a systematic survey among art professors, critics and organizers of the official art and culture circuit while I was in Syria, and later, the situation in the country no longer permitted me to travel there and conduct further research. For this reason, I cannot provide a qualified view on this issue.

42 These were misgivings expressed to me in conversations with a number of young artists.
43 Toukan (2015), p. 336.
44 Here it is significant to note the almost total absence of pieces of video art or installation art at official exhibitions. One exception was an exhibition focused on the young artistic generation which was part of the retrospective of visual art in Syria organized as part of the Damascus Arab Capital of Culture festivities in 2008. The retrospective was curated by Delphine Leccas, former head of cultural programming at the Centre Culturel Français. Leccas was well acquainted with the work of young video and installation artists and it was probably thanks to her that they were included in the programme.
45 Workshops were welcomed as valuable opportunities to gain first-hand knowledge from established artists, but they were irregular and the results often suffered from the lack of thorough and long-term commitment, which is inherent in this training model. The common practice of inviting a well-known European artist to conduct a workshop and afterwards exhibit alongside young, inexperienced Syrian artists was criticized on several occasions, as it was seen as presenting a distorted image of the Syrian art scene. Indeed, the practice does run the risk of conveying the unfortunate idea of an underdeveloped local scene in need of guidance from the more sophisticated European art world. Thereby, the agency of local artists might easily be overlooked. However, this issue is more related to European cultural policies than the contemporary art scene in Syria and is not the subject of the present study. In the first part of the decade, a young self-taught videomaker, 'Ala Arabi Katbi, set up a video atelier to promote digital media and offer basic technical and theoretical training. He was able to get some professional film and TV directors on board who offered workshops for young aspiring videomakers. However, due to financial constraints and lack of useful institutional contacts, he was obliged to abandon the project after some years. See Boëx (2006), §21–23.
46 Amiralay (2006), p. 97.
47 Ibid., pp. 97–98.
48 Ibid., p. 98.
49 Amiralay (2009) (filmed dialogue).
50 The AIF was established together with the Lebanese-American filmmaker Hisham Bizri, the Egyptian filmmaker Hala Galal and three teachers from the Danish National Film School, Jesper Højbjerg, Jakob Høgel and Anders Østergaard. Funding came from the Danish NGO, IMS (International Media Support).
51 Salamandra (2008), p. 177.
52 Ibid., p. 179. This was not without risks on the artistic level, as commercial work risk influencing the artistic work and making it unsuitable for the art world. Howard Becker mentions the example of photographers who do commercial work as well as artistic work and complain that commercial attitudes have found their way into their art, "making it hard for them to see and photograph in a way that does not embody the restraints of the advertising mentality", see Becker (1982), p. 96.
53 These only began to develop in the second part of the decade, but despite the undeniable promises they held, the uprising and war of the 2010s put an end to their activities and they were never allowed to flourish.
54 See Boëx (2006), §19.
55 Christie's inaugurated annual auctions in Dubai in 2006, Sotheby's followed in 2008 with auctions in Doha and Bonham's held auctions in Dubai in the same year: www.art-finance.com/AA_Nov_2012.pdf (accessed 10 October 2019).
56 To get an idea of the installation *Tent*, which was presented in the courtyard of the National Museum in Damascus, see www.buthaynaali.com/alkhema.htm (accessed 10 December, 2019).
57 Marks (2003), p. 43.
58 See Marks (2000), p. 6 for a discussion of the term "cinema", which she prefers in her discussion of intercultural, experimental work, whether shot on video, 35 mm, or other formats.
59 See Salloum (2005), pp. 28–29; Hadria (2005), p. 33; Keiso (2006), unpaginated.
60 Marks (2015), p. 2.
61 Ammar Al-Beik, conversation with author, Damascus, November 2007.
62 Alkassim (2004), p. 6.
63 The fact that these films are unauthorized copies of copyright material does not constitute a criminal offence in Syria, as the country has not signed international copyright agreements.

However, these films were not normally screened in Syrian cinemas and would therefore not have received the green light from the censors. The informal market for pirated DVDs therefore constituted a tolerated, grey area of semi-illegality.

64 Rosler (1990), pp. 31–33. It is interesting to note that video as an artistic medium came to Syria as a digital medium. VHS had no importance in the Syrian art scene and I do not know of any artists who experimented with it. Its popular use, e.g., to commemorate important family festivities such as weddings, is much older.

65 See Alberro (2009), pp. 3–4.

66 See Boëx (2006), §14.

67 See ibid., §20. The stress placed here on the affordability of video equipment for young Syrian artists is somewhat contradicted by observations by Samirah Alkassim, who sees the costs involved in the acquisition of video equipment and technology as a significant deterrent, placing it out of reach for the majority of artists in Egypt, see Alkassim (2006), pp. 140–141. The reason for such diversity in opinions may lie in the fact that the costs of acquisition of video equipment fell significantly in the course of the decade. But a certain possible difference between the two locations notwithstanding, it is important to note that the majority of artists in the Arab world belong to the privileged strata of society, whose financial situation makes such investments imaginable.

68 Marks (2003), p. 44.

69 For example, the association All Art Now could have developed into a kind of catalyst.

70 Marks (2000), p. 20.

71 Rami Farah, artist talk at symposium "Resistance. Continuing Traditions of Satire, Art and the Struggle for Freedom", organized by DCCD (Danish Centre for Culture and Development) and Rundetaarn Exhibition Space in Copenhagen, Denmark, March 2013.

72 Quoted in cooke (2007), p. 155.

73 Dressler (2010), p. 51.

74 cooke (2007), p. 119. That there was a certain truth in this statement was confirmed to me during the film programme I curated for the Arsenal Institute of Film and Video Art in Berlin in 2009. After one of the screenings, I was approached by a young Syrian student who told me about his immense pleasure at finally seeing those famous, controversial films whose daring critique he knew of and admired, but which he had in fact never seen.

75 Ibid., p. 119.

76 Boëx (2006), § 12.

77 See Nashashibi (1998), pp. 165–166. The debates about a particular aesthetic rooted in a cultural and/or national identity have given rise to heated discussions among artists and critics in the Arab world. See e.g., Scheid (2005), pp. 31–32, 41 and Winegar (2006), pp. 96–127.

3 Creating Meaning in Visual Art
Technique, Critique and Subject Matter

At the beginning of 2013, an image appeared online and soon went viral on social networking sites: Gustav Klimt's famous painting *Der Kuss* (*The Kiss*, 1907–1908) projected onto a bullet-ridden façade. The artist who had created this image was the Syrian Tammam Azzam, an artist who had fled his native country to Dubai to escape military service. However, it was not a projection, nor a piece of graffiti although the title *Freedom Graffiti* suggested just this. Rather it was a photomontage, created on Azzam's computer in an attempt to protest against the war in Syria and the silence of the world faced with this tragedy.

The image was not only widely shared in online spaces, but also caught the attention of the international media, where several major newspapers ran stories about the work and the artist behind it. Until that time, the war in Syria had not been among the major international news, despite the large-scale destruction and massive suffering in the country. It may be too much to claim that Azzam's image helped put Syria in the headlines, but the attention it got was quite new for Syrian artists. Suddenly, it seemed, the world recognized their work and commitment. *Freedom Graffiti* was part of a larger series of manipulated images, that Tammam Azzam created by using motifs of well-known Western art works and inserting them into Syrian bombed-out cityscapes. This series, *Syrian Museum*, attracted a lot of attention and was widely exhibited. It is one of the early examples of works by Syrian artists that ushered in a change in the international art world's reaction to this production. I will focus more on this aspect in the Chapter 4.

While Tammam Azzam's wish to criticize the world's silence at the destruction and violence in his home country seemed new to Western audiences, it stands in the tradition of Syrian artists' commitment to comment on political and social issues. In Chapter 2, I discussed this as the particular world-making project of Syrian artists. I will now turn attention to individual artists and art works, discuss their relationship to the concepts of commitment and critique and trace the particular role of art as a location within which to re-imagine and re-make the world. In doing so, I will follow four broad thematic lines that can be traced throughout the history of modern and contemporary art in Syria, thereby linking the practice of several generations of artists. I will begin my discussion of each of these thematic lines with an in-depth analysis of a video work by a young artist which I will then relate to other works, by artists of the same generation as well as artists of previous generations. By highlighting the relationships between the works of different generations of artists, I will show how certain themes have remained significant to Syrian artists and how they have been addressed at different stages in the history of modern and contemporary art in Syria. This approach differs from common readings of the history of art in the Arab world, discussed in Chapter 1, namely, of defining a major break between

the pre- and post-independence eras. While it is not my intention to completely refute this notion here, I will attempt a slightly different approach and focus on aspects that allow us to identify a certain continuity, traceable throughout the history of modern art in Syria. My intention in following this method is to locate the "legacy" of critical artistic commitment in the history of art in Syria.

In my discussion of artworks, I will consider visual artistic production in various media, including painting, photography, installation, video and film. Whereas artists in the past tended to work in only one medium, most artists now work in different media and sometimes create works that stretch over more than one medium. The notion of the medium has become "mobile" or "fluid", and artists now tend to work in different media while referencing and citing works in a variety of media. Terry Smith has defined this fluidity or mobility of the medium as typical of all forms of contemporary art.[1] My focus here will fall largely on video, as it was the most important new artistic medium to be adopted by visual artists in Syria at the beginning of the new millennium. As mentioned in Chapter 2, the young video scene in Syria showed strong links to auteur and experimental cinema, a feature shared with contemporary art in other Arab contexts.

In my discussion of works by several generations of Syrian artists, I will identify what could be called "moments of criticality". By using the term "moment", I want to draw attention to the fact that artists produce works that address a wide variety of subjects and not all works might be "critical" or "committed". This is particularly important in a context like Syria. In a country where the official ideology has demanded of its artists a particular commitment to social progress and where much of the art that was produced adhered to this, it becomes paramount to go beyond superficial notions of "committed art" in order to limit our pool of works to half-way manageable argumentative dimensions. This is especially true in the case of the first theme I will discuss, namely, the issue of Palestine and how it has been negotiated in critical art production. Here, I will focus on works that go beyond the simple narratives of refugees' plight or the glory of resistance fighters. Instead, what I will discuss is how the Palestinian theme as a metaphor allowed artists to address other critical issues related to the political status quo. The second thematic focus will distinguish a different kind of metaphor, one which I call the "metaphor of the abyss". With this designation I intend to trace works that speak about the presence of hidden, menacing forces in society, forces that everybody is aware of, but which remain unseen like the unrecognizable secret agents that everybody knew were omnipresent.[2] The third theme I will discuss is related to the issue of conflict between the individual and society, with an emphasis on questions of gender and gender-normativity as they are viewed by Syrian mainstream society. The last theme is one that has often involved the greatest risk for the artists, namely, the attempt to question official ideology. I will start my discussion of each theme with a new video work, then turn to look at other works that can be related to it and thus create rhizomes of meaning around each of the guiding themes.[3] I thereby look at the artworks as phenomenal artistic creations produced within a particular historical, political, social, and cultural context.

3.1 On the Borders of Official Ideology: The Issue of Palestine Between Activism and Metaphor

Ammar Al-Beik's two essayistic, interconnected videos, *Jerusalem HD* (2007, 18 min., Figure 3.1) and *Samia* (2008, 40 min., Figure 3.2), present reflections on the lived reality of Palestinians and the many impossibilities connected with it. Al-Beik (born 1972), an

autodidact artist and filmmaker, is possibly the most radical of the young video artists to start working around the year 2000. With an uncompromising aesthetic and scorn for the artistic establishment in his home country, he was the first to make use of found footage in his work, a practice that became widespread after 2011 and which I will discuss in more detail in Chapter 4. *Jerusalem HD* represents the attempt to tell a fictional story about a young woman and her lonely existence, in which reality seems to keep interfering. *Samia* is an idiosyncratic reflection on the impossibility of travel in the Middle East and Palestinian exile, while also being a portrait of the Palestinian painter, Samia Halaby (born 1936). Al-Beik wanted to film Halaby's visit to her hometown, Ramallah, but, as a Syrian, could not travel with her to Palestine. To overcome this obstacle, he gave her a camera and asked her to film her visit herself and to bring back the footage. In its final form, the video mixes Halaby's shaky, strongly personal footage with that of Al-Beik's, along with some re-used, highly aestheticized footage from *Jerusalem HD*.

Jerusalem HD oscillates between fiction and documentary and appropriates footage from Jean-Luc Godard's film *Notre Musique* (2004). Godard's plea for the Palestinians' right to fiction, their right to be something other than "subjects of documentary", serves as a central point of reference in the film and its attempt to tell a fictional story about a young Palestinian woman. She is left nameless, hardly utters a word throughout the whole film and is mostly presented walking restlessly, not unlike a ghostly presence, through the streets of an old Arab city. The streets are in fact those of Damascus, but by leaving out any reference to particular landmarks, Al-Beik seems to suggest that it could also be a Palestinian city, maybe Jerusalem, or – reflecting many Palestinians' status of permanent exile – indeed, any city, Arab or otherwise. In one scene, the young woman is seen moving through a cemetery, hanging her black clothes on a line between two trees, the blurred image of Jerusalem with the prominent Dome of the Rock beckoning in the

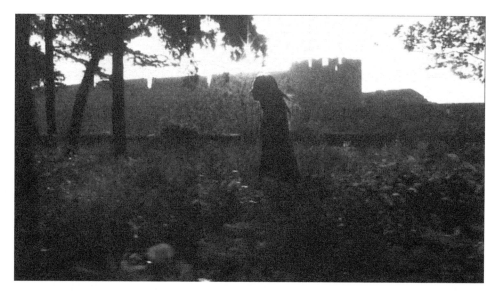

Figure 3.1 Ammar Al-Beik, *Jerusalem HD*, 2007, video
Source: Courtesy of the artist.

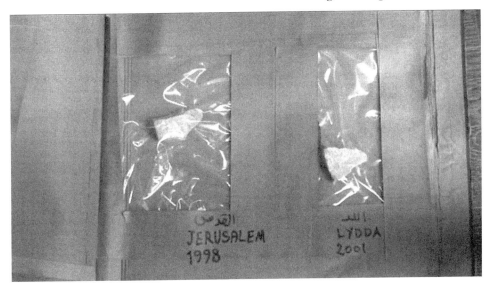

Figure 3.2 Ammar Al-Beik, *Samia*, 2008, video
Source: Courtesy of the artist.

distance. The black clothes and the cemetery, as well as her mainly silent presence, seem to suggest that she has no place among ordinary human beings, or even the living, but is left in a strange limbo, somehow belonging more to the realm of the dead than that of the living. In about the last five minutes of the film, she is seen walking at a brisk pace, but with no apparent goal. Here, she appears as a timeless character, an eternal, restless wanderer, searching the city for something unknown, left to herself and her own brooding. Throughout the film, the woman appears strangely detached from contemporary reality, her clothing suggests no particular fashion and her enigmatic story is left unfinished. As spectators, we are never allowed to learn where she is coming from or where she is heading. Only at one point do we see her interact with an elderly woman, with whom she seems well acquainted, but this narrative thread is not pursued any further and as spectators we are again denied any deeper insight.

Al-Beik presents the spectators with fragmented pieces of a narrative that is left incomplete; he interrupts the narrative at several points both by using found footage and by inserting his own image into the flow of the film. The technique of disrupting the smooth cinematographic narrative is a characteristic feature of the French Nouvelle Vague, used to question classic Hollywood-style cinema and the relation between the spectator and the image. Al-Beik has made use of this technique in other works, such as e.g., *Ana alati tahmol azouhour ila qabriha* (*I Am the One Who Carries Flowers to Her Grave*, 2006, 110 mins, co-realized with Hala Alabdallah).[4] The transitions from one kind of imagery to the other are often sudden and rough. Godard's statement about the Palestinian tragedy, thus, harshly brings us back to reality and seems to corroborate the impossibility of fictional storytelling and imagination in the Palestinian context. The difference in colouring and resolution of the footage of Jerusalem, both of which are left un-manipulated, makes it clearly recognizable as found footage, and thus clearly distinguishes it from the rest of the film. These interruptions, together with the final,

long walking sequence, have the effect of frustrating the viewer's expectations for an easy-to-consume, narrative story.

If *Jerusalem HD* presents itself as a parable of Palestinian exile, told in suggestive and symbolic images, *Samia*, produced one year later, is related to a very real story of Palestinian exile. The work is partly a homage to the Palestinian painter Samia Halaby, partly a visual conversation between the two artists, Al-Beik and Halaby, and partly a video essay that revisits some of the reflections of *Jerusalem HD*. It uses footage taken by Halaby during a trip to her hometown of Ramallah, together with reused footage from *Jerusalem HD*, documentary footage and shots of Halaby's art as well as statements of hers. The mature artist Samia Halaby, forced into exile and returning to her hometown on a rare visit, is linked to the young woman of *Jerusalem HD* through the searches for a home that haunt both women. Halaby records her own search for memorized points of reference in her hometown and her lengthy search for a stone that Al-Beik has asked her to bring him from Ramallah. This stone represents a link between the two artists: As a Syrian citizen, Al-Beik was prevented from travelling to Palestine, a situation the film criticizes in a subtle, but consequential way. The stone thereby becomes a substitute for Al-Beik's own hindered presence; if he cannot travel to Palestine, a part of Palestine will travel to him. The search for the right stone (they are all, Halaby says in the video, the "words of the Palestinian people ... the people, not the government") takes up a large part of the video, putting a certain strain on the viewer's patience, but at the same time stressing the importance of this personal, tactile interaction between the two artists and Halaby's native soil. Halaby also makes a point of filming her interaction with a young man whom she asks to say a few words of greeting to Al-Beik in Syria. The paradox of a political situation, in which a young artist cannot travel from Syria to Palestine and which prevents any free interaction between the two populations is all the more remarkable, as the official discourse of the Syrian regime places great stress on solidarity with Palestine and its people and resistance to "imperialism". While the impossibility of travel between Syria and the Palestinian territories is rooted in the state of war between Syria and Israel and the resulting lack of diplomatic ties between the two countries, the stark contradictions between rhetoric and reality that the video lays bare through the impossibility of personal encounters between Syrians and Palestinians, represent an unmistakable critique of official discourse and its hollowness.

Like Tawfiq Saleh's film *Al-makhdu'un* (*The Dupes*, 1972), mentioned briefly in Chapter 1, which severely criticizes the difficulties faced by its Palestinian protagonists to travel and work in other Arab countries, something which proves fatal for them in the end, Al-Beik's video questions the sincerity of Arab leaders' commitment to the Arab cause by offering examples of how citizens of different Arab countries are prevented from travelling and meeting each other. Although critical of official political rhetoric, the video has been shown in Syria. The subtleness of its critique and the fact that it works through hints rather than direct confrontation probably worked in its favour for its presentation. But its experimental character also meant that it received only limited exposure, remaining within the non-mainstream circuit of the Dox Box film festival for creative documentary, where it was screened as part of the Syrian focus programme in the spring of 2010.

The two videos, *Jerusalem HD* and *Samia*, use interrupted, fragmented narratives in combination with overly long sequences to present a critique of the facile reading of the Palestinian issue as it has been presented for the past 60 years by the Syrian

and other Arab regimes and to which Arab audiences have become habituated (and also often tired of). Both films break with well-established knowledge and beliefs. In *Jerusalem HD*, the flow is interrupted either by the image of the filmmaker himself or by Jean-Luc Godard's solemn voice, by breaks in the narrative, by images that jar through the difference between their texture and that of the surrounding images or by sequences that disrupt the otherwise clear rhythm of the film. In *Samia*, the different sources of footage serve the same end. Al-Beik's two videos mark a departure from the grand narratives usually connected to the Palestinian theme and the way in which they have often been presented artistically. Instead these works show a preference for personal stories of individual Palestinians and reflection on the relationship between documentary and fiction in the Palestinian context. Like Mohamad Malas' *The Night*, which I will discuss in more detail below, they offer a critique of official ideology through broken narratives and doubts spread throughout the works. These apparent inconsistencies create a feeling of unease in the viewer and invite a process of reviewing established beliefs.

In a certain way, these two works represent a rarity among the works of the young generation of Syrian artists. For many artists I spoke to, the question of Palestine and its people's long struggle represented a difficult issue and many were reluctant to touch upon it, regardless of any personal sympathy they might have had for the Palestinians' situation. But the regime's continuous abuse of the issue for its propaganda and as a justification for so many disastrous policies (the state of war with Israel and the occupation of the Golan have served as justification for the state of emergency)[5] made many younger artists wary of the subject, with some expressing a strong reluctance to even approach the topic. One young filmmaker, with whom I briefly spoke, strongly criticized a colleague of hers for producing a documentary about a Palestinian family in the Yarmouk camp[6] and their family relic, the old key to their house in Palestine. Her argument was that, as a Syrian, he should rather be concerned with Syrian contemporary society and leave Palestinian issues to Palestinians. A young Palestinian artist in Damascus emphasized a preference for work concerned with social isolation in Syria and preferred not to address the particular concerns of his people.[7] In his opinion, most works that directly addressed the Palestinian situation (whether films, paintings or other artworks) actually did the Palestinians a disservice by corroborating stereotypes of violence and terrorism. Thus, he was highly critical of Hany Abu Assad's widely acclaimed film *Al-janna al-'an* (*Paradise Now*, 2005), a film that attempts to understand the psychology of suicide bombers and investigates what leads young people to such desperation, that suicide and the collective murder of civilians appear to be a rational act and a way out of their miserable situation.

But despite such criticism, the topic of Palestine does occasionally appear among the works of younger artists, often as a reflection of individual sentiments triggered by international events. One such work is Buthayna Ali's *I'm Ashamed* (2009, Figure 3.3).[8] Buthayna Ali (born 1974), an artist and educator at the Faculty of Fine Arts at the University of Damascus, works mainly with installations and often produces large-scale works. *I'm Ashamed* is a large, room-filling installation that uses photos of children, allegedly from Gaza, taken from press sources. It was created in reaction to the Israeli "Cast Lead" operation in the Gaza Strip during the winter of 2008–2009 and was exhibited by the Green Art Gallery at the Bastakiya Art Fair in Dubai in 2009. With this work, Buthayna Ali wanted to address the accumulation of images and memories in times of war and conflict.[9] The work was accompanied by a short poem by the artist:

Figure 3.3 Buthayna Ali, *I'm Ashamed*, 2009, mixed media installation
Source: Courtesy of the artist.

Politics, Religion and Economy,
either one or all of them,
don't they exist to protect people!? Isn't Gaza an icon?
I'm ashamed of being a human
at this time in this world.
when I see all this death, and yet I can't do anything!
when I realize all human right organizations are unable to put an end for it!
when I am aware that I am corporeal just like these criminal! [sic][10]

The photos were hung from the ceiling of the exhibition space and a lighting source placed behind them, thus projecting the images onto the floor. The installation was created specifically for the event and was never shown in Syria. According to the artist, rather than for reasons of political controversy, it was the general lack of exhibition

opportunities in Syria which made its presentation at any space in Syria difficult, a problem that was constant and specifically dire for an artist like Buthayna Ali, whose work generally needs larger spaces.[11]

While Ammar Al-Beik's two works steer away from well-rehearsed representations of the Palestinian issue as they are found in the works of Syrian (and generally Arab) artists, Buthayna Ali's focus on children could at first sight seem to be closer to familiar portrayals of the issue in the works of older Syrian artists, in which the plight of women and children often played an important role. However, Buthayna Ali adds a new angle to the theme by focusing on the media's use of such images. By using a massive amount of press photos of unnamed children, she creates a literal "flood" of images from above, which confronts the visitor and forces them to step on the delicate images when entering the space and moving around within the installation. The effect is one of a shower of images descending upon the visitor, while the ground appears like a minefield, making one wary at every step. This embodied engagement with the images creates a strong feeling of discomfort, something that is emphasized by the poem, in which the artist expresses her personal reaction to the military action. The poem, while not without a certain didacticism, calls on the visitors to share the sentiment of the artist when engaging with the work.

The installation goes beyond the habitual visual engagement with images of conflict such as the war photography we see in a newspaper, on television or an online news site. The effect of images showing war atrocities has often been questioned, the argument being that their proliferation leads to "compassion fatigue".[12] However, as Susan Sontag has argued, revising a position she had voiced earlier,[13] the context within which photographs are viewed plays an important role in diminishing compassion for victims of atrocities:

> It is because a war, any war, doesn't seem as if it can be stopped that people become less responsive to the horrors. Compassion is an unstable emotion. It needs to be translated into action, or it withers ... people don't become inured to what they are shown ... because of the quantity of images dumped on them. It is passivity that dulls feeling.[14]

Images as such are not powerful due to their internal qualities, to their specific content or form, but are or can be powerful in a specific context in which the spectator is given a certain amount of agency or allowed individual reflection.[15] As Sontag puts it:

> The standing back from the aggressiveness of the world ... frees us for observation and for elective attention ... there is nothing wrong with standing back and thinking. To paraphrase several sages: 'Nobody can think and hit someone at the same time.'[16]

In creating a context different from that of the mass media, a work like that of Buthayna Ali's may offer a space for this kind of thinking and for a critical engagement with a tragic situation: a war that brought massive suffering to an impoverished population and in which many victims were young children.

The theme of Palestine and its people has been a stable presence on the Syrian art scene, it was a major theme in politically committed art from the 1960s onwards. Following the defeat of 1967 and the ensuing collective trauma, it became the dominant theme for some time.[17] Palestine and its people's struggle might be expected to be one

of the officially accepted themes, a theme that allowed artists to comfortably stay within the borders of official ideology, while also expressing a personal commitment to the issue. Yet, Palestine also represented a potent metaphor and in more interesting works it served as a means to articulate a wider range of misgivings. As noted by the curator Rasha Salti, "Its signifying power multiplied and conjugated with lived experience and the representations of other traumas ... the metaphor of Palestine was a key motif for citizens to question the legitimacy of the rule of their own regimes."[18] This critical potential of the Palestinian theme is particularly well illustrated by its presence in Syrian auteur cinema since the 1980s, of which I will discuss some examples below. But it is also present in some early films produced by the NFO. I mentioned Tawfiq Saleh's *The Dupes* above, along with its criticism of Arab politics vis-à-vis the Palestinians' possibilities to travel and work in other Arab states. Likewise, Bourhane Alaouie's *Kafr Kassem* (1974) offers a critique of Arab politicians' failure to agree on the right policies to solve the Palestinian problem. The film revolves around the massacre committed by Israeli Border Police in 1956 in the village of Kafr Qasim. While Alaouie's sympathy clearly lies with the innocent victims of the massacre, he gives a rather bleak view of the potential for political action among the villagers. Most of the men in the village either belong to the Communist Party or are followers of the Egyptian president Gamal Abdel Nasser and, ultimately, neither these two factions, nor the members of each faction can agree on a common position, not even faced with an overwhelming adversary.[19]

One of the earliest examples of an artwork that addresses the theme of Palestine and one that also carries with it a nuance of social critique is *The Refugees* or *Family of Refugees in Abu Rummaneh Street* (1950, Figure 3.4) by Adham Ismail (1922–1963).[20] The painting was submitted to the first national exhibition in 1950.[21] Painted in a manner that is far more realistic than other, slightly later works by the artist, and not without a certain sentimentality, Ismail depicts a small family consisting of a young couple and two children. The young man is lying down with the woman seated next to him, her one hand protectively placed upon him, the other touching a small boy seated between the two adults. A second, slightly older boy stands behind the woman, his head turned away from the other three persons and looking towards the bright lights of a city boulevard, namely, the main street of the elegant Damascene quarter Abu Rummaneh, which appears in the distance, almost like a mirage. The contrast between the glittering lights of affluence and the simplicity of the young family is striking and is emphasized by the boy who, all too aware of his own isolation from the comfort of life in the new buildings, directs his longing gaze towards them. But, despite the desperate situation of the refugee family, they do not appear miserable. Rather, they represent a close-knit entity that seems to create a protective space. The woman's caring pose next to the lying man, the white scarf covering her hair, as well as the way the family group is set apart from its surroundings carry a reference to the classical Pietà of European painting. The figure of the loving, protective female figure clad in a white, loose head cover recalls, on one hand, the Virgin Mary, while, on the other, it refers to a motif that was later to become iconic in Palestinian nationalist painting as practised, among others, by painters Ismail Shammout and Nabil Anani and which is commonly understood as a symbol of the longed-for motherland.[22]

A painting from 1965 by Louay Kayali (1934–1978), *Thumma madha* (*Then What?*, Figure 3.5), shows a solemn assemblage of darkly clad persons huddled together in an undefined space. The group consists mostly of women dressed in black garments that

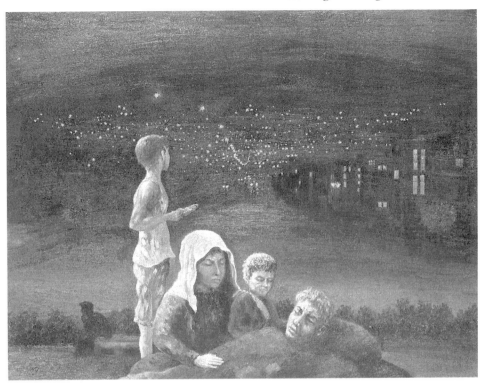

Figure 3.4 Adham Ismail, *Family of Refugees in Abu Rummaneh Street* or *The Refugees*, 1950, oil
 on canvas, 65 x 85 cm
Source: Samawi collection.

extend down to their bare feet; their heads are covered, either by black veils or loose,
black hair, indicating mourning. The expressions on their faces are distinctly mournful,
their features appear distorted by grief, some of the women have their gaze turned
upwards and others look to the side. Two children stand at each end of the group, one
clinging to the mother looking upwards to her almost questioningly or as if seeking
guidance, while the other child is shown gazing directly at the viewer, his eyes wide
open with a questioning, somewhat accusing look, his hands gently holding a dead
pigeon. As the only figure in the entire assemblage, the boy confronts the viewer
directly and, as the artist himself has said, with the determination to react, despite the
grief he is feeling.[23] The central figure, the only adult male figure in the group, is shown
with his back hunched, looking down and appearing utterly broken. The entire painting
conveys a feeling of profound tragedy. The frieze-like arrangement of the immobile
figures recalls the solemn processions of ancient Greek and Roman art, yet the expres-
sive features of the figures are wholly modern. The background of sombre ochre, the
dark clothing and bare feet of the figures as well as their exhausted, emaciated
appearance are features that add to the work's quality of tragic timelessness of an
almost classical dimension.

Both paintings show Palestinian refugees and both convey the desperate situation of
the many people who were forced to leave their homes following the *Nakba* of 1948.[24]

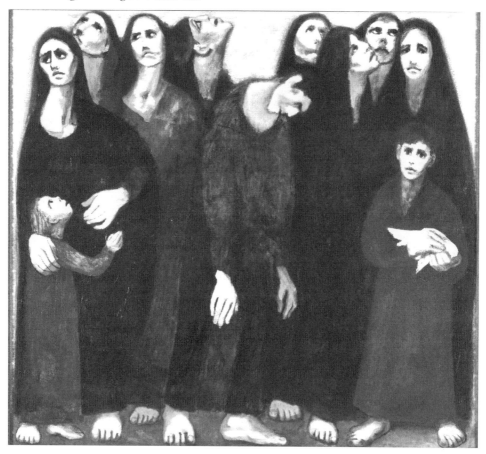

Figure 3.5 Louay Kayali, *Thumma madha (Then What?)*, 1965, oil on canvas, 172 x 190 cm
Source: Samawi collection.

In focusing on refugees, the two Syrian artists take up a theme that was common among their Palestinian peers, in whose early works the figure of the displaced person was a dominant theme. With their high degree of realism and easily understood iconography, paintings like Ismail Shammout's *Where To?* (1953)[25] and *We Will Return* (1954)[26] gained an importance that far exceeded an audience of art lovers and which became popular among the general public, to which its reproduction on postcards and posters testify.[27] The wish to reach a larger audience might also be the reason for Adham Ismail's choice of a more traditional, realist style for *The Refugees*, despite the fact that he was generally an artist whose entire praxis was focused on a radical search for new forms of expression.[28]

After the traumatic experiences of the war of 1967, Syrian artists' works related to the Palestinian issue changed in character. The tragedy of expulsion and exile became less dominant themes and the traumatic experiences of war began to appear. *Napalm* (1967), by Nazir Nabaa (1938–2016), is a vivid expression of the horror of civilian victims during a military attack.[29] The painting shows a woman in three-quarter profile seen from the back, her arms outstretched, her head shown in profile and

turned upwards. Her one visible eye is drawn frontally in the manner of ancient Egyptian or Mesopotamian art and depicted as wide open, her mouth frozen in an unheard scream of terror. The woman's body and the entire surface of the painting are kept in ochre, yellow and orange colours, suggestive of fire and chemicals. The situation of the displaced, the horrors of war and human vulnerability dominated works that dealt with the Palestinian theme for quite some time. But after a few years, they gave way to works dominated less by passive feelings of despair and more by calls for collaborative mobilization. The armed struggle and figure of the freedom fighter (*fida'i*) gained in importance in the works of Syrian, Palestinian and other Arab artists, often in the format of the poster rather than oil painting.[30] The *fida'i*, the guerrilla fighter, came to represent hope in the form of a person who had kept his dignity where regular armies had failed.[31] The figure of the *fida'i* also found its way into works by Syrian artists living outside the country. A painting by Marwan (1934–2016) from 1970, its title either *Three Palestinian Boys* or *Fidayeen* (Figure 3.6), shows three youngsters, painted as seen from a low angle.[32] The painting was produced as a reaction to a newspaper article about the attack on the Israeli embassy in Rome by three young men, an action that made a profound impression on the artist at the time.[33] Rather than placing the desperate political action in the foreground, Marwan wanted to stress the humanity and vulnerability of the boys, showing them with their shirts open at the neck and their sleeves rolled up and a somewhat disorderly appearance, suggestive of the street children one could find on the streets of any city or in a refugee camp.[34]

Another Syrian artist living in Germany, Burhan Karkutli (1932–2003), chose a more declaredly activist stance and produced works rooted in both Palestinian revolutionary visual language and Arab folk imagery. Karkutli's artistic practice was strongly informed by his commitment to the international leftist revolutionary movement. Defining himself as a "political artist" whose work should be accessible to all people, regardless of their

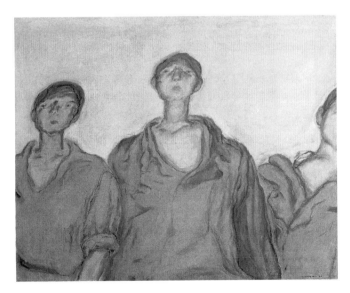

Figure 3.6 Marwan Kassab-Bachi, *Three Palestinian Boys*, 1970, oil on canvas, 130 x 162 cm
Source: Collection of Barjeel Art Foundation.

economic means, he mainly produced graphic works and drawings that he often sold for very little, thereby shunning the gallery circuit. Instead, he preferred to sell his works at street markets, political events, solidarity events for Palestine, and through politically committed bookshops. For Karkutli, political art had a particular beauty, since it spoke of the "dreams of the people for a better life". Being firmly committed to the Palestinian cause, Karkutli regarded the resistance movement as a driving force for what he called a "progressive and democratic Arab art".[35] As he saw it, the term "Palestinian art" related to the content of an artwork, not the nationality of the artist, who might be from any Arab nation. This conviction led him to publish a book with the title *Grafik der Revolution. Burhan Karkutli. Ein palästinensischer Künstler* [36] and, in fact, he was often referred to as a Palestinian artist by German journalists.[37]

While artists like Louay Kayali and Marwan chose to refrain from the use of common symbols of the Palestinian issue, such as the *keffiyeh*, the Dome of the Rock, women in embroidered dresses, the olive tree or the *fida'i* (Marwan's *fida'in* are only recognizable as such by the title of the painting and the story behind it, not through their dress or postures), Burhan Karkutli chose to revert to an easily recognizable imagery that was accessible to everybody, regardless of their knowledge of art or cultural capital. His drawing *Palästinensische Frau* (*Palestinian Woman*, 1975) shows the static figure of a young woman standing upright and wearing a traditional embroidered dress and a loose white head scarf, richly bejewelled with bracelets, earrings and, notably, a pendant in the shape of Palestine hanging around her neck.[38] On her right shoulder the woman carries a machine gun, a feature that seems to contrast with her serene appearance and elaborate dress. The middle ground of the image is taken up by a procession of three women carrying richly decorated water jars on their heads and in the background houses of an old Arab town can be seen. In the upper section of the image are four flying birds, the lower section resplendent with sumptuous vegetation. Overall, the image conveys a joyful mood of strength and celebration. The references to Palestine, to its abundant nature, its people and to the resistance movement are clear; the image was created to be easily understood.[39]

Works such as Karkutli's, with its easily recognizable visual codes, are often decried as "propaganda" as they are created within a particular political ideology. In the case of Karkutli, however, a more differentiated reading is required. The accusation of "propaganda" is all too often launched at works taken out of their particular context and therefore misunderstood. When considering these works, it is of vital importance that one sees them in their proper art historical context, in this case, as part of Syrian artists' social and political commitment to a cause they were strongly attached to on a personal level. In the case of Burhan Karkutli, it is also important to remember that his residence in Germany meant that he was working in a context where solidarity with the Palestinians was anything but mainstream and even required a certain amount of courage to articulate. Karkutli's concern with the Palestinian situation corresponds to his leftist convictions, something that is reflected in a similar manner in his other works, e.g., the images produced during his one-year residency in Mexico.[40] The majority of Arab intellectuals saw themselves as part of an international leftist movement, in which Palestine was one important issue among others. The "International art exhibition for Palestine", organized in 1978 by the Plastic Arts Section of the PLO in Beirut, is an example of this artistic commitment and gathered artists from around the world, who sent in works for the exhibition. Thirteen Syrian artists are listed in the catalogue: Ghayas Akhras, Khalil Akkari, Abdul Kader Arnaout, Sami Burhan, Ziad Dalloul, Naim Ismael, Nazeer Ismael,

Burhan Karkutli, Nazeer Nab'a, Said Makhloof, Ghouzaima Olwani, Ghassan Sebaye and Iliyas Zayat.[41] Furthermore, a sympathetic concern with the Palestinian issue did not foreclose a critical stance on Palestinian and Arab political movements, as discussed above in relation to the films *Al-makhdu'un* and *Kafr Kassem*. Both films suggest a connection between internal divisions in the movements and the failure to solve the issue in any effective way. In Oussama Mohammad' film *Stars in Broad Daylight*, discussed in Chapter 1, the Palestinian theme was linked to a critique of local circumstances, of the Syrian regime and its policies in a biting critique of the official discourse's misplaced use of the issues of Palestine and Arab solidarity.

With its central importance for the official policy of the Syrian Ba'ath Party, the Palestinian issue might seem like a "safe", less conflictual theme for artists. A number of Syrian artists, particularly in the early decades following the *Nakba*, created works in which their sympathy with the Palestinian people and their struggle was at the forefront. Many of these works appear simplistic and only engage with the theme in a most superficial way. Such works have not been included here. Instead, I have been more interested in works that go beyond a simple declaration of solidarity with the Palestinian people. These include works that through several layers of meaning offer a critique of restrictive policies and the misuse of the Palestinian issue by the Syrian regime to create a climate of fear and subject the Syrian population to a harsh regime of control.

3.2 Hidden Menaces: The Metaphor of the Abyss

If Palestine represents a powerful metaphor for the articulation of critique, this section will discuss a much more fleeting one, something that I propose to call the "metaphor of the abyss". By "abyss", I am referring to the unseen dangers lurking in a controlled society and the threatening darkness of political imprisonment and torture. As I have mentioned earlier, critique of authoritarianism and state violence in Syrian art could mostly only be expressed through the use of allegorical and metaphorical languages. The films of Oussama Mohammad, in which the extended family serves as a metaphor for the state and its power structures, offer an example of such critique.[42] But while the family represents an easily understood metaphor, the quality of the "metaphor of the abyss" is entirely different. It refers to something unseen and unutterable, something that is hinted at rather than openly expressed, a reality that cannot be named or grasped, but remains present and menacing. Coping with forces that are hidden and threatening and that can overturn a person's life in the blink of an eye was a reality that Syrians, like other people living in authoritarian states with an arbitrary legal system, faced on a daily basis. Speaking about these issues directly was impossible for artists and required them to revert to a veiled language. In what follows I will discuss some examples of this.

Rami Farah's short video *Point* (2005, 3 min, Figure 3.7) offers a good example of how this kind of metaphor functions. Farah (born 1980), a graduate of the Higher Institute of Dramatic Arts in Damascus who went on to study at Omar Amiralay's Arab Institute of Film (AIF) in Amman, created this short video when he was just beginning to experiment with video as an artistic medium. What makes this piece particularly interesting, is that it allows multiple readings. It can be seen as strongly political or as a haunting parable for the hopes of a nation, but it can also be seen as relating to existential questions that every individual faces in life. It opens with the blurred image of a barren desert landscape; a tiny, moving dot soon appears in the

distance. As the dot grows larger, it turns into a young man running towards the camera. Once he has reached the camera, he stands in front of it, panting to catch his breath, clearly happy and relieved to have reached his goal. But then the atmosphere changes and the camera, up to this point objective and neutral, starts to tilt and move back and forth and then towards the young man. The expression on his face changes from joy and expectation to fear, even panic, he turns away from the menacing force, but it pursues him as he tries to escape. Eventually, he falls to the ground and the credits of the film appear with a still image of the desert as the background.

The opening seconds of the video are not unlike the opening of Tawfiq Saleh's *The Dupes* and the tragic ending of that film's protagonists and their hopes for a better future can also be related to Farah's work. *Point* can be seen as referring to the hopes of young Syrians during the early years of Bashar al-Assad's presidency, when the first public appearances of the new president gave rise to high hopes for a more open, democratic Syria, hopes for a better future that many saw crushed as time went on. But it can also be seen as addressing existential questions of hope, desire, anxiety and fear. Incidentally, seen now, more than ten years after its completion, it could also be seen as an almost prophetic work about the failed hopes of the peaceful uprising of 2011. When asked about any metaphorical meaning of the work, Farah usually offered the more general, existential version. Such double meanings allowed artists to steer free of censorship by allowing a universal, non-political reading of works of art. And yet, with its reference to hidden forces that pose a threat to every Syrian, Farah's video is related to a series of other works by Syrian artists with similar concerns. The change from objective to subjective camera hints at an unseen agent, a force that is bent on harming the young man, whereby this menacing force that threatens and pursues him remains hidden from view. Just as the Syrian system of coercion with its many agents represents a threat to every human enterprise, so too the young man is doomed to fall the moment he has seemingly reached his goal. Nobody in Syria, Farah seems to imply, can be sure of achievements; the dark forces of the system are omnipresent and can turn any success into failure. Through the use of the subjective camera that forces the spectator to take on and even embody the position of the predator, the video directly involves and creates an

Figure 3.7 Rami Farah, *Point*, 2005, video
Source: Courtesy of the artist.

uneasiness in the spectator. As viewers, we are forced to reflect on our own responsibility in keeping structures of violence alive.

The notion of a hidden menace lurking somewhere unseen is a theme that resurfaces in the work of several Syrian artists. Another work from the same decade is Hrair Sarkissian's (born 1973) photographic series *Execution Squares* (2008, Figure 3.8).[43] Knowledge of the signification of the images lies entirely in the title, without it, the particular meaning of the images would only be known to the few people familiar with certain dark aspects of Syria's history. The series of 14 photographs shows views of different squares around Syria. The photos have been taken in the early morning hours and are suffused with a beautiful, serene light. There are no people in the scenes, everything appears calm and ordinary. But there is a sinister truth hidden below the surface: All these squares used to be execution places in the past and the time of day the photos were taken is also the time when executions took place. While many cities in the world possess such spaces of historical violence, in Syria, this history was not long gone, but an on-going reality, the only exception being that executions were now taking place hidden from the public eye (this work was produced before the current war where violence, torture and executions again appeared everywhere). The squares look the same now as they did in the past, grass and brightly coloured flowers give an illusion of elegant urbanism, in the words of the artist, "everything is in its place. Nothing has been moved or demolished. The square is covered in grass with different, brightly coloured flowers scattered around in no particular pattern", in a way, the knowledge of the square's true history seems to question even the capacity to see, "Can what I am seeing now be true?"[44]

Figure 3.8 Hrair Sarkissian, *Execution Squares*, 2008, archival inkjet print, 125 x 160 cm
Source: Courtesy of the artist.

The series has been widely shown internationally in galleries and at biennials and this international audience was probably also the main target from the outset, as showing the work in Syria would have been difficult. However, the relevance this work could have for a Syrian audience surpasses its relevance for the international biennial circuit. The chilling effect of Sarkissian's images comes not from what is shown, but what the spectators are left to imagine, based on the information carried by the title of the work. Like the German saying "to let grass grow over something", meaning to allow something to be forgotten, the Syrian regime has let grass and flowers grow on the locations of earlier atrocities in the hope that these might be forgotten.

Works like Rami Farah's and Hrair Sarkissian's have parallels among previous works by Syrian artists, in film as well as in fine art. The 100 minutes of Nabil Maleh's (1936–2016) film *Al-kompars* (*The Extras*, 1993, 100 min.) take place in a small apartment and are dominated by the two protagonists' fear of looming dangers. Initially, the film seems like a straightforward love story between two young, working-class people. It tells the story of two young lovers, Nada and Salem, who, being unmarried and too poor to change this situation, have nowhere to meet in private. After eight months of meeting in parks and other public spaces, they have managed to arrange a meeting in the apartment of a friend of Salem's. But even though they desperately try to enjoy this moment of intimacy, the controlled environment in which they live keeps interfering. Although a widow, Nada is frightened lest her family find out about her relationship to Salem. Only making things worse, a neighbour in the apartment building turns out to be wanted by the secret police, thus bringing the risk of further interference even closer to the two lovers. As they tentatively move towards an intimacy they both desire and yet fear, the confined space, into which outside forces are continually bursting, whether through sound or physical presence, represents the social and political confinement of authoritarian Syria. The atmosphere of the film is generally claustrophobic; the setting is limited to the apartment and only the brief opening sequence and the very final scenes take place outside. The dialogues are hectic and often fragmented and even though the two lovers also share moments of joy and laughter, these moments are soon interrupted by the nervousness caused by sounds that penetrate the walls and windows. As the film scholar Josef Gugler writes, the film conveys the idea of a society haunted by fear.[45]

The ugliness of the forces controlling Syrian society is the central theme of the graphic artist Youssef Abdelké's (born 1951) series *Ashkhas* (*People*, Figure 3.9), produced throughout the 1990s. The series shows constellations of grotesque figures in groups of three, often clad in suits and elegant dresses. Masks or the distorted grimaces of fake smiles make the faces of the figures unapproachable. Abdelké, a long-time outspoken critic of the Syrian regime who produced this series in his Parisian exile, has called these works a "règlement de comptes" – a settling of scores, an attempt to get even with the pressures and humiliations that his generation had to suffer.[46] The faceless, masked or shadow-like figures reflect the presence of oppressive forces in society and the state apparatus, all part of a system in which cruelty is hidden behind a variety of façades, constantly present but never openly showing its true face.

A similar concern with the unseen powers that affect the lives of human beings can be traced in the works of the painter Fateh Al-Moudarres (1922–1999). Here too, strange creatures appear, sometimes sketchy, at other times more clearly outlined (Figure 3.10). They are rarely very large and appear to be intruding into the space of paintings without any clear relation to the other figures. It is almost as if they wanted to remind the observer of the uncontrollable forces that are at work in the

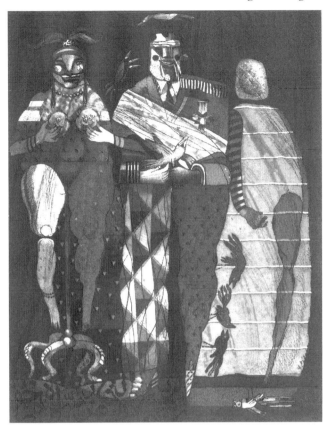

Figure 3.9 Youssef Abdelké, *People, No. 10*, 1993, etching, 63 x 50 cm
Source: Courtesy of the Atassi Foundation for Arts and Culture.

background, affecting people's lives in troubled political times. According to Al-Moudarres, these creatures entered his works following the defeat of 1967 and multiplied with the onset of the Lebanese Civil War.[47] Al-Moudarres' monsters are like those creatures from nightmares that remain unspecific and featureless, appearing in the background of the paintings like a side-note, but never as the main figure. They are what the art historian Frances S. Connelly has called "boundary creatures" that exist "in the tension between distinct realities".[48]

The enigmatic creatures of Youssef Abdelké's *Ashkhas* and the monsters of Fateh Al-Moudarres can be related to the tradition of the grotesque, as discussed by Connelly. According to her, it represents "a state of change, breaking open what we know and merging it with the unknown", while situated in a "transitional, in-between state of being".[49] Located in such a liminal space, it can function as a catalyst, setting a reaction in motion.[50] This space can also allow the articulation of dissent or subversive ideas. In the way the grotesque "ruptures the boundaries of disparate realities", it creates a space between these realities and this is where meaning is created, a "gap" or "Spielraum", a space within which to play, with "play" here including the carnivalesque.[51] Understanding the grotesque in this way explains how it has been appropriated on numerous

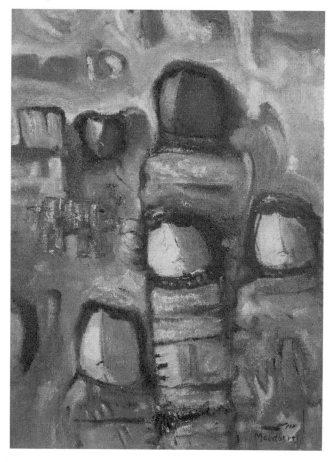

Figure 3.10 Fateh Al-Moudarres, *The Beast and the Commoner* [*al-Wa'ash wal-Maskeen*], 1987, oil
 on canvas, 76 x 55 cm
Source: Collection of Barjeel Art Foundation.

occasions as the weapon of choice for social protest throughout the modern era.[52] The literary scholar Peter Fuss has discussed the grotesque as a creative process and an active agent of social transformation, rather than its mere indicator.[53] For Youssef Abdelké, the *Ashkhas* series represented a way to articulate political dissent by laying bare the ugliness of the forces of power in Syria. The works of the Belgian artist James Ensor use the motif of the mask to a similar end and express a deep scepticism about humanity. In a reversal of the traditional function of carnival masks (i.e. hiding the wearer's identity in the context of carnival and allowing for behaviour that transgresses accepted, social norms), Ensor's masks serve to expose the true identity of those wearing them, laying bare the meanness of their character.[54] The masks of the equally well-dressed figures in Abdelké's *Ashkhas* serve a similar purpose. They lay bare the ugliness to be found beneath power and its abuse.

For Youssef Abdelké, the preoccupation with mask-clad figures had exhausted itself by the end of the 1990s. In the 2000s, he turned towards the so-called "still lives" (Figure 3.11), which were no less dark, but which made use of a different visual

language. Many of these works present classical *memento mori*, such as skulls, decaying flowers and dead animals. Abdelké often adds an element of violence; the flowers are pierced by nails or by a knife driven perpendicularly into the surface on which they are lying, a dead songbird is shown lying on a table with a knife driven into the table behind it, fish are likewise pierced or bound, or the severed head of a fish stares out at the spectator. Abdelké, who decided to return to Syria in 2005 after many years in exile in Paris, was and is a relentless critic of the Syrian regime, a dissident who, depending on the cultural context and political situation, carefully chooses the means by which to voice critique. In 2008, he stated: "Artists can't change their skin even if they change their subject matter."[55]

The dark, troubled atmosphere with its feelings of anxiety that characterizes the works discussed here is closely related to what the painter Boutros Maari has termed "art violent" when writing about works produced by his older colleagues in the wake of the defeat of the Arab cause after 1967 and the subsequent increasing bitterness.[56] I would also see the anxiety prevalent in these works against the background of the increasingly stifling climate imposed by the Ba'ath Party through its tight political control, oppression of individual rights and regional conflicts with a general arbitrariness that characterized the period and made the situation seem more and more hopeless. When artists resorted to grotesque, looming figures hiding behind masks, indefinable creatures and ways to indicate absent horrors, they were searching for the best way to convey the anxiety, with which they were confronted on a daily basis. The grotesque seemed appropriate for this end. As an artistic trope, it resurfaced in works produced since the beginning of the uprising, this time as expressions of the real horrors of war, torture and violence as well as the artists' own troubled emotional state faced with these horrors. I will discuss these works in more detail in Chapter 4.

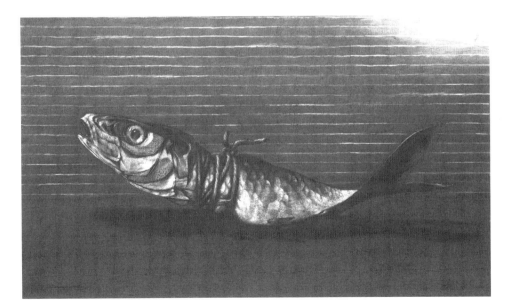

Figure 3.11 Youssef Abdelké, *Fish*, 2015, charcoal on paper, 145 x 275 cm
Source: Courtesy of the Atassi Foundation for Arts and Culture.

3.3 Critique of Societal Rigidity

In Sections 3.1 and 3.2, I focused on the use of metaphorical language as a means of critique. In both cases, the works of young artists could be linked to a series of works by earlier generations of artists. In this section, I will discuss works by young artists that address issues of rigid social morality and their consequences for the individual. In most cases, they are concerned with gender questions. While this is generally a question of more recent concern, a few older works such as the films *Dreams of the City* by Mohamad Malas and Oussama Mohammad's *Stars in Broad Daylight* show a concern with rigid societal traditions and the subordination of women, without it being the central theme of the work.

One of the most remarkable video works of the 2000s is the documentary video *Madinatayn wa sijn* (*Two Cities and a Prison*, 2008, 40 min., Figure 3.12) by Soudade Kaadan (born 1979). It stands out for several reasons. While a number of works discussing gender-related issues were produced by artists of the young generation during the 2000s, they generally restricted themselves to discussions of issues related to female experience. However, Kaadan's video works with changes of perspective and discusses both male as well as female gender roles and how these are linked to themes such as power and violence. As it follows an experimental, interactive theatre project, the "Studio" theatre group, on its tour through provincial Syria, concluding with a workshop conducted for young delinquents in a prison in Damascus, it also shows us audiences who are eager to discuss controversial issues and engage in open debates. In this way, the video presents an image of Syria that is rarely seen, whether in the West or in Syria itself.[57] The theatre group worked with improvised theatre techniques around a loose script and with strong reliance on audience participation.

The video is divided into three parts. The first two are shot in the north-eastern cities Al-Hassakeh and Qamishly and show us stagings of a play that questions traditional social norms and role models, while also addressing the topics of birth control, polygamy and domestic violence. The third and last part of the video was shot in a youth detention centre in Damascus. The directors of the theatre group conducted a workshop in which they let the young prisoners talk about the crimes for which they were serving prison time as well as their pasts in general. These narrations, often quite

Figure 3.12 Soudade Kaadan, *Madinatayn wa sijn* (*Two Cities and a Prison*), 2008, video
Source: Courtesy of the artist.

distressing stories of extreme neglect and violence, served as the basis for the final play. In all three parts of the video, the frankness, with which the participants engage and talk about controversial issues is noteworthy. In the outdoor settings of the play in Al-Hassakeh and Qamishly, the director Omar Abu Saada asks audience members to assume different roles on stage, gently directs them together with his team and lets them improvise, based on their own experiences of the topic. The seated audience is encouraged to engage actively with the "actors" on stage and they do so vigorously whenever they disagree with the actors' arguments.

The play centres on discussions between a man, who holds a number of conservative views, his wife and a doctor. In one scene, the man, whose opinions may still be found in conservative social environments in Syria, argues that a man needs a large number of children, especially boys, and that if his wife is incapable of providing them, he has the right to take a second wife. Arguments to the contrary are voiced by the doctor and the man's wife, who argue for the rights of women to control their own bodies and limit the number of children they bear. This view is also held by a number of audience members who actively argue their points. An elderly, veiled woman who steps onto the stage to take over the role of the doctor firmly tells the stubborn young man, who insists his wife is strong and can easily have more children, that "she has the right to take care of her body", turns to the audience with a smile and asks "Is this true or not?" Another woman, this time from a position in the audience, asks the young man if he and his brothers would not have been better off, had there been fewer of them. When he denies this, she shakes her heads, commenting "Abdul Rahman is super stupid" to the great amusement of other audience members. The video shows a highly motivated audience, whose members reflect a variety of different views and who do not shrink back from a discussion of controversial issues. Noteworthy is also the ease with which the audience members adopt their assigned roles and enter into the play. For, while experimental theatre might have been available in Damascus, it was certainly not common in the remote provinces.

While the last part of the video conveys a very different atmosphere, due to its location in a detention centre, here as well, the frankness with which the adolescent prisoners talk about their experiences is remarkable, especially when one takes into account the highly supervised and controlled environment of a Syrian prison. Filming the workshops presented quite a challenge for the videomaker. Since it would not normally have been possible to get permission to film inside the prison with the aim of producing a film, Kaadan had to present herself as a member of Abu Saada's team in order to film the workshop. The video footage, she explained to the prison authorities, was necessary for training purposes.[58] In order to assure the anonymity of the young men, Kaadan decided to film the protagonists in fragmentary frames, sometimes showing only their eyes, sometimes only their mouth or their feet.[59] While this assures the privacy and anonymity of the prison inmates, it also adds a somewhat claustrophobic atmosphere to the video which parallels both the youths' imprisonment and their personal histories, characterized as they are by betrayal and violence both inside and outside the prison walls. Under the cover of anonymity, the video presents unique, personal stories of a different Syria, one hardly ever shown in the arts, whether film, visual art or literature. The final public staging of the play is not part of the video, as heavy surveillance made any filming, whether open or clandestine, impossible. Because a large part of its footage was obtained without permission and includes some critical statements regarding the situation in Syrian prisons, the video has never been shown publicly in Syria.

In *Two Cities and a Prison*, there is a strong focus on male violence and dominance. The disastrous implications of expectations of male behaviour are the topic of Hazem Alhamwi's (born 1980) *Asfur hajar* (*Stone Bird*, 2006, 30 min., Figure 3.13, Figure 3.14).[60] The video follows a man with the nickname "Abu Hajar" ("the man with the stone") who lives a life apart from society and is a well-known "eccentric" in the artist's home-town of Salamiyeh in northern Syria. Abu Hajar is presented as a person who suffers from an unnamed mental affliction, the basis of which is revealed through what might be termed an "archaeological" method of storytelling, by allowing the story of the protago-nist to unfold slowly and removing layer after layer of his life. We learn that his condi-tion is rooted in an irresolvable personal conflict, namely, the discovery that his father was having an affair with his (i.e. Abu Hajar's) wife. The patriarchal social mores of Abu Hajar's environment would expect him to kill the adulterers, but since his own father was involved and Abu Hajar was not willing to kill his wife, he saw no way out of the conflict.[61] The video presents the story of an intelligent, sensitive man who found himself incapable of complying with his society's rigid and violent rules for normative male behaviour. It suggests that the mental condition of the protagonist might be not so much of an illness, but maybe rather a deliberate choice made in order to escape his moral and social dilemma. Through this suggestion, the video offers a strong critique of traditional aspects of society and the crippling effects it can have on human beings. In Alhamwi's view, it is not Abu Hajar who is ill, but rather a society that expects violence of its members. For those who are not willing to comply with such rules, the only possible way out is to withdraw from human society. By concentrating on a person on the margins of society, whose behaviour defies its rigidly defined norms, the video lays bare the cracks inherent in Syrian society, a society that casts out members who do not conform to its narrow ideas of normality. This critique is corroborated by a member of the medical staff, who takes care of Abu Hajar. In his words, society prefers to "look at 'madmen' for the sake of entertainment".

Alhamwi follows Abu Hajar through his wanderings through the streets of the city and lets him tell parts of his own story. By focusing on marginality and a person whom society would rather forget, the video articulates critique of the political system that allows such conditions to persist. The marginalized or socially outcast often appears in critical works by artists working in authoritarian states and dictatorships.[62] They indi-cate those aspects of reality which such regimes prefer to silence, even acting as symbols of all other silenced realities. Artists who chose to work closely with individuals on the margins often consciously place themselves close to the margins. This may involve not only a willingness "to be misunderstood, misread, mistaken and dismissed", but also means "working in complicity with those who dwell on another margin and who offer, however unknowingly, their corpus and voice to the recording of another; and knowingly to risk exploiting them".[63] The risk of appearing exploitative was very present for Alhamwi during the filming of this project and he was careful to compensate his use of the protagonist's time and patience by helping him in other ways. This also involved inviting Abu Hajar to Damascus, something that was met with a complete lack of understanding by a number of people, in particular because of Abu Hajar's "uncleanliness".[64]

The two videos just discussed link critique of gender norms and the social conventions that serve to limit women's freedom to broader societal issues. Similar concerns appear in a few works by older artists and filmmakers. In the films *Dreams of the City* by Moha-mad Malas and *Stars in Broad Daylight* by Oussama Mohammad, this represents a

Figure 3.13 Hazem Alhamwi, *Asfur hajar (Stone Bird)*, 2004, video
Source: Courtesy of the artist.

Figure 3.14 Hazem Alhamwi, *Asfur hajar (Stone Bird)*, 2004, video
Source: Courtesy of the artist.

phenomenon that is closely related to other forms of abusive power. In *Dreams of the City*, a young widow has no other choice than to return to the house of her father after the death of her husband, despite his unkind treatment of her and her two young children. In *Stars in Broad Daylight*, the young brides who refuse to fulfil their weddings and thereby thwart the dynastic aspirations of the protagonist, suffer his anger. Nabil Maleh's *The Extras* discussed previously, offers, beside its central theme of lack of political freedom, a critique of the submissive social status of women. The female protagonist Nada is a widow and a working woman, yet this does not mean that she can determine how to spend her life and with whom. The nervousness she displays throughout the film is due to her fear that her family might find out about her secret rendezvous with her lover. She is unable to live an independent life and is subject to a rigid moral code of conduct. The lack of freedom for women and the suspicion, with which their lives are monitored, are also the theme of Mohamad Malas' *Bab al-maqam* (*Passion*, 2005), a film inspired by a real-life incident.[65] The film tells the story of a young woman whose passion for music is misunderstood by her family, who suspect her of having an extramarital affair and therefore kill her. In these films by filmmakers of the older generation, critique of social conservatism and the limits it imposes on women were part of the critique of social and political lack of freedom. It has not been a major topic for painters in Syria. However, Anneka Lenssen has read a painting by Fateh Al-Moudarres, *Women at the Wedding* (1963) as a critique of traditions in rural Syria that "serve to bind and choke". According to her, the blushing cheeks of one of the figures depicted are so gaudy in colour that they rather evoke the false adornments of "idols".[66] Though Lenssen's interpretation deviates from the more common interpretations of this particular work by Moudarres', generally seen as a celebration of *turath* and patriotic ideals,[67] it is interesting to consider it in the context of critical art practice in Syria.

While Hazem Alhamwi's *Stone Bird* and Soudade Kaadan's *Two Cities and a Prison* offer a critique of male behaviour patterns, most works produced during the 2000s that were concerned with gender-related issues tended to focus on women's lived conditions, and the limitations put on women's freedom and life options were of central importance to these works. Diana El-Jeiroudi (born 1977) produced two videos that examine Syrian society's expectations of gendered behaviour, especially the focus on motherhood as the fulfilment of female existence. One of them, a short experimental documentary video entitled *Al-qarrura* (*The Pot*, 2005, 12 min.) presents a series of interviews with women from different social backgrounds that are remarkable for their openness; they offer a variety of views, from the open regret of one woman, who tells of her sadness when leaving her job, to the more stoic acceptance of a situation seen as unavoidable and necessary. The "pot" of the video's title refers to what El-Jeiroudi sees as society's view of women as "containers" of future generations.[68]

Filmed in a "raw" style, reminiscent of home videos and avoiding sophisticated effects, the work questions the importance placed on motherhood and the ideals surrounding it in Syrian society.[69] In order to ensure the necessary privacy for intimate statements, all the women are presented anonymously and are filmed without their faces being shown, keeping the image focused on their torsos and bellies. This solution has two effects: it creates a climate of confidentiality in which the women are willing to talk openly about very personal matters and it depersonalizes the statements, lending them a representative character. At the same time, it focuses on those body parts related to child-bearing and nurturing and it also stresses the emotional distance and critical, slightly ironic view of the artist towards the subject. The focus on motherhood as reflected in the recorded

statements should be seen in the light of a change in Syrian social discourse of recent decades. The Ba'ath Party had been following a policy of gender equality and of encouragement of women's participation in the workforce since coming to power through the 1970s and 1980s. Women's emancipation was seen as a symbol of progress and the nation's development.[70] Such notions, referred to as "state feminism" began to decline through the 1990s, when economic recession and population growth led to job scarcity and educated women were encouraged to focus on their roles as mothers and wives, rather than as public employees.[71] Diana El-Jeiroudi went on to explore another aspect of women's reactions to society's expectations of them in a later film, *Imra'a min Dimashq* (*Dolls – A Woman from Damascus*, 2007, 56 min.). Paralleling the story of a young woman, Manal with the success story of the "Arab Barbie doll", "Fulla", the film is a critical investigation of the role of product marketing in conveying conservative role models for women and girls.[72] As was the case with some of the women in *The Pot*, Manal misses her job and would like to return to work, but is torn between this personal wish and her family's demands and the general expectations of society, which she also attempts to live up to.

Some young women artists chose to approach the subject of gender-related issues from a personal angle, being more interested in women's subjective experiences than in socially imposed limitations on female existence.[73] Nisrine Boukhari's two installations *peu-r-ouge* (2008)[74] and *Kun* (*Be*, 2009)[75] deal with the limitations of women's choices on a more metaphorical level and consider the difficult balancing act of being a woman in Syrian society. In many of her works, Boukhari adopts a strongly personal approach that explores the inner and outer worlds of women, often with an element of autobiography. *peu-r-ouge* is a room-filling work, which visitors could enter through a door that was half-covered with a red curtain. The space was painted red, illuminated by red light and suffused with scent. Some 99 glasses of red wine were placed along the walls, sharp needles hung on red strings from the ceiling, and the following words were written on the floor in Arabic:

> How many women drink this glass of tears?
> How many women fill it?
> It is red…
> Bleeding to fill and still not satisfy (sic) …
> She's an inmate of a revolution burning with no fire
> No flames and no match
> It's her world, it's your world
> It is a woman's sacrifice[76]

By using the colour red with its conflicting connotations of sexuality, femininity, passion and danger, Boukhari created a highly ambiguous space, at once inviting and tempting, yet also slightly disturbing, which allowed her to comment on the many threats which a woman faces to her well-being.[77] With the other mentioned work, *Kun*, Boukhari explored the connotations of another colour and created an entirely white room. The walls of the space were painted white, the floor was covered in soft, white mattresses and light white feather boas were hanging from the ceiling. But the comfortable, cocoon-like impression was disrupted by the glaring, cold white light and the large bowls containing an undefined white powder placed in three corners of the room. As the artist's statement informed visitors, the bowls were filled respectively with sugar, salt and poison, but it did

not disclose which bowl had a sweet content and in which one, the dangerous or even deadly substance was found. Both installations present spaces that are ambiguous, inviting, on one hand, but also filled with unseen dangers. At first sight they appear comforting, spaces where one can find shelter and feel "at home". However, they turn the notion of home as a safe haven upside down. The domestic space, traditionally the realm of women, is here far from reassuring, in *peu-r-ouge* the needles remind visitors of the double-edged quality of the choices that women are forced to make in their lives. In *Kun* the "poison" takes on this role.

Buthayna Ali explored a traditional, communal space for female interaction and relative freedom, the *hammam* (bathhouse) in her installation *Don't Listen to Her, She's Only a Woman* (2010).[78] Being at first uncomfortable with the theme and its possible Orientalist connotations, the artist decided to revisit her own memories of her grandmother and the stories she had heard about how the *hammam* had represented an opportunity to take time off from the daily chores, meet friends and relax, talk and think. By using a metal locker with multiple compartments similar to those used in public baths and gyms, Buthayna Ali placed an item of women's clothing (such as handbags or shoes) in each compartment, while women's stories and recollections were played from the compartments. The clothing items were those that women left behind upon entering the space of the *hammam*. Once inside, the work suggests, she was free to move around, unburdened by the social conventions that determines her life outside. In this way, the *hammam* can be seen as a "space of femininity" in the sense of the art historian Griselda Pollock, a space "from which femininity is lived as a positionality in discourse and social practice".[79] In Buthayna Ali's work, the *hammam* becomes such a feminine space, a space for genuine female lived experience rather than the stereotypical Orientalist image of a secluded space where sensual women with endless leisure time wait for their master to call upon their services.

For most artists, the wish to address gender issues and more specifically, women's lived conditions grew out of a wish to inspire a process of rethinking and to advocate for change. The films of the older generation of filmmakers link women's issues to the broader subject of political and social rigidity and deal with the violence inflicted upon women in a system that lacks all substantial freedoms. Links between social issues, violence and the construction of gender roles are also common in the works of younger artists, while a turn towards more personalized subjects can be observed.[80]

In some cases, however, gender issues could also be negotiated humorously. Samer Barkaoui's (born 1973) short video *Poster* (2004, 1 min., Figure 3.15) presents an ironic take on full-body veiling in the context of mediatic self-representation.[81] The video shows an unspectacular everyday scene: three young women having fun taking pictures of each other in a park. But the girls' clothing turns the situation into parody: all three of them are completely covered in black veils and cannot be distinguished from one another, something which makes the private photo session appear somewhat pointless for the outsider, though certainly not for the women. The atmosphere of the video is light-hearted, and the sound of the girls as they are laughing, their clattering high-heeled shoes as they run back and forth, the birds singing in the background adds up to an atmosphere of joyful casualness. Without resorting to moralizing, the video comments on the irony of three identically-looking women's continuous self-photography and the contradictions between notions of modesty and individualism. The use of a subjective camera angle causes the spectator to identify with the fictional photographer (i.e. whichever woman is taking the picture) and thus we are drawn into a reflection of what kind of representation makes sense in a world that is generally obsessed with self-display. Despite the video

Figure 3.15 Samer Barkaoui, *Poster*, 2004, video
Source: Courtesy of the artist.

being intended as a humorous take on a contemporary phenomenon, i.e. the growing tendency to prefer modest styles of dressing in Syria, and reflecting a kind of humour not uncommon in the region at the time of its production,[82] it has not been shown publicly in Syria, as it was deemed too controversial.[83] It has, however, been shown internationally at film festivals and exhibitions.[84]

3.4 Counter-Narratives: When Artists Challenge Official Discourse and Taboos

Some videos produced during the 2000s sought to challenge official discourse directly and tackle sensitive taboos, regardless of any potential risks. Reem Al-Ghazzi's (born 1973) *Adwa'* (*Lights*, 2009, 23 min., Figure 3.16, Figure 3.17) presents a direct critique of poverty in rural regions and failed reforms, while also touching upon inter-generational and gendered power structures. The video portrays a family in a remote village in the Jabal 'Arouda region who had been displaced when the area was flooded by the Assad Lake, created by the Tabqa Dam in the 1970s. The village in which they now live has neither electricity nor proper roads and water for drinking and household purposes has to be fetched from the lake, but this is polluted by the sewers of nearby towns and villages. The reality that Al-Ghazzi presents is filled with struggles and hard work. She follows the family members in their daily work, fishing fish in the lake, washing clothes and taking care of the household. These activities are filmed with great care and a particular tender attention to small details, making the video aesthetically pleasing. But Al-Ghazzi never attempts to gloss over the hardship the family faces. As spectators, we are allowed intimate views of their life. We see them sharing meals, talking and joking about the motorboat, which the mother insisted on selling because they were spending all the money on fuel, and arguing about who catches more fish. The children say they prefer to fish with their mother, because they catch more fish with her. When the father softly denies this, one of the boys counters: "With her, we catch five to six kilos of large-size fish. With you, we can't even get one kilo of that size."

Figure 3.16 Reem Al-Ghazzi, *Adwa'* (*Lights*), 2009, video
Source: Courtesy of the artist.

Figure 3.17 Reem Al-Ghazzi, *Adwa'* (*Lights*), 2009, video
Source: Courtesy of the artist.

All of the village's families and all of their members work hard and yet, there are subtle differences, which are shown through contrasting images. The boys find ways to combine moments of playfulness with their daily tasks: while helping their families fishing and tending to the fishing nets, they play in the water or with rubber ties, or they engage in occasional boat racing. The girls, however, appear constantly occupied with household work. While the men do very specific work that suggests some level of specialization, the women's and girls' work includes fishing, tending to animals (chicken and sheep), carrying water, washing, baking bread, cooking and cleaning. Some critical questions posed by Al-Ghazzi about the distribution of work are met by the men with seemingly rational answers:

> If we catch a lot of fish, the women come to help … they help us, so the fish won't go bad. Then we can sell it fresh … it depends, if you have wives, then they'll work with you. If you have daughters, they'll help you. But if you have neither of them, then you have to work alone.

The boys also have very clear ideas on how work is distributed between the sexes and giggle: "Men work in fishing, or in Damascus or in Jordan. Women work cleaning bathrooms, cleaning toilets, sweeping the yards." There is a hierarchy at work here and each person has a very clear position in this society. It is a hierarchy that resembles the very hierarchy essential to the Syrian state and that allows stronger elements to step on those below.

However, despite such tensions, the family presents a tight-knit unit. While they are held together by the daily struggle, depending and relying on each other, worries are never far off. "I sleep very few hours, sometimes because of thinking, sometimes because of fatigue," the mother says. She would like to offer her children a better future, "we shouldn't let our children live like we have", she says. Yet poverty stands in the way. The school is far away from their home and the roads are in bad condition and get blocked during rain. In the case of bad weather, the children either stay at home or are sent back from school before the roads become impassable. For the daughter of the family, as for other girls in the village, education automatically stops after the sixth grade, as any school offering further education is located too far away to be acceptable for the families. In this way, moral rigidity adds to poverty in standing in the way for a better future for the children. Time for studying is scarce, as everybody in the family has to share in the work: Homework can only be done at night by the light of a gas lamp. In short, any hope for future improvement is slim; the children will most likely continue their lives along the same lines as their parents.

Lights is a beautifully filmed work that brings to life a world unknown to most people, including many urban Syrians: the world of remote rural areas in the country. Reem Al-Ghazzi presents the family's hardship while making sure they retain their dignity. The viewers find themselves directly faced with a bitter reality within an incomprehensible paradox: the Tabqa Dam was constructed to bring progress to rural Syria, it was part of a large-scale plan to develop agriculture in the Euphrates Basin, but as the video suggests, it has done quite the opposite.[85] As one protagonist says, "We are exporting electricity to Lebanon and Jordan, but our village cannot get it from the power plant one kilometre away", going on to say "the village is forgotten by time itself". Throughout the work, Al-Ghazzi's closest attention is on the children, a particular interest of hers,[86] and it also highlights the dire situation of a country where children's dreams are doomed to failure

from the beginning, or where children dream of becoming teachers in order to beat up unruly students, as one of the sons of the family jokingly says.

Lights should be seen against the background of the shocking poverty of rural communities in the rural areas, particularly the Syrian Jazira.[87] The desperate conditions of this area's population, the government's failure to address the issue adequately, and the power structures at play in families and communities had already been the subject of several films in the 1970s, notably Omar Amiralay's *Al-hayat al-yawmiyya fi qarya suriyya* (*Everyday Life in a Syrian Village*, 1974, 90 min.) and *Al-dajaj* (*The Chicken*, 1977, 40 min.) as well as Oussama Mohammad's *Khutwa khutwa* (*Step by Step*, 1979, 23 min.). As in Al-Ghazzi's *Lights*, the focus of Oussama Mohammad's *Step by Step* is also on the children of a Syrian village, their dreams and the grim reality of their lives. The children dream of becoming doctors, teachers, engineers, but their will is broken by life's hardships and by violence, both at school and at home. In the end, only the army with its rigid discipline and control offers a way out of their misery. The film interrogates ideology and structures of power as they are disseminated and upheld at all levels of society, from the village head to schoolteachers down to family relations. Apparently, little had changed in the 2000s and during the latter part of the decade, a severe drought that lasted from 2006–2010 only made the misery worse.[88] Later films like Omar Amiralay's *Tufan fi bilad al-Ba'th* (*A Flood in Baath Country*, 2003, 46 min.) and Oussama Mohammad's *Sunduq al-dunya* (*Sacrifices*, 2002) also conveyed an idea of the dramatic level of poverty in many rural areas of Syria, although it was not the central theme. These filmmakers' main concern was the nature of authoritarianism and how its structures were reproduced and maintained in schools, families and the state, something that also resonates in Reem Al-Ghazzi's film, although with a softer and more subtle critique.

In contrast to poverty in rural areas, the economic struggles of the urban working class have been much less examined in visual art and film. Ammar Al-Beik's *Innahum kanu huna* (*They Were Here*, 2000, 8 min., Figure 3.18) is rare in this way with its focus on the everyday struggles of the poor urban population. The video was filmed in the steam engine works of Damascus, which was threatened with closure at the time. Despite barely earning a living wage, the workers were fighting to keep the plant running and with it their source of income, but found themselves faced with an inflexible political system. In black and white images involving only minimal movement, Al-Beik's camera documents and explores the work environment of the plant, the tools, furnaces and the workers' simple prayer room. Fragments of workers' stories tell of many years of hard work, but also of pride in a life without debts or their children's relative successes. The atmosphere of the video is one of melancholy, of regret at a once ambitious project which "embraced the industrial revolution but relied on imports only, while manufacturing and development remained non-existent".[89] In 2000, after decades of neglect and lack of appropriate care, the workers found themselves faced with the prospect of unemployment or early retirement without a proper pension. Al-Beik's video is at once a reflective homage to the old industrial works and its workers and a critique of an ineffective regime that is unable to meet the needs of the country's population. A sentence written in white chalk on one of the walls seems to capture the entire tragedy of this mismanagement: "We want eggs, milk, soap and detergent."

A concern for the struggles of the working urban poor resonates in an oil painting of the early post-independence era, Adham Ismail's oil painting *Al-hammal* (*The Porter*, 1951, Figure 3.19).[90] At a time when massive building projects were underway in Damascus and new neighbourhoods for the privileged classes were created, the artist

Figure 3.18 Ammar Al-Beik, *Innahum kanu huna* (*They Were Here*), 2000, video
Source: Courtesy of the artist.

drew attention to the fact that only a small class was profiting from this construction and that these signs of new urban elegance actually came at a high cost. The porter is seen carrying a large load on his back, while climbing a row of steps made out of dissolving human forms. Ismail breaks up the surface of the pictorial elements as if to show the corrosive effects of class antagonism and a social fabric that lacks coherence. Ismail, who was one of the youthful founders of the Ba'ath Party (which was still oppositional at the time he painted this image), was a fervent supporter of its vision of pan-Arabism and redistribution of wealth, and expressed these concerns in this painting.[91] After nearly being rejected, it was exhibited at the second annual national exhibition in 1951, held at the National Museum in Damascus. Its radical concern with labour and workers' rights go hand in hand with what Anneka Lenssen sees as a call for a "new type of polity", a collective Arab nation, expressed through a process of looking back at indigenous aesthetic traditions, such as the arabesque of Arab-Islamic art.[92]

While videos such as *Lights* and *They Were Here* present critiques of different aspects of official discourse and policies, some works realized during the 2000s sought to tackle darker issues and taboos. One such work is Reem Ali's (born 1977) *Zabad* (*Foam*, 2008, 46 min., Figure 3.20), a video that – like Reem Al-Ghazzi's *Lights* – focuses on the daily life of a family.[93] One of its members suffers from a mental illness, but is lovingly taken care of. While the family members are shown pursuing household tasks, washing and doing repair works around the house, drinking coffee on the terrace and playing with their cats, sinister details of the past slowly surface: the husband and wife, both

Figure 3.19 Adham Ismail, *Al-hammal* (*The Porter*), oil on canvas, 80 x 100 cm, 1951.
Source: Photo credit: catalogue DACC 2008. Damascus National Museum.

communists, were political prisoners with everything that entails. The memories of their arrest, their imprisonment, torture and their disillusionment, interrupt their seemingly calm family life and social activism (the woman, Asmahan, gives classes to illiterate women). Their dream of leaving Syria to start a new life elsewhere is complicated by their concerns about Asmahan's brother, Muhammad, who, due to his illness, would need to be taken care of.

Figure 3.20 Reem Ali, *Zabad (Foam)*, 2008, video
Source: Photographer: Jack Hagop Kirkorian. Courtesy of the artist.

The video turns several typical features of Syrian cinema on its head. As in films like Oussama Mohammad's *Stars in Broad Daylight* and *Sacrifices* or Mohamad Malas' *Dreams of the City*, the focus is on a family. But unlike these, no patriarchal father or elder brother tyrannizes his family; rather, the husband and father in *Foam*, Ali, is a soft-spoken, considerate and kind man. But as the film progresses, we learn about several traumatic experiences, including not only the couple's imprisonment, but also family violence suffered by Muhammad at the hands of his father. Due to his illness, Muhammad blurts out uncomfortable truths about his sister's political affiliations, something that would normally be left unmentioned, and the violence he experienced as a child. He continuously addresses the filmmaker, thereby bringing the outside world into the film and breaking up the smooth narrative. Muhammad functions not only as the mediator between the audience, the filmmaker and the other protagonists, but also has the function of a jester – the only person who had the right to "speak the truth to the prince". This gives him a key role in the film. It is up to him to articulate the truths that lie under the surface of the family's life and threaten their chances for happiness. Though clearly a loving couple, Asmahan and Ali suffer from the tensions of living in Syria with its oppressive political climate, a situation they long to leave, but are unable to. Muhammad asks the uncomfortable questions about the couple's fantasies of flight, their dreams of starting a new life elsewhere, in freedom. As become apparent, the truth about living in Syria can only be spoken through the mouth of a societal outsider, a mentally afflicted person. But even with this precaution – of letting a marginalized person speak – the Syrian authorities were adamant that the film remain unseen, not only in Syria but elsewhere as well. When the film was selected for the Carthage Film Festival in Tunisia in 2009, the Syrian government vainly tried to intervene and have its participation cancelled.[94]

Political imprisonment lurks in the shadows in Reem Al-Ghazzi's short documentary video *Shuq* (*Crack*, 2007, 4 min., Figure 3.21). The video is a good example of fragmented story-telling that works through hints and allusions and leaves the spectator free to draw their own conclusions. The video tells the story of an elderly Egyptian tailor who has witnessed his beloved son sent to prison, while the other son, "who only lives for his pleasure" as the protagonist says, is free. The reason for the son's imprisonment is not mentioned, but the father's insistence on his excellent character seems to hint that he is a prisoner of conscience, rather than a petty criminal. The protagonist has chosen to withdraw from the world; he works alone in his workshop and keeps the door firmly closed to protect himself from what he calls "the cruelty of society", observing the world from a distance through a narrow crack in the door. To film the protagonist, Reem Al-Ghazzi adopted a particular technique: the camera focuses mainly on the tailor's hands as he carries out his daily routines and talks about his disappointment with life. The technique of showing only fragments of the protagonist's body or face is reminiscent of Diana El-Jeiroudi's *The Pot* and the prison scenes in Soudade Kaadan's *Two Cities and a Prison*: This makes the film at once intimate and yet distanced. The spectator is allowed glimpses into the withdrawn world of the old man, but not entirely invited into it. The work relies on the viewer's ability to put the fragmented words and images together in order to get the whole picture. The political dimension is hidden and might easily be overlooked. Thus, the brief mentioning of the son's beard might be an indication of his political affiliation, namely, that he belongs to an Islamist movement, such as the Muslim Brotherhood. But it could also merely be a father's attempt to recall his son's physical appearance before imprisonment left its marks on him. The video was made during a workshop in Cairo that the artist attended and has been shown internationally, but not in Syria. It is an excellent example of how young Syrian artists continued to use ambiguity and double meanings when addressing particularly critical issues, such as, in this case, political imprisonment.[95]

The themes of political oppression and the critique of leaders appear quite obvious taboos. Subjects which are more difficult to identify as taboo are related to recent Syrian history. A work that addresses a particular sensitive taboo of recent Syrian historiography is Rami Farah's documentary video *Samt* (*Silence*, 2006, 40 min., Figure 3.22). Like Hazem Alhamwi's *Stone Bird* and Reem Ali's *Foam*, it was made during a course at the Arab Institute of Film in Amman. The work juxtaposes two antagonistic views of the loss of the Golan in the war of 1967 and the Syrian army's role in it. The subject is sensitive as the role of the then Minister of Defence, Hafiz al-Assad, is somewhat controversial. Popular belief, represented in the video by an old inhabitant of Quneitra, who was an eyewitness to the events, holds that the Syrian army was ordered to retreat at a moment when a Syrian victory was still possible.[96] In the video, the official view is presented through a civil servant from the Ministry of Information. The two positions stand in stark contrast to each other. Farah follows the civil servant in various surroundings, filming the office and corridors of the ministry with a crooked camera angle that underlines the atmosphere of secrecy and lack of transparency. The civil servant, who used to host a TV programme on history, talks about his work and "mission" in "setting historical misconceptions right" and becomes angry at the artist's implications that the official version of the events of 1967 differs from that of popular memory. He comes across as quite unlikeable and his angry fanaticism stands in stark contrast to the old man's sorrowful recollection. It is not until the very end of the video that he shows a human face, when Farah (whose family comes from the city of Quneitra, like the civil

Figure 3.21 Reem Al-Ghazzi, *Shuq* (*Crack*), 2007, video
Source: Courtesy of the artist.

Figure 3.22 Rami Farah, *Samt* (*Silence*), 2006, video
Source: Courtesy of the artist.

servant) accompanies him to Quneitra and he breaks down upon receiving the news of the death of a relative. The video shows Syrian officialdom as based on false assumptions that even those who are fully part of the propaganda apparatus are unable to uphold when faced with reality. By questioning official narratives, Rami Farah ventured into dangerous terrain and as a consequence, the work has been shown internationally, but never in Syria, where it remains banned.

Laura U. Marks writes that certain films have the power to recreate "not the true historical event, but at least another version of it" by examining the discursive layers of the event.[97] The issue of the Golan and its loss is particularly sensitive in Syria and only few artists have attempted to tackle such taboos. However, Mohamad Malas' autobiographically inflected auteur fiction film *The Night* (Figure 3.23) is another example of a transgressive work that links several sensitive themes. The film is a highly complex, aesthetically sophisticated work that plays on several levels of memory, including what Malas himself refers to as "imagined memory".[98] Through the recollections of the protagonist, it tells the story of his parents, their marriage in Quneitra and the disappearance of his father. Sometimes the narrator is the protagonist looking back on the events as a young man and, at other times, it is the boy who has just lost his father. A particular ambiguity as to which memories are real and which are the creations of the protagonist's dreams runs through the film. The figure of the narrator's father represents the link between several delicate issues of recent Syrian history. While he was on his way from his hometown of Hama to join the revolt against the British in Palestine, he and many other volunteers stopped in Quneitra to rest. It was here that his marriage to the narrator's mother was arranged by the young woman's father.

Figure 3.23 Mohamad Malas, *Al-Layl (The Night)*, 1992, 33 mm film
Source: Courtesy of the artist.

These two cities, Hama and Quneitra, share a destiny of destruction and in *The Night*, their histories are linked to the issue of Palestine, an issue close to the heart of many Syrians and other Arabs, but also the issue that allowed a freezing of active political life and the prolonged state of emergency. The latter factors are what has forced all political activity in Syria underground and ultimately caused the confrontations that led to the massacre of Hama in 1982.[99] Malas has referred to the film as being "not about memory. It is memory itself." A memory that "needs to be tested, to be put in the witness stand".[100] In his quest to find out the truth about his father and his death, the narrator wanders through the streets of Quneitra, and explores his own memories and those of his mother. We do not learn where and how the father died, but the vague hints at the circumstances of his death suggest its relation to something that needs to be kept secret. The film shifts between different historical moments, creating an ambiguous space that allows an interrogation of history, both the official version and that of personal recollections.

In taking this sceptical stance towards easy narratives of liberation and national greatness, *The Night* is linked to Shohat and Stam's notion of "Post-Third Worldist" cinema. Rather than presenting a "grand anticolonial metanarrative",

> [such films] install doubt and crisis at the very core of the films ... They favour heteroglossic proliferations of difference within polygeneric narratives, seen not as embodiments of a single truth but rather as energizing political and aesthetic forms of communitarian self-construction.[101]

The Night interrogates history and official historiography, it asks questions but hardly answers any. With its complex narrative technique, the film casts doubts and makes suggestions. Shadows of windmills may recall the metonym of the city of Hama, known for its ancient waterwheels. The real character of the mills is revealed, but the suggestion has been made and it is up to the viewer to draw their own conclusion. And indeed, the link between the two cities, destroyed either by direct actions of the state or the state's inaction, was clear to critics and viewers of the film.[102] Works such as *The Night* and *Silence* attempt, as Laura U. Marks has put it, to "destroy myths from the inside".[103] By exposing the myth as fiction and hinting at the state's active role in its creation, they become dangerous for power and this necessitates their ban. As mentioned above, *Silence* has never been shown in Syria and *The Night* was more or less banned, only to be screened at very rare occasions like a special screening during the Damascus International Film Festival in 1995.[104]

Conclusion

In order to express critique and comment on current political and social issues, young Syrian artists employed a number of different narrative and visual techniques. Some of these had also been used by earlier generations of artists, who, faced with the constraints of the authoritarian state, needed to be particularly ingenious in developing techniques which would allow them to produce their critical artworks. Among the most commonly used techniques were: the use of fragmentation both in imagery and narrative techniques and what one might term "archaeological storytelling", i.e. removing layer after layer of the story to approach the central theme, the use of ambiguity and metaphorical and symbolic languages, favouring "smaller" stories over the big issues of official ideology, as well as the use of changes of perspective, i.e., placing poor or marginal people at the

centre of their stories or letting stories be told through the eyes of children or social outsiders. These techniques would also often be combined in the same work.

In several videos discussed in this chapter, different forms of fragmentation were used. While focusing on persons who are in some way vulnerable, Reem Al-Ghazzi, Diana El-Jeiroudi and Soudade Kaadan all make use of images that show only a small part of the persons' faces or bodies. Thus, El-Jeiroudi's images of women in *The Pot* consistently leave out their faces. Only through this measure was the filmmaker able to create a secure atmosphere for the interviewees and capture frank and honest statements. Soudade Kaadan wanted to protect the identities of the young prisoners in *Two Cities and a Prison* and therefore made the choice to only show small parts of the young men's faces. These practical and ethical choices also have other effects: in El-Jeiroudi's video, it creates an ironic distance and thus underlines the filmmaker's own critical view on the subject. In Kaadan's video, the fragmented images add to the claustrophobic atmosphere of the prison and the general feeling of secretiveness. In Reem Al-Ghazzi's *Crack*, the fragmented images are used mainly as a stylistic device, as is the fragmented speech of the protagonist. The camera focuses on the tailor's hands or on a part of his face as he performs his daily work and talks about his disappointment with life. The effect is one of intimacy and tenderness, of a quality that is almost "haptic" in the sense of Laura U. Marks, i.e., inviting the viewer to respond to the images in an intimate, embodied way and thereby opening up to other sensory impressions.[105] However, it also helps to keep a certain distance. Just as the protagonist has closed his door to the world outside his workshop, so the video only allows the spectator some glimpses into the world of the old tailor. Here, the fragmented images and speech offer a way to "speak between the lines", leaving it up to the spectator to piece the story together.

The narrative technique of *Crack* is similar to Rami Farah's *Silence*, Reem Ali's *Foam* and Hazem Alhamwi's *Stone Bird*. Each of these videos' story is built up around a central secret that is revealed as the work progresses. The central issue in *Crack* is only mentioned in a brief remark by the protagonist; that his imprisoned son had a beard might mean that he belonged to the Muslim Brotherhood, but it could also be entirely innocent. Thus, the political significance of the work is located in one short comment and a less alert viewer could easily miss it. In *Silence*, the viewer only gradually gets close to the personal story of the ministry official. Presented as a rather unlikeable character, it is only towards the end that he shows some genuine emotion rather than the practised speech of a government official. When Farah accompanies him to Quneitra, we understand that he is originally from the city. Upon receiving the news of the death of a relative, he breaks down and turns into a fragile human being who suddenly displays his feelings. Here, the propaganda is no longer any help. In *Foam*, the history of Asmahan's and Ali's imprisonment is gradually revealed, while the narrative is centred on the family's daily life and care for the mentally afflicted brother. Similarly, in *Stone Bird*, Alhamwi gradually unfolds the terrible secret behind the protagonist's mental condition. This narrative technique serves two important purposes: it creates a certain tension that captivates the interest of the spectator and, particularly important when dealing with sensitive issues such as prisoners of conscience, it creates deviations from the central issue and allows a certain ambiguity.

Ambiguity and the use of metaphors are techniques commonly found in the context of authoritarian states with widespread censorship. In Syria, filmmakers in particular have proven highly skilled at using these to address critical issues. As pointed out by the artist Martha Rosler, this particular form of critique often relies on an audience that is familiar

with the codes used and therefore needs no explanation and such works might be considerably less accessible for outside audiences.[106] The significance of metaphors for Syrian artistic production lies in the space they offer to address issues that could not otherwise have been addressed. Critique of power structures, abuse of power and violence are themes that have been articulated through a variety of metaphors, such as the extended family as a metaphor for the state, parallels between history and contemporary reality and the particular case of Palestine as a metaphor. While apparently staying well within official ideology, Palestine could function as a metaphor that allowed a critical questioning of the legitimacy of Arab regimes and the representations of other traumas. It appears in the works of older generations of filmmakers and also some works of younger artists. The metaphor of the family was particularly important in Syrian auteur cinema of the older generation, but does not play a major role in the works of younger artists. Nor does the use of historical themes. Generally speaking, among the young generation of artists, there is a tendency towards franker language and attempts to get rid of the heavy metaphors of former generations. But as the cases of Rami Farah's *Silence* and Reem Ali's *Foam* demonstrate, this sometimes led to works being censored or even the attempt to prevent them from being shown abroad.

In a number of the works discussed here, the focus is on marginalized people, on those whose existence is far removed from decision-making circles and who are often hopelessly at their mercy. The two protagonists in Nabil Maleh's *The Extras* suffer from the confined social and political environment in which they live, but are so paralyzed by fear that they are incapable of actively looking for ways out of their misery.[107] The focus on the powerless allows the artist or filmmaker to look for stories that are situated outside of official discourse. The Lebanese video artist and photographer Akram Zaatari has explained his interest in such a perspective as an attempt to "construct an alternative history" by allowing stories to be told by ordinary people.[108] In her two videos, *Lights* and *Crack*, Reem Al-Ghazzi let the poor speak about their grievances that are directly linked to the systems of power. Ammar Al-Beik's *They Were Here* presents a critique of ideologies of progress through the stories of poor Syrians and their daily struggles. In Hazem Alhamwi's *Stone Bird* and Reem Ali's *Foam*, the main protagonist suffers from a mental illness. As Caterina Preda writes, a focus on social outcasts and those on the margins of society is a common feature of critical works by artists working in authoritarian states and dictatorships.[109] Such works contradict official propaganda, they point to facts that these regimes seek to ignore or deny the existence of and realities that exist outside official knowledge.

Other works allow their stories to be told through the eyes of children, something that can open up a questioning of oppressive and hierarchical structures of social relations and their functions within society. It is a stylistic method that is often used in Iranian cinema.[110] In Syrian cinema, this has been less common and children do not figure prominently in the works of the young generation of Syrian artists. Reem Al-Ghazzi's *Lights* is one example of how including the point of view of children can stress a critical position. As mentioned above in the discussion of this video, the harshness of some of the children's statements underlines the hopelessness of the families' situation. Likewise, Oussama Mohammad's *Step by Step* stresses the lack of hope for a better future in al-Assad's Syria by juxtaposing the work aspirations of children (teacher, doctor, engineer) with their actual prospects (the military, day labourer). Mohamad Malas' two auteur fiction films *Dreams of the City* and *The Night*, both works that are critical of official ideology, are told through the eyes of a young boy. The protagonist of *Dreams of the*

City, Dib, is sent to work in a laundry by his grandfather who resents the presence of him, his brother and his mother. Dib observes the behaviour of the adults surrounding him, their cruelty towards each other, the tumultuous political atmosphere of the 1950s and their characteristic changing alliances. As a young boy, his observing gaze is still innocent, allowing for insights that would otherwise have been impossible to articulate or too threatening for the regime. The point of these stylistic devices lies in the wish to create a space within which to express critique of social and political issue that cannot be openly articulated.

Notes

1 Smith (2006), p. 686.
2 Here one should perhaps mention that most Syrians became quite adept at recognizing agents of the *Mukhabarat* (secret police). This is echoed in the remark of one of the characters in Nabil Maleh's *Al-kompars* (*The Extras*), who says about a secret service agent: "People like those have their ID's ... stamped on their faces", cited in Gugler (2011), p. 127.
3 I am loosely adapting the concept of a "rhizome" as it was developed by Gilles Deleuze and Félix Guattari in *Mille Plateaux* (*A Thousand Plateaus*) to describe a concept of knowledge formation that resists hierarchical structures and allows for multiple starting points and lines of thought, see Deleuze and Guattari (2013), pp. 1–27.
4 See also Boëx (2011a), pp. 245–247, for a discussion of this film.
5 See e.g., cooke (2007), pp. 6–8; Perthes (2004), p. 106.
6 Mukhayyam al-Yarmouk, the large Palestinian refugee camp in Damascus, its administrative status being a city in the governorate of Damascus. With its architecture that more resembled popular, working-class districts, Yarmouk appeared more like a popular quarter than a "camp". The camp became heavily involved in fighting between various factions of the Syrian Civil War from 2012 onwards and large parts were destroyed, leaving it in the state of a ghost town in 2015 after it was overrun by militants of ISIS.
7 Anonymous artists, conversation with author, May 2008.
8 See www.buthaynaali.com/I_am_ashamed.htm (accessed 15 November 2019).
9 Buthayna Ali, conversation with author, Damascus, April 2010.
10 Ali (2009), see also www.buthaynaali.com/I_am_ashamed.htm.
11 Buthayna Ali, conversation with author, Damascus, April 2010.
12 For a theoretical discussion of the concept, see Campbell (2004), pp. 61–62.
13 See ibid., pp. 61–62.
14 Sontag (2003), pp. 101–102. See also Bank (2019a), pp. 136–137, for a discussion of the effects of "viral" images in the context of the Syrian uprising and war.
15 Campbell (2004),p. 71.
16 Sontag (2003), p. 118.
17 Lenssen (2013), p. 63.
18 Salti (2006), p. 30.
19 Cecile Boëx sees these films as straightforward examples of radical cinema (Boëx, 2011a, pp. 77–78). However, the example of Alaouie's film demonstrates that critique on several levels was also present in these early films. Thus, Alaouie's film also criticizes a general lack of social coherence and willingness to organize around a common cause. For example, an attempt to organize a strike to force an increase in pay fails due to selfishness and corruption and opportunism create a general sense of hopelessness and stagnation.
20 In the catalogue of the Samawi collection, which holds the painting, the title is given as *The Refugees*, Ayyam (2011), p. 17. Anneka Lenssen, who has done extensive research on the artist and his work, gives the title *Family of Refugees in Abu Rummaneh Street*, Lenssen (2014; 2017).
21 Lenssen (2014), p. 69; Lenssen (2017), p. 226. There seems to be conflicting information about the dating of this painting. It is currently held in the collection of Khaled Samawi, the owner of the Ayyam Gallery. In the catalogue *The Samawi Collection: Curated Selections of Arab Art*, vol. 1, published by the Ayyam Gallery in 2011 on the occasion of the exhibition *The*

Samawi Collection at the Ayyam Art Center in Dubai, the date provided is 1960, see Ayyam (2011), p. 17. Anneka Lenssen gives the early date of 1950 together with the information that it was submitted to the first national exhibition of art of that year. Boutros Maari gives the date of 1949 and mentions a reference to a review that defines the painting as "the first Arab painting of the Nakba in an expressionist style different from the usual manner of other artists who paint torn tents, barbed wire and desolate landscapes", Maari (2006), p. 1.

22 Palestinian art abounds with such motifs. See e.g., Boullata (2009), pp. 172, 257.
23 Louay Kayali, cited in Maari (2006), pp. 186–187.
24 "Nakba" meaning "catastrophe" is the common designation in Arabic for the war of 1948–1949 that led to the creation of the state of Israel and the expulsion of more than 700,000 Palestinians, see e.g., Takkenberg (2010).
25 Ankori (2006), p. 49.
26 Boullata (2009), p. 132.
27 As a Palestinian friend emphasized, cheap reproductions of such paintings were common items of decoration in simple Palestinian homes.
28 See Lenssen (2017), for a discussion of the painter's work and his search for a specific Arab aesthetic.
29 See Ayyam (2011), p. 21 for an image of the painting.
30 See Lenssen (2014), pp. 323–326, for a discussion of Nazir Nabaa's works of this period. For images of a selection of his posters, see the website of The Palestine Poster Project: http://palestineposterproject.org/search/site/nabaa
31 Lenssen (2014), pp. 323–324.
32 See also Bank (2014), p. 1, for a discussion of this painting.
33 Personal statement by Marwan in a conversation with author, January 2015.
34 As related to me in an interview, the fate of the Palestinians remained an important concern for Marwan. Apart from his paintings of young Palestinians, he has often expressed a profound sympathy for the struggle for a Palestinian homeland, not limiting his commitment to paintings or declarations. Thus, in 1997, he dedicated a collection of paintings to a future Palestinian National Museum in the hope that a Palestinian state in which art and culture had its recognized role would come into existence. And as the director of the Summer Academy of the Darat al Funun/Khaled Shoman Foundation (1999–2003), he always made sure that the largest number of available places were reserved for Palestinian students. See also Marwan (1998).
35 Interview with Burhan Karkutli, in Karkutli (1981), unpaginated.
36 That is, "Graphics of the Revolution. Burhan Karkutli. A Palestinian Artist".
37 Cf. obituary by Georg Baltissen in the *Tageszeitung*: www.taz.de/1/archiv/?dig=2004/01/02/a0150 (accessed 10 November 2019).
38 For an image of this drawing, see an essay by Burhan Karkutli, available at: www.ipk-bonn.de/kultur/news/2013041100.html (accessed 10 December, 2019). For a discussion of the figure of a young woman as a personification of the homeland in the works of Palestinian artists, see Ankori (2006), pp. 61–65.
39 It is also one of Karkutli's most widely used images, appearing in different formats with different titles. This can at times be confusing, but echoes well the artist's understanding of an uncomplicated art that was accessible to everyone. Karkutli also seems to have regarded his drawings as a kind of open well of images made to be used and reused for different purposes related to the Palestinian cause.
40 "Viva la revolución. Grafiken aus Mexico", in Karkutli (1981).
41 PLO (1978), pp. 103–108. I have listed the names here as they are written in this catalogue, even though this might not correspond to the way the names are commonly spelled in writings on international art.
42 See also Wedeen (1999), pp. 113–116.
43 See the artist's website for views of the entire series: http://hrairsarkissian.com/work/execution-squares/ (accessed 15 November 2019).
44 Sarkissian (2011), pp. 349–350.
45 Gugler (2011), p. 130.
46 Cited in Maari (2006), p. 365.
47 Fateh Al- Moudarres, cited in Arabi (1995), p. 25.

48 Connelly (2012), p. 8.
49 Ibid., p. 5.
50 Ibid., p. 8.
51 Connelly (2012), pp. 12, 15.
52 Ibid., p. 18.
53 Fuss (2001), pp. 12–14. Also mentioned in Connelly (2012), p. 22.
54 See ibid., p. 107, for a discussion of the use of carnival masks in the work of James Ensor.
55 Cited in Muhanna (2008), p. 47.
56 Maari (2006), p. 363.
57 On several occasions when the work has been part of video and film programs I have curated in Europe (Denmark, Germany, Italy, Switzerland and the Netherlands), the European audiences have often been surprised at the discussions' level of openness and the in-film audience's ease with the situation.
58 Soudade Kaadan, personal statement during a Q&A session moderated by the author at International Film Festival, Rotterdam, February 2012.
59 Soudade Kaadan, conversation with author, Damascus, September 2009. The respectful presentation of the youths was a major concern for the artist.
60 The video was realized during a training programme at the Arab Institute of Film in Amman under the supervision of Omar Amiralay.
61 The literature on so-called "honour killings" is vast and discussing the subject in detail exceeds the scope of this study. While the use of the term is debated, it is used to describe murder of a woman for sexual transgressions by members of her family, usually a brother, father, cousin, paternal uncle or husband, most often, who plan and commit the crime together. The killing is seen as a way to restore the honour to the family, who lost it due to the deviant behaviour of one of their female members. Central points of critique of the use of the term is its essentialism, as it leaves no room for differences in how communities define the concept of "honour" and its easy appropriation by mainstream media and right-wing political players, which often serves as an excuse to express Islamophobic sentiments. For a discussion on the appropriateness of the term and its definitions, see Terman (2010).
62 Preda (2012), pp. 901, 903.
63 Alkassim (2004), p. 6.
64 Hazem Alhamwi, artist talk moderated by the author, International Film Festival, Rotterdam, February 2012.
65 The film was inspired by a small note in a newspaper about an instance of "honour killing". Conversation with author, October 2010.
66 See Lenssen (2014), p. 246.
67 See ibid. p. 248 and pp. 258–259.
68 El-Jeiroudi (2005), p. 40.
69 See also Bank (2008). The video has received considerable attention outside of Syria. It was presented at an exhibition project entitled "Some Stories" at the Kunsthalle Wien in 2005, and after that has been shown at other exhibitions and at numerous festivals and curated film and video programmes in the USA, Asia and Europe. In Syria, it has received considerably less attention. It was presented at the Women's Arts Festival in Aleppo in 2005 and at the Goethe Institute in 2007 during a programme which showed short films by German film school graduates together with works by young Syrian artists and filmmakers.
70 Sparre (2008), pp. 7–9.
71 The term "state feminism" describes state policies aim at encouraging women's education and participation in the workforce. In Syria, the policies of "state feminism" also included measures to facilitate the participation of mothers in working life, e.g., by providing maternity leave, time for nursing mothers to breastfeed their babies and the establishment of day-care facilities in state-owned workplaces. See Wedeen (1999), p. 191, note 83, for a discussion of the concept. For changes in state policies towards educated women, see Sparre (2008), pp. 8–10.
72 For an interview with Diana El-Jeiroudi about this video, see https://cinemawithoutborders. com/1327-diana-el-jeiroudi-talks-about-veiled-barbie-dolls/ (accessed 15 November 2019).
73 See Bank (2020) for a detailed discussion of the following three works by Nisrine Boukhari and Buthayna Ali.

74 Presented as part of the visual arts exhibition programme at the "Damascus Arab Capital of Culture" event in 2008. The title is a word play on the French words "peu" ("a little") and "peur" ("fear"). "Un peu rouge" can be translated as "a little flushed" or "slightly embarrassed or excited". Thus, it conveys an idea of excitement combined with fear of the unknown.

75 Presented at the group exhibition "Magnetism" at All Art Now, www.allartnow.com/magnetism.php (accessed 10 November 2019).

76 English translation on the website of the artist: http://nisrineboukhari.com/picture-gallery.php

77 Nisrine Boukhari, interview with the author, Damascus, June 2009.

78 The work was commissioned for an exhibition on the theme of traditional bath cultures entitled "Sharing Waters: Sauna Meets Hammam", and presented at Tutun Deposu in Istanbul in 2010. The work has not been shown in Syria. www.depoistanbul.net/en/event/exhibition-discussion-sharing-waters-sauna-meets-hamam-istanbul-2010/ (accessed 15 November 2019) .For more impressions of the work, see www.buthaynaali.com/Don%E2%80%99t%20listen!%20Only%20a%20Woman!.htm (accessed 15 November 2019).

79 Pollock (2003), p. 93.

80 See Marks (2003), pp. 42, 58 for a discussion of the practice of tying gender issues to societal ones among female Arab videomakers.

81 See also Bank (2008), for a discussion of this video.

82 For example, the growing numbers of veiled women on the streets of Damascus was commented on in a "classification" of different styles of hijab by the anonymous Syrian blogger "Pupetteer" in 2007. Available at: http://thoughts-journal.blogspot.de/2007/04/islamic-syria_06.html (accessed 15 November, 2019.

83 Delphine Leccas, personal communication.

84 Exhibitions have included "Mahrem, Notes on Veiling", a project by the Turkish sociologist Nilüfer Göle, shown in Istanbul and at the Tanas art space in Berlin in 2008, and "Taswir, Pictorial Mappings of Islam and Modernity", a project by Almuth Shulamith Bruchstein Çoruh at Martin Gropius Bau in Berlin in 2009–2010.

85 Springborg (1981), p. 192.

86 Reem Al-Ghazzi, conversation with the author, Damascus, August 2009.

87 The "Jazira", literally "island", comprises the regions of north-eastern Syria.

88 De Chatel (2014), pp. 1–2, 5.

89 Statement on Al-Beik's Vimeo page: https://vimeo.com/64006255 (accessed 15 November 2019.

90 *al-Hammal* was the Arabic title given in the exhibition program. In later publications, the title is given as *al-'Attal*, Lenssen (2014), p. 54. For an in-depth discussion of the painting and place in the oeuvre of Adham Ismail, see Lenssen (2017).

91 Lenssen (2014), p. 56.

92 See also ibid., pp. 54–57 for an analysis of this painting.

93 The film was mainly produced at the Arab Institute of Film in Amman under the supervision of Omar Amiralay. The later date of completion seems to indicate that it was finalized at a later stage.

94 Reem Ali, personal statement during a Q&A session moderated by the author at a screening at the International Film Festival, Rotterdam, February 2012.

95 Imprisonment, especially for political reasons, and its conditions represent an important theme, especially in Syrian literature. One such example was *Under the Sun, On the Sand* by Ghassan Al-Jabai. Mohamad Malas went on to make the film *Fauq al-raml taht al-shams* (*Under the Sun, On the Sand*, 1999) in collaboration with Al-Jabai as a commemorative project for the occasion of the 50th anniversary of the UN's Universal Declaration of Human Rights. For a discussion of the category of "prison literature" in Syria, see cooke (2007), pp. 4, 121–144. For a discussion of Malas' film, see cooke (2011), pp. 180–181.

96 cooke (2007), p. 6.

97 Marks (2000), p. 29.

98 Mohamad Malas, conversation with author, October 2010.

99 Throughout the late 1970s and early 1980s, oppositional political activities by the Islamist opposition, the *Ikhwan al-muslimin* or Muslim Brotherhood presented a serious challenge to the regime of Hafiz Al-Assad. The Islamists launched a campaign of sabotage, which involved assassinations of Alawi elites and which continued in a series of attacks against government

installations and violent mass demonstrations. The potential danger for the regime lay in the fact that several other groups, such as radical leftists and professional associations, allied themselves with the Islamists for tactical reasons, hoping that a weakened regime could either be brought down or transformed. An attempted assassination of the President in June 1980 led to a massive crackdown on dissent, which included the massacre of Islamist prisoners at the infamous Tadmur prison, the assassination of the exiled Ba'ath Party founder Salah Al-Din Bitar in Paris and mass executions of Ikhwan activists and supporters, culminating in the killing of thousands of Islamists in the city of Hama in February 1982, an operation which also led to sweeping destruction of the historic city. See Hinnebusch (2001), pp. 98–103, for an outline of these events. For a history of the Tadmur prison, see Taleghani (2015).

100 cooke (2007), p. 113.
101 Shohat and Stam (1994), p. 288. See also cooke (2007), pp. 113–114.
102 Ibid., pp. 114–115.
103 Marks (2000), p. 66.
104 cooke (2007), p. 106. See also pp. 115–116, for a discussion of the controversy surrounding the production of the film.
105 Marks (2000), p. 2.
106 Rosler (2010), pp. 106, 108; Preda (2012), p. 901. However, the international interest in Iranian cinema, which relies to a large degree on allegory and symbols, seems to contradict this view. See Naficy (2002), p. 53, for a discussion of international interest in Iranian cinema. Syrian auteur films, whether or not their visual language is "obscure" (Boëx 2006) are not necessarily entirely inaccessible to outside audiences. During a programme of Syrian auteur films that I curated for the Arsenal Institute of Film and Video Art in Berlin in 2009, some German members of the audience expressed their surprise at the level of critique in these films. For this audience, not necessarily familiar with the complex context of Syrian authoritarianism, but certainly with the sophisticated language of art-house cinema, the different means with which Syrian filmmakers had veiled their criticism of the regime were quite lucid. The links between power structures in an extended family and those in a dictatorship needed no explanations. See www.arsenal-berlin.de/en/arsenal-cinema/past-programs/single/article/1697/2804//archive/2009/october.html. The programme comprised films by Omar Amiralay, Mohamad Malas, Oussama Mohammad, Abdellatif Abdelhamid, as well as experimental works by young filmmakers and videomakers.
107 See Gugler (2011), for a discussion of the film.
108 Cited in Hadria (2005), p. 34. See also Chapter 2, Section 2.1.
109 See Preda (2012), pp. 901, 903.
110 Egan (2011a), p. 52, and Egan (2011b), p. 99.

4 Singing in the Kingdom of Silence
Syrian Artists and the International Art World

In 2014, the *New York Times* ran a story about Syrian artists who had fled the violence in their country to find refuge in nearby Beirut and with it a space that allowed them to work and exhibit their art.[1] The article cited several artists who commented on the effect the new location had had on their work and how they experienced the art scene in Beirut. It further cited a number of gallerists who gave their often highly euphemistic views on the situation. Samer Kozah, a Damascene gallerist who moved to Beirut at the beginning of the uprising, is cited as saying, "Really, Beirut is like the oxygen for Syrian artists. This is why most come to Beirut." This view entirely leaves out the problematic issues of exile, social insecurity and fear for the well-being of relatives left behind in Syria with its war. But it was not only the recent developments that were discussed in the article, the state of the Syrian art scene in the previous decade was also mentioned. Thus, the artistic director of the Ayyam Gallery at that time, Maymanah Farhat, stated: "Syrian art has benefited from a significant following for decades … Between 2004 and 2011, however, the Damascus scene exploded with the efforts of several commercial galleries and non-profit spaces, which piqued the interest of international curators and collectors." From these words, one might get the impression that in the 2000s Damascus was teeming with international curators and other art professionals who were busy picking artists for their next international shows and collections. However, this image is misleading and hardly reflects the actual situation.

As outlined in Chapter 1, several initiatives were launched in the second half of the 2000s that offered a space for new art and young artists. But they were few and so were the serious, private galleries. The Damascus art scene before the uprising was showing promising signs, but it was still a small and rather modest scene, the attractiveness of many artistic events notwithstanding. And international curators who visited Damascus were very few indeed, most of them preferring to stay in Beirut with its admittedly greater vibrancy. One of the consequences of this lack of interest from international curators was the striking absence of Syrian artists from large exhibitions that proliferated during the decade and sought to present a comprehensive overview of the contemporary "Arab" or "Middle Eastern" art scene(s). In this chapter, I will look closer at the situation of Syrian artists in the international context. Inclusion in or exclusion from the international exhibition and biennial circuit depends on numerous factors, such as access to relevant institutions and networks as well as place of residence. Capital cities, or what the media likes to call "hubs" of contemporary art, are better starting points than provincial towns and, similarly, some capital cities are better than others.

But, as the Serbian artist Mladen Stilinovic (1947–2016) implied with his work *An artist who cannot speak English is no artist* (1994), language skills are also crucial.[2] Artists who are unable to conceptually frame their works in English have considerably fewer chances to find their way onto the international scene. That the knowledge (or lack of knowledge) of English has a fundamental importance for artists can be aptly illustrated by the case of a "pioneering" Lebanese video and performance artist, Imad Issa. Issa was one of the first artists in Lebanon to adopt contemporary practices and create videos and performance art directly after the Civil War (1975–1990). Lebanese artists became some of the most sought-after contemporary "Arab" or "Middle Eastern" artists in the early years of the new millennium and one might have expected an artist like Issa to be among those presented on the biennial circuit.[3] But unlike Walid Raad and Akram Zaateri, who, besides being excellent artists, are also proficient in English, Issa speaks only Arabic. And as a consequence, he was entirely ignored. Most young artists in Syria did speak fairly good English, although they did not usually frame their practice in the current theory-laden "artspeak" or what has been termed "International Art English", that also seem to be a decisive factor for inclusion in the international art world.[4] Writing about exhibitions of Iraqi artists in the West after 2003, Silvia Naef has observed that "the language of communication and [the language] in which the often-conceptual artworks have to be conceived is English".[5] In other words, writing and speaking English, and particularly the "right" kind of English, are of decisive importance for artists if they want to succeed on the international stage.

Another important factor that presented a severe obstacle to young Syrian artists' international presence was the lack of an institutional framework that would have facilitated connections to international curators and programmers. Institutions such as Beirut's Ashkal Alwan or Cairo's Townhouse Gallery have facilitated access to local artistic networks for visiting foreign curators and thus secured increased visibility for artists in those cities. Damascus lacked similar institutions. Official art institutions in Syria, such as the Ministry of Culture or the Faculty of Fine Arts, were generally ill equipped to help and, consequently, rather than embark on the troublesome and time-consuming adventure of independent research in a largely unmapped field, most international curators preferred to stay away and hold on to the comfortable view that Damascus had nothing of interest to offer. As an independent curator working in Syria in the late 2000s, I was often met with astonishment by my international colleagues when I told them about my place of work, since most of them had assumed that there were no contemporary artists of any interest in Syria. The result was that Syrian artists, and especially those belonging to the younger generation, remained almost invisible internationally and were very much left on their own to seek out opportunities. It was only towards the end of the decade that relevant institutions were established, one of them being the independent space All Art Now, and began to have a small impact, but this positive development was halted when the uprising started in early 2011 and subsequently turned into a devastating war.

In the years that followed, artistic production changed greatly and gradually so did the living conditions of Syrian artists. The early months after the beginning of the uprising were characterized by a proliferation of creative output by activists, who staged protests in the streets and uploaded critical content onto the internet. Examples of actions in the public space included colouring the fountains of Damascus red with dye, releasing ping-pong balls inscribed with revolutionary slogans from Jabal Qasiyun (the mountain overlooking Damascus) and placing recorders playing protest songs in garbage bins throughout the city.[6] Amateurs and ordinary people-turned-activists began to produce

creative, activist videos, often with great wit and humour that mocked the reactions of the regime and forces of order to the popular protests.[7] Most such actions were staged by activists who were not connected to the artistic community. During the early months of the uprising, professional artists mostly appeared to be reluctant to speak about the unfolding events in their works, often expressing feelings of having been overwhelmed by the events on the streets and the courage and creativity of ordinary people-turned-activists.[8] Early steps towards a collective engagement of artists was a call by Syrian filmmakers in April 2011, which addressed filmmakers worldwide and called upon them to express their solidarity with the "peaceful Syrian citizens [who] are being killed today for their demands of basic rights and liberties", "to contribute to stopping the killing by exposing and denouncing it" and to allow for the realization of the "dreams of justice, equality and freedom" of Syrians.[9]

While the filmmakers' call stands in the tradition of the petitions of the "Damascus Spring" and its (unfulfilled) hopes of greater freedoms and political participation, new forms of artistic activism began to appear on online platforms like Facebook and YouTube from the late summer of 2011 onwards.[10] Of the young artists mentioned in the previous chapters, several made the decision to engage in the popular uprising through their art. They were joined by recent art school graduates as well as a number of artists living abroad who involved themselves in the internet activism for peaceful change in Syria. The creativity of online communities also fed into art and film production and inspired new aesthetics, thereby thoroughly changing the look of works by Syrian artists and filmmakers. This exuberant creativity lasted for about a year, after which the level of violence in the country increased and more and more people began to leave. In the beginning, many artists found refuge in neighbouring countries, such as Lebanon, Jordan or Turkey, in the hope of returning home soon. But as the conflict wore on, many began to look for long-term solutions. Beirut remained attractive for many established artists, who chose the city due to its status as one of the main artistic centres of the Arab world. But many early-career artists sought to settle in Europe. Paris would have seemed the first choice with its traditional associations with art and large number of Arab intellectual exiles, but from 2015 onwards, Berlin's cosmopolitan vibrancy and relatively liberal asylum policies began to attract increasing numbers of Syrian artists.

As Syrian artists began to integrate into the art scenes of their new locations of residence, they were met with a new set of challenges: Audiences and organizers of artistic events were in most cases not familiar with either the history of art or the art and culture scene in Syria prior to the war, and events were not always guided by artistic quality but more by a humanistic or even sensationalist interest. As a result, distorted ideas about artistic practice in Syria before the uprising, such as the idea of a crippled or non-existent art scene abounded. This is an unfortunate but by no means unique idea when it comes to little-known art scenes.[11] The title of this chapter, which was chosen with a certain irony, refers to such notions: "Singing in the Kingdom of Silence" is the title of an article published online in 2015 on an internationalist, left-wing portal. The article, while sympathetic to the popular uprising, reiterates ideas of a lack of artistic expression in Syria prior to the uprising. Statements such as "All over Syria, the uprising went hand in hand with an outpouring of artistic expression" and "Syria's long silence was broken not only by the flood of visual art but also by the emergence of a remarkable citizen journalism movement" help perpetuate the idea of a country devoid of art and creative expression.[12] For the Syrian artists, recently displaced and eager to re-connect to their former practice

as artists and present their work in the new environment, dealing with such simplistic views of their home country while attempting to build up solid professional networks was challenging indeed.

As Syria and especially the destruction of its cities and historical sites became a subject of regular reporting in European media, exhibitions of "Syrian art" also began to proliferate. In a way, the under-representation of works by Syrian artists on the international art scene was replaced by a strange over-representation. In what follows I will discuss the representation (and its lack) of Syrian artists on the international art scene in the new millennium. I will begin with an outline of the situation during the 2000s and the growing interest in Middle Eastern contemporary art. From there I will move on to discuss some possible reasons for the relative exclusion of artists from Syria from this development and in Section 4.3 I will focus on the increased international visibility of Syrian artists that went hand in hand with their large-scale displacement since the beginning of the uprising in 2011.

4.1 "Branding" Contemporary Arab or Middle Eastern Art

The first decade of the twenty-first century saw an expansion in exhibitions with a focus on contemporary art from the Middle East. The terrorist attacks of September 11 2001 are often mentioned as an important factor in this interest, but should not be seen as the only reason.[13] The so-called "global turn" of the international art world had already begun with some seminal exhibitions of the late 1980s, especially the *Magiciens de la terre*, curated by Jean-Hubert Martin's at the Centre Georges Pompidou and the Grande Halle de La Villette in Paris, one of the first exhibitions that claimed a "global" overview of contemporary artistic production.[14] It took place in 1989, a year that marked an important historical rupture with the fall of the Berlin Wall and the "Iron Curtain" as well as the end of the division of Europe into a socialist East and a capitalist West, and with it the end of the Cold War system of alliances.

With his ambitious project, Martin wanted to refute the idea that objects produced outside a Western context did not possess a contemporaneity and that they were inherently archaic. He insisted on the auratic quality of the exhibits, making no distinction between the Western works of art and objects from non-Western societies. But he also did not designate the latter as "art", stating that he wished to avoid putting the label "art" on creative productions from "societies that did not know this concept".[15] He did, however, call the producers of these objects "artists" and stated that the exhibited objects were all made by individual artists whose names were known and that he was not interested in anonymous works, produced by a cultural community.[16] But, while the exhibition was conceived in order to "question the relationship of our culture to other cultures of the world" and "initiate dialogues",[17], it apparently did not succeed in steering clear of a monolithic understanding of "cultures" and a reiteration of the centre-and-periphery view of the art world. The non-Western artists were largely selected according to their individual mastering of traditional and folk arts and their ability to re-invent these with a "sense of adventure".[18] Non-Western modern art practices were of no interest to Martin. Speaking about modern painting practices in Morocco and Algeria, he said:

> In these countries you will find a widespread tendency to harmonize traditional calligraphy with Ecole de Paris painting. This transposition of calligraphy into a Western easel painting technique leaves me totally cold. I prefer to show a real calligrapher like the Iraqi Youssuf Thannoon.[19]

Such dismissal of actual modern and contemporary artistic practices in the non-West led to heavy criticism of the exhibition, among others by Rasheed Araeen, who dedicated an entire volume of the journal *Third Text* to it. According to Araeen, by bypassing modern artistic development in non-Western countries in favour of "authenticity", the exhibition presented a distorted image of non-Western artistic reality, representing a "grand spectacle with a lot of fascination for the exotic".[20] While much of Araeen's criticism is entirely justified, some assertions seem overtly polemical. For instance, he asks, "It is true that there are cultures which somehow still operate outside the limits of Western culture, but can we say that they are not affected by modern developments?"[21] In fact, Martin stresses that all the Third World artists visited during the selection process had a certain contact with Western culture, even if only slight.[22] But the de-contextualization of the exhibits from their political and social environments, which ultimately serves to exoticize them and which both Araeen and Buchloh criticize, as well as the failure to engage with non-Western visual production included in the exhibition from an art-historical or theoretical/critical angle and to acknowledge "that the 'other' has already entered into the citadel of modernism and has challenged it on its own ground" did point out some of the significant problems of the show.[23] Even harsher criticism came from the Turkish artist Bedri Baykam, who called the exhibition "contemporary cultural colonialism" and criticized the reduction of non-Western artists to "ethnic, folkloric, local backgrounds", arguing that

> The show overtly stated that if you had one of those prestigious passports you could paint in universal styles, and if you had any other passport you were confined to your own backyard, and this restricted area was the limit permitted by 'Western curators'.[24]

But despite the justified criticism, *Magiciens de la terre* marks the international art world's "global turn".[25] If the term "international" had hitherto largely referred to the Western world, it now expanded to include the non-West. In the course of the next 20 years, large-scale exhibitions purported to give an overview of artistic production that had up to that point been neglected. However, when looking at what art was deemed worthy of inclusion in this "global" art world, it becomes clear that it was by no means all works from faraway places that were accepted and that this world was not as inclusive as it claimed to be. As the art historian Joan Kee has pointed out, "Art from non-democratic and illiberal states is rarely included in books, exhibitions, conferences and other vehicles through which the field of contemporary art takes shape."[26] Further excluded was official art commissioned by dictatorial governments and art that displayed an uncritical endorsement of religious ideas. In order to be considered for inclusion in these exclusive circles of the global contemporary, works would have to be produced from positions of individual subjectivities and appear as "products of free will, unmediated by any external power".[27] As the anthropologist Jessica Winegar has discussed in her studies of contemporary art in Egypt, this often meant that the art and artists, who were held in high esteem on the local scene, were not those who were selected for inclusion in international shows.[28]

The interest in the Middle East and its artistic production also dates from the 1980s (the British Museum in London had begun to collect contemporary Middle Eastern art, mainly works on paper, in the mid-1980s),[29] but, as mentioned above, it was after the dramatic events of the terrorist attacks of 2001 that Western institutions began to stage

large exhibitions focusing on the art of the region, a phenomenon the curator Media Farzin refers to as the "Great Middle Eastern Art Rush".[30] These shows were often driven by the wish to offer a different, more positive image of the region. On the occasion of a talk in Toronto in 2008, the director of New York's Museum of Modern Art, Glenn Lowry, explained that the main aim of the exhibition "Without Boundary: Seventeen Ways of Looking", which the MoMA had presented in 2006, was to show that the Islamic world could produce art and not just violence and that contemporary artists from the region could reflect critically on their own realities.[31] While one might be surprised at the truism of this statement, it was a recurring objective in many exhibitions of the decade.

One of first of its kind in the decade, Jack Persekian's *DisOrientation* (2003) at Berlin's House of World Cultures endeavoured to give an overview of artistic production in the region. Other projects were Catherine David's travelling project *Contemporary Arab Representations* focusing on Beirut (2002) and Cairo (2003); the Victoria and Albert Museum's *Arabise Me*, organized together with the cultural organization Ziarat (2006); *Images of the Middle East*, organized by the Danish Centre for Culture and Development in Copenhagen (2006) with a large team of curators; Predrag Pajdic's *In Focus* in London (2007); *Unveiled: New Art from the Middle East* at London's Saatchi Gallery (2009); *Dream and Reality: Art from the Near East* at the Zentrum Paul Klee in Berne; and *Taswir: Pictorial Mappings of Modernity and Islam* at Martin Gropius Bau in Berlin.[32] I do not wish to imply that these exhibitions were all similar, nor is it my intention to say that they were lacking in merit. They came at a time where only little art from the region had been shown in the West and for some artists, they proved a stepping-stone towards international careers. But often enough, these exhibitions also suffered from a (self-imposed?) need to give a "coherent" view of artists' work, despite the great diversity of the vast Middle Eastern region. While most of these projects were singular exhibitions, Catherine David's *Contemporary Arab Representations* was conceived as a long-term, discursive, and interdisciplinary project along lines of investigation that she had pursued from her work at Documenta X in 1997. In these exhibitions, she focused on the "radicality of contemporary non-Western expressions [that find their] privileged avenues in music, oral and written language (literature, theatre), and cinema forms which have traditionally contributed to strategies of emancipation".[33]

Many of these exhibitions do, however, gather very diverse groups of artists from different geographical and political contexts. The artists' ethnicity and biography are thereby placed in the forefront and together with their work, they are understood as part of a particular culture ("Arab", "Muslim" or "Middle Eastern").[34] The essentialist reduction of a group of different artists and artworks under one category inevitably holds the danger of feeding into stereotypical representations. As noted by the Indonesian artist and curator, Jim Supangkat, the pressure to make non-Western art accessible to Western audiences can easily lead to a particular contextualization that "work[s] into the discourse of the mainstream", i.e., confirms assumptions of the general public.[35] Often, such assumptions entirely overshadow the reception of particular works by critics and audiences, even though this might not have been the intention of the curators. As Silvia Naef has noted, works by Iraqi artists have, when exhibited in the West, often been read as "resistance to a situation of destruction and war" and seen in the context of exile. This reading has almost entirely overshadowed the modernity of these works, which has only rarely been noted by critics and audiences.[36] While an exaggerated politicization of artworks is problematic, exhibitions that entirely leave out any considerations of the

particular socio-political context are equally questionable. The exhibition "Without Boundary: Seventeen Ways of Looking", mentioned above, was criticized by the art magazine *Art Monthly* for leaving out any reference to contemporary politics of the region in order to present what was called an "easy-going universalism".[37] Prominent artists like Shirin Neshat and Emily Jacir likewise offered severe criticism, Neshat stressing the need to address the politics with which artists constantly deal and Jacir naming the particular case of Palestinian narratives that are routinely censored in the USA.[38] Distinctly apolitical exhibitions seem, however, to be the exception (the British Museum's "Word into Art" of 2006 would be another one).[39] Most other shows represented a particular kind of "pedagogic activism", in the words of Media Farzin.[40]

As mentioned above, another important problem lies the disparity between works of art recognized as important in the countries of origin and those which are sought after by international curators.[41] For example, the question of gendered religious practices is one of the most common frames that Western institutions and curators have chosen when staging exhibitions of "Arab", "Middle Eastern" or "Islamic" contemporary art. The practice of "veiling" and its link to the perceived oppression of women is a recurrent theme in Western mainstream media and culture and one that seems to be ever-topical and regularly finds its way into exhibition practices seeking to respond to this interest.[42] The veil as a sign of the inherent otherness of Muslims has a long tradition in the Western understanding of the Middle East. It is constructed as fixed and timeless, with a "historical and geographical continuity to both the form and the meaning of the garment" that "ignores the diversity in the nomenclature, practices, and meanings of veiling both historically and geographically".[43]

Any attempt here to discuss the multiple layers of the "veil" and its representations in art and exhibition practices would by far go beyond the scope of this study. The overwhelming presence of the subject in Western mainstream media and culture has led a great number of Middle Eastern artists and artists of Middle Eastern origin living in the West to interrogate its significance in their works. In many of their works, these artists (who are themselves often un-veiled) attempt to counter negative stereotypes of the contested garment.[44] That they, however, also do not wish to endorse conservative Muslim discourse surrounding the veil, places them in an ambiguous position of double-critique. In her discussion of narratives of the veil in the works of contemporary Middle Eastern artists, the art historian and critic Valerie Behiery links the deconstruction of notions of the veil as practised by some of these artists to Gayatri Spivak's notion of "resistant mimicry", an approach that seeks to alter master narratives from within.[45] This allows the artists to express critique "of both Eastern and Western representations of, and discourses on, the veil and the Muslim woman". It "permits criticism of the veil, Muslim norms, or politics without reinforcing the Western trope of the veil and the bipolar geopolitical map it traces".[46] However, this multi-layeredness of meanings in works related to the "veil" is seldom noticed. That it can also serve as a "tool for discussing issues of multiculturality and migration" rarely enters general discussions about these works, as Silvia Naef writes.[47] The ambiguity of these artists' position is also reflected in the curatorial framing of art that discusses the "veil". Here, two main approaches can be defined: one that seeks to counter stereotypical representations of Muslims and their practices and one that highlights the critique of Islam at the centre of certain works.[48] Both approaches run the risk of conveying an overly simplistic image of the artworks, Islam and the religious practice of individual Muslims. Since it is difficult to escape the dominant frameworks for presenting such works within the Western art world, i.e., the

common need to provide a cultural and/or religious context for this art, the risk of actually confirming rather than refuting stereotypes of Arabs/Muslims/Middle Easterners as fundamentally "other" cannot be ignored.

Drawing on Olu Oguibe's notion of a "culture game", according to which non-Western artists must constantly prove and represent their cultural background in order to be seen as good "Arab" or "Muslim" artists (or any other ethnic, national or religious affiliation) and not just as "good artists" *tout court*, Jessica Winegar suggests that Middle Eastern artists are also forced to enter into a "humanity game". They always need to remind Westerners that they are "humans" and non-violent, that they indeed share the same humanity with the same universal values as people in the West.[49] Likewise, Silvia Naef has noted that Iraqi artists are often presented as the "better Iraqis" at exhibitions of their work, i.e., "those who prefer to take a paintbrush in their hands rather than a gun".[50] The artworks themselves become less relevant in this context. Works that do not easily fit into this framework face considerable difficulties and are generally not shown in the West, or at least more rarely. As examples, Winegar mentions works that critique the Middle East policies of the West and its allies and works that advocate resistance against occupation, for example, works by Palestinian artists that are critical of Israel as well as works that celebrate contemporary, conventional Islam.[51]

4.2 The Missing Link: Syrian Artists and Their Relative Invisibility on the International Art Scene

In 2003, the curator of the large *DisOrientation* exhibition at Berlin's House of World Cultures, Jack Persekian, wrote the following dismissive words about the Syrian art scene: "I met with a few artists and gallery people. What I saw, however, did not go beyond self-indulgent orthographies and anachronistic development." He went on to explain that the works of Syrian artists were ill-fitted for his exhibition concept, because he wanted to show "new trends in contemporary Arab art and to present a somewhat coherent and homogeneous manifestation in terms of the genre of work and the under-lying conceptual framework".[52] Many aspects of this statement are problematic. First of all, one might ask why it was important to present a "homogeneous" image of a region as diverse as the "Arab world" in the first place, and his idea that a few days were sufficient to get an overview of a city's art scene and even pass such a grave judgement (he stayed in the country from August 22 to August 26 2002) can only leave any researcher and self-respecting curator in a state of complete wonder. Surely, any serious curatorial research would necessitate a longer stay to understand the particular paradigms of artistic production at work in a place? Persekian, however, did not bother to do so and his statement went uncontested. It might even have had a lasting influence on the view international curators had with regard to the Syrian capital: In 2009, six years after Persekian had published his catalogue, not much seemed to have changed. The city, and with it its artists and its art scene, are notably absent in the curator Nat Muller's introduction to Paul Sloman's "Contemporary Art in the Middle East".[53]

These are the textual and therefore more tangible expressions of such prejudices that I experienced as widespread. Such views were in many ways typical of the attitude of international curators towards Syria, even in the later part of the decade, and stand in direct contradiction to the gallery manager's assessment mentioned in the introduction to this chapter. In 2008, Anneka Lenssen (one of the rare people who actually under-took research in Syria) noted that "today, the city's [i.e., Damascus'] art scene is often

overlooked – dismissed as retrograde by ostensibly more cosmopolitan artists in neighbouring countries".[54] Those Syrians ultimately included in Persekian's exhibition were the filmmakers Omar Amiralay, who curated the film programme, and Oussama Mohammad, whose feature films *Stars in Broad Daylight* and *Sacrifices* were shown as part of that programme. The only "Syrian" visual artist included was Roza El-Hassan, a Budapest-based Syrian-Hungarian artist who has received her training in Hungary and whose practice is more rooted in the Central and Eastern European critical tradition. But El-Hassan's critical, performative practices were deemed more suitable for an exhibition that attempted to give a "homogeneous" image of "contemporary Arab art". This absence of Syrian artists from international art events and lack of interest in their work (despite a notable tradition of art production in the country) can perhaps be compared to the situation faced by Iraqi artists. Silvia Naef has noted that, "Artists from Iraq have been absent from this 'globalization' of the international art scene for some time, although the country has been one of the most productive in the region since the 1950s."[55]

The expanding gallery scene mentioned in Chapter 1 did not change this situation to any notable extent. The conceptual works that might have found their way onto the international biennial circuit were not exhibited in these mainly commercially oriented spaces. But towards the very end of the 2000s decade and with the unexpected success of certain Syrian artists at regional auctions, the idea of a vibrant art scene in Damascus that attracted international art professionals and collectors developed into a marketing strategy that some gallerists used and communicated to international journalists. As illustrated by the gallery manager's words referred to at the beginning of this chapter, there is even an effort to backdate the beginning of this "interest". Articles celebrating the artistic and cultural life of "the remote and ancient capital of Syria" started to appear in Western print and online media. They often mentioned Damascus' "hip new galleries" and the city's "evolvement from artistic backwater into a thriving hub of contemporary Middle Eastern painting". Ayyam Gallery is mentioned as one of those places that is giving the "ancient city" its new and attractive face, illustrating the successful marketing strategies of this gallery.[56]

Works by young Syrian artists that has made their way onto the international art circuit and which were discussed in Chapter 3 was Diana El-Jeiroudi's *The Pot*, Samer Barkaoui's *Poster*, and Buthayna Ali's, *Don't Listen, She's Only a Woman*, a work that explores the traditional *hammam* (bath house) as a traditional space for female encounters and freedom from the social constraints of the outside world. That these were works which discussed gender-related issues might easily fit into the common idea that these issues constitute a Western thematic preference. But is it really so easy? When discussing Arab women videomakers, Laura U. Marks has suggested that feminist works (what she calls works along "first-wave feminist lines") were mainly produced for foreign funders and foreign audiences.[57] The issue of foreign funding (often coming from Western NGOs with agendas more social than artistic in nature) is large and complex and funders certainly do have a considerable influence on the work being produced. But it is important here not to forget the artists' own agency and commitment to social critique. Artists (whether in Lebanon, Syria or in other Arab countries) often need to seek their funding from many different sources, many of them Western, and, as a rule, they quickly become very adept at stretching funders' production regulations to accommodate their own more pro-active projects. And as pointed out by Marks, more experienced and established artists often have a greater say in the works they produce.[58] When considering the role of

foreign funding in the production of works that display concern for gender-related issues, we should also keep in mind that, at the time of my research in Syria, foreign funding for artistic projects was still limited, presenting a situation that was very different from that of other Arab countries such as Lebanon. As already mentioned, the situation at the end of the decade seemed to be changing towards more foreign recognition of the Syrian art scene and its artists. But with the beginning of the uprising and the subsequent war, Syrian artists needed to respond to entirely different challenges. This will be the subject of Section 4.3.

4.3 Increased International Visibility of Syrian Artists after 2011

My focus in this book has been on the production of Syrian artists in the first decade of the twenty-first century and its relation to certain works of the twentieth century. As discussed, these works have been severely underrepresented at international art events as they proliferated during the 2000s. However, as mentioned in the introduction to this chapter, the previous underrepresentation seems to have been replaced with an over-saturation of events related to Syrian art and creative production since 2011 and the beginning of the uprising-turned-war. Here, I will look at some aspects of this production, how artistic languages have changed, how artists are coping with new life situations as their existence has been turned upside-down and, finally, how their works find the way into international events and how they are read there.

Like so many Syrians, great numbers of artists have also been forced to leave the country and what was once a small, close-knit scene, has become dispersed throughout the world, although with some locations of concentration, such as Beirut, Paris and particularly Berlin.[59] In their new locations of residence they find themselves facing challenges that are very different from those they knew in Syria. Many of those artists who have been displaced were invested in a more or less explicit critique of the authoritarian system in Syria and many also took a critical stance vis-à-vis the reaction of the regime to the demands of those Syrians who took to the streets from early spring 2011 onwards to protest against the lack of freedom in the country. In their new environment, they might find themselves in need of balancing a wish to continue some form of artistic activism and speaking about the situation in their home country with that of curators and institutional staff to present what might be called Syrian "war art". Deeper engagement with social and political issues might not be understood by audiences, leading to some degrees of frustration among the artists. Countering the stereotypes of their new environment might overtake the wish to continue a form of artistic activism.

For anybody studying the production of Syrian artists after 2011, three things are striking: (1) the internet became enormously important as a space to discuss, share and disseminate art; (2) new forms of collaboration were developed; and (3) the critical language of art became more outspoken, sometimes at the expense of the artist's anonymity.[60] The great importance of the internet in distributing activist artworks was new to Syria. The country was late in getting access to the internet; public access was only established in 2002 and remained rare for several years. When I first began my research on contemporary art in Syria in 2006–2007, only a few artists had websites and the online presence of galleries was also limited. Conducting research on the Syrian art scene necessitated being "in the field". This changed slightly in the course of the final years of the 2000s, but it was not until the uprising that the internet became an important medium for artistic exchange and for the distribution of critical artworks. From 2011 and the

closure of the country to foreign journalists and researchers, the internet became the location to turn to for information on the art and culture being produced within the borders of Syria and by Syrians residing elsewhere.

One of the first striking artistic activist videos appeared online in autumn 2011. A short piece of five minutes length, *Conte de printemps* (*A Spring's Tale*, 2011, Figure 4.1) was uploaded on several platforms from which it was widely shared.[61] The artists, Mohamad Omran and Dani Abo Louh, were both living in France at the time of the video's production and had been doing so for many years. What is remarkable about this video is its outspokenness and unmistakable denouncement of the violence perpetrated by the Syrian forces of order. This makes it very different from videos produced prior to the uprising, which in general veiled critique in indirect language and metaphors. But also in terms of techniques applied, it shows differences. Documentary footage is interwoven with animated drawn paper figures. Before a background of found images, these figures rise one by one until they are crushed by a giant, real foot, but they rise again, dishevelled-looking yet defiant. Set to a classical opera aria, *Conte de printemps* tells the story of the hopes of the Syrian uprising with simple means. In its aesthetics, it stands in stark contrast to the video works produced during the 2000s. It makes use of found footage, something that was not common during the previous decade, Ammar Al-Beik being the only artist who had used the technique widely in his works and it combines drawing and animation with video. The video was produced quickly, uses simple technical means and does not attempt to hide this. The main purpose was to communicate a message. Compared to the pre-uprising works discussed in Chapter 3, the video is surprisingly frank in its open denouncement of violence. Publishing such a work under the artists' real names was not without its dangers, yet, as Dani Abo Louh explained at a talk in Berlin, after careful consideration of the pros and cons, the artists decided to clearly state their identities.[62]

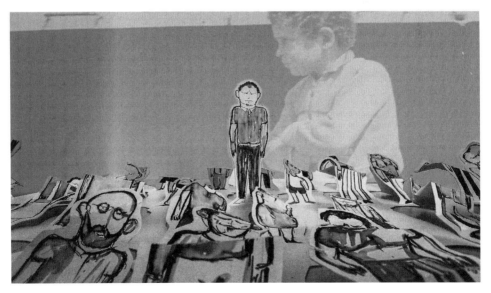

Figure 4.1 Mohammad Omran and Dani Abo Louh, *Conte de printemps* (*A Spring's Tale*), 2011, video
Source: Courtesy of the artists.

Ammar Al-Beik presented a highly personal reflection on the ongoing events in his video *Hadinat al-shams* (*The Sun's Incubator*, 2011, 12 min., Figure 4.2) at the International Film Festival in Venice. The work interweaves the very personal story of the birth of the artist's daughter with the protests erupting in Egypt and across the Arab world in early 2011 and the torture and murder of the 13-year-old boy, Hamza Al-Khatib. As discussed earlier, Al-Beik frequently inserts his own image into his videos, thereby interrupting the narrative and drawing the spectator into the work. The human body is central to this work, whether in its life-giving qualities or in its vulnerability. Al-Beik filmed the birth of his daughter, the first moments of her life and the care he and his wife give their baby, while the unfolding protests and deaths of the so-called "Arab Spring" are constantly present through sound or television images in the couple's home in Beirut. The terrifying footage of the mutilated body of Hamza Al-Khatib, a young boy who had joined the protests in Deraa and was arrested and murdered while in police custody,[63] is shown on the television screen of the couple and stands in jarring contrast to their loving care for their own child. In the case of Ammar Al-Beik, the outspokenness with which he had denounced the violence of the regime meant that he could no longer travel to Syria, instead moving first to Dubai and later to Berlin.

Another project in which participating artists consciously decided in favour of publishing their works under their real names as a statement of solidarity with the protestors on the streets is the Facebook group *Al-fann wa-l-hurriya* (*Art and Freedom*), which was initiated by Youssef Abdelké. The name of the group refers to the group of Egyptian artists and poets around the poet Georges Henein, mentioned in Chapters 1 and 2 and their advocacy for artistic freedom and social engagement. Abdelké's wish was to take a position against oppression and violence in Syria and to "chronicle all works of art that deal with this current moment".[64] *Al-fann wa-l-hurriya* differed from other Facebook groups that claimed a "creative" focus in that it was a group by and for professional artists who presented art in a

Figure 4.2 Ammar Al-Beik, *Hadinat al-shams* (*The Sun's Incubator*), 2011, video
Source: Courtesy of the artist.

variety of media with a clear curatorial concept.[65] But for many artists, openly revealing their identities was simply too dangerous. Some artists chose to produce work anonymously, but others entirely abandoned the idea of individual authorship and chose collective formats. The blogger "Amal Hanano", who was herself using a pseudonym, expressed this decision in the following words:

> We encoded ourselves so we would stop speaking in codes. To call things by their real names, things like murder, torture, rape, repression and humiliation. And to call for what we never thought we would dare to in our lifetimes: freedom, justice, and dignity.[66]

A collective project that quickly became popular, not only in Syria but also at an international level, was the group "Masasit Mati", whose name refers to the straw used for drinking maté tea, a practice popular in rural areas and, allegedly, particularly so among members of the security forces. The members of this group were artists, theatremakers and journalists, all graduates of the Higher Institute of Dramatic Arts in Damascus. While they had all been participating in the street protests from the beginning, they soon realized that in order to get the attention of the international community more news about them needed to get out of the country.[67] This led to the creation of the satirical video series *Top Goon: Diaries of a Little Dictator* (2011–2012).[68] Limited to simple means of production due to financial constraints, the series tells stories related to the Syrian uprising and satirizes regime discourse in a series of finger puppet plays.[69] What the series lacks in sophisticated techniques is compensated for by the care that has clearly gone into crafting the puppets and the wit exhibited in these episodes which appeared on YouTube during the final months of 2011 and beginning of 2012.

The central character is "Beeshu" (diminutive for Bashar), who, speaking with a characteristic lisp (Bashar al-Assad actually does have a lisp), appears like an immature and capricious child who is prone to nightmares and whose whims have to be followed by everybody in his surroundings. He regularly flies into fits if he feels himself misunderstood or not properly celebrated and is in constant need of the reassurance of one of his thugs that "his people still loves him". Each episode starts with a theme song that begins with Beeshu declaring: "I am not insane" and the presentation of the series' main characters: "Beeshu": President of Syria; the "Rose of Damascus"; the regime thug "Shabih", and "the peaceful protestor".[70] These characters all refer to different aspects of regime discourse or debates taking place in the online space. "Rose of Damascus" recalls an article published by the fashion magazine *Vogue* in February 2011 about the Syrian first lady, Asmaa al-Assad. The title of the article was "A Rose in the Desert". Following the beginning of the uprising, it was quickly removed from the magazine's website after it was met with wide criticism for glossing over atrocities committed by the Syrian regime.[71] The need to receive regular confirmations of the Syrians' love refers to those images and posters with declarations of love for the president, that were abundant in the public space all around the country and that all visitors to Syria will be familiar with. The project was conceived with the aim of changing Syrians' perception of the regime, to "break the barrier of fear and remove the god-like aura around [the president]" and to allow the spectators to laugh about him.[72] According to the director of the project, who used the pseudonym "Jameel" for his public appearances, the project succeeded in doing so, as some people did in fact start using the name "Beeshu" as a nickname

when speaking about Bashar al-Assad.[73] *Top Goon: Diaries of a Little Dictator* received considerable international attention, helped by the English subtitles and the project's articulate director. The series also found its way into a number of exhibitions focusing on Syrian artistic production in relation to the uprising. Some episodes, for example, were shown at the exhibition "Culture in Defiance" at the Prince Claus Foundation in Amsterdam in 2012, which was curated by Malu Halasa.[74]

The interest with which artistic production by Syrian artists was met internationally from 2012 onwards, increased in the following years. In part, this had to do with the growing media coverage of the ongoing conflict, but also the great number of Syrian artists who relocated to European cities played an important role. The decision to leave was not an easy one and some artists and filmmakers decided to remain in Syria, regardless of the dangers. Thus, in 2012, Youssef Abdelké expressed the conviction that activism for change should happen from inside the country: "It's more of a political statement to be silent in Syria than to speak out abroad."[75] For him, cautiously expressed critique carried more weight than loud statements of defiance expressed from a position of exile. And even after being arrested in 2013 and released after five weeks, he decided to stay in his country, true to his conviction of "not abandoning your burning house, but staying to put out the fire".[76]

The agony of following the news from a remote location was the subject of some artists who were already living outside Syria before the beginning of the war. Thus, in his photographic series *Cheek* (2013, Figure 4.3), the Vienna-based artist Akram Halabi uses images from the internet and manipulates them to keep only the essential elements. He then adds descriptive text fragments to different parts, almost as if he were painstakingly attempting to understand the content of the image, incredulous when faced with the horrifying news from home.

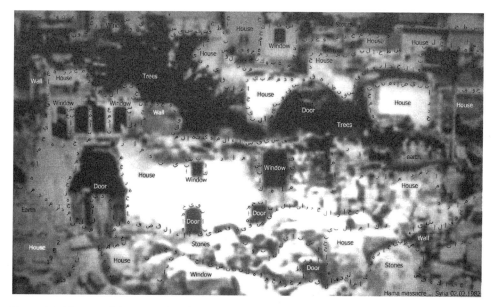

Figure 4.3 Akram Halabi, From the *Cheek* Series, 2013, digital print on paper, 50 x 85 cm, Edition 1/6
Source: Courtesy of the Atassi Foundation for Arts and Culture.

Less directly linked to revolutionary issues is Kevork Mourad's and Kinan Azmeh's animation video *A Sad Morning, Every Morning* (2012, Figure 4.4), a work that conveys the feelings of despair and impotence provoked by the morning ritual of reading and hearing tragic news from their far-away home (both artists are based in New York and have been so for a long time).[77] Suggestive rather than explicit, the video is a reflective work that draws the viewer into a sad, melancholic mood through its use of sequences of animated, grey drawings, underlined by Azmeh's clarinet improvisation. Though nothing is clearly outlined, the drawings are suggestive of human figures and architectural forms, all swathed in an eerie grey atmosphere that suggests complete desolation. These works speak about themes related to the destruction of Syrian towns, cities and heritage sites, and with them the country's history, as well as issues focused on the interlinked themes of exile, memory and the idea of home.

A preoccupation with oral history in the form of memories and personal recollections of refugees have become central themes of Syrian artists working in exile, such as Bissane Al-Sharif's multimedia installation *Mémoire(s) des femmes* (2015) and Iman Hasbani's immersive installation *Here, There, and Other Places* (2017), but also in films such as Liwa Yazji's *Maskoon* (*Haunted*, 2014) and Avo Kaprealian's *Manazil Bela Abwab* (*Houses Without Doors*, 2016).[78] The Paris-based multimedia artist and scenographer Bissane Al-Sharif presented the fragmented memories of four women who are now living in exile in countries neighbouring Syria or Europe in her multi-media installation, *Mémoire(s) de femmes* (*Women's Memory*, 2015).[79] In the videos, the women reflect on the

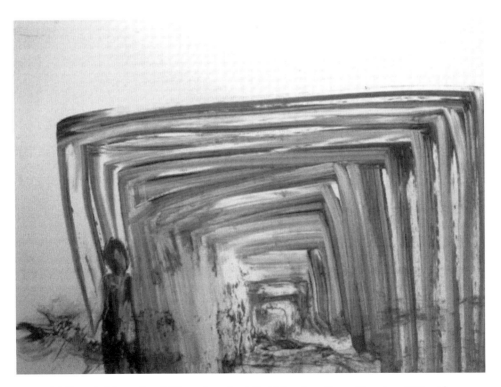

Figure 4.4 Kevork Mourad and Kinan Azmeh, *A Sad Morning, Every Morning*, 2012, video
Source: Courtesy of the artists.

meaning of "home" and its loss, on their future hopes for their country, for themselves and for their children. Their narratives testify to the necessity to come to terms with the past in order to move on with one's life, of creating a future for their families, in connection with their personal histories and relationship to their country. Writing about the work of intercultural film and video artists, Laura U. Marks has suggested that this process of "sometimes traumatic interrogation of personal and family memories" might create an "empty space where no history is certain". She has linked it to a "process of mourning, a search for loved ones who have vanished and cannot be recalled with any of the means at the artist's disposal. These lost ones may be people, places, or even ways of inhabiting the world."[80] Berlin-based Iman Hasbani's immersive installation *Here, There, and Other Places* (2017, Figure 4.5) sought to give space to the articulation of traumatic, or at least disturbing and troubling memories. Gathering the personal narratives of a group of young, displaced Syrian women now living in Berlin, she created a tunnel-like device with soft, white fabric and placed loudspeakers from which the narratives were heard inside. Visitors could crawl into the tunnel and stay in for as long as they wished, listening to the accounts of the young women. These memory-based works are closely related to a subject that has an overwhelming importance for all Syrians: How to cope with the multiple traumas that has affected most of them? How to move forward and build a life for oneself and one's family with a burden of witnessed deaths and destruction?

Figure 4.5 Iman Hasbani, *Here, There, and Other Places*, 2017, immersive installation. Art-Lab Berlin in collaboration with Shubbak Festival, London
Source: Photo credit: Salah Saouli.

Some artists have chosen to revert to the grotesque in order to visualize these traumas, thereby taking up a form of expression that previous generations of artists had found meaningful to articulate the experiences of fear at work in the authoritarian context of Syria and its arbitrariness. The etchings of Yaser Safi, who came to Berlin via Beirut in 2015, are populated with monstrous creatures, distorted bodies and blurred images of severed human limbs, haunting scenes that seem to have stepped straight out of a nightmare (Figure 4.6). Safi's images are sketched with a light hand and appear delicate, something that stresses their disturbing quality by standing in stark contrast to the violence inherent in them.

Distorted, tortured bodies and monstrous figures also populate the paintings, drawings and etchings of other artists, such as Mohamad Omran, one of the artists behind the video *Conte de printemps* mentioned above. Omran's drawings are haunted by disturbing and grotesque figures expressing human suffering and violence. Certain figures clearly resemble al-Assad and other regime figures; others look like victims of torture (Figure 4.7). The drawing *Untitled* (2014), shows a tall, slim figure with dark glasses standing with his arms outstretched on the back of a person lying face downwards on the floor. The hairstyle and dark glasses of the standing person are a clear reference to Bashar al-Assad, who is often shown wearing aviator sunglasses on popular photos. The figure on the ground is both muted and immobile, his hands are bound behind his back, his mouth is gagged and his lower body has been amputated, a stick put in its place. On the right side of the drawing, a bull that bears a certain resemblance to the bull in Picasso's *Guernica* (1937) peers into the image, as an art historical reminder of another instance of state violence against a resisting population.

Figure 4.6 Yaser Safi, *Extract from a Diary*, 2012–2013, 30 x 42 cm, ink on paper
Source: Collection of the author.

Figure 4.7 Mohamad Omran, *Untitled*, 2014, ink on carton, 21 x 21 cm
Source: Courtesy of the Atassi Foundation for Arts and Culture.

It is a disturbing image. The act of standing and jumping on the back or stomach of prisoners has been reported as a method of torture in Syrian prisons, and videos showing soldiers jumping on captured persons appeared in the early days of the uprising. The outstretched arms have ambiguous connotations. It bears resemblances to crucifixion scenes, but also to the most sinister of the Abu Ghraib torture photographs that hit the international media in 2004 and showed a prisoner standing on a box with outstretched arms connected to wires.[81] Mohamad Omran might not directly refer to the religious content of the Christian image tradition of crucifixion scenes, but more to its global presence as an iconic, easily recognizable image. The image has connotations of the carnivalesque. By inverting the roles in the image (the "crucified" is here the perpetrator), Omran turns the content upside-down and offers a view of the pathetic character of both the torturer and the act of torture. Approaching Christian religious imagery through a carnivalesque lens can, in the words of Frances S. Connelly, appear as "powerful

inversions that ultimately reaffirm that which they mock".[82] The torturer, dressed only in his underwear which shows his thin limbs, appears utterly ridiculous despite his attempt to take up a heroic pose.[83]

Many of Omran's adaptions of grotesque imagery to denounce the violence of war and torture in Syria remain close to the limit of what one can bear to see. He does not shy away from showing the repulsive or the abject, as in the drawing *Wada'an* (2012), an image replete with disembowelled, mutilated and vomiting figures, over whom a delegation of repulsive figures from regime "thugs" to ISIS fighters, loom.[84] Images such as Omran's and Safi's make "visual what is most threatening", to quote Connelly again, and force the spectator into a liminal world of fear, a "world that threatens the carefully constructed veneer of our identity". With their nightmarish atmosphere, the drawings of Mohamad Omran and Yaser Safi speak about deep, existential fears, but the grotesque imagery also exerts a strange fascination, which Connelly has linked to apotropaic images, i.e., images that are meant to bind negative forces and thereby render them harmless.[85]

In the way that Omran's and Safi's images depict the horrors of war, they represent a closeness to that aspect of the grotesque that serves as a means to give a visual expression of the trauma of human suffering and war. They remind us of Francisco de Goya's *Disasters of War* and the work of modern European artists like Otto Dix and Max Ernst, in whose work the grotesque represented a site from which to criticize modern horrors such as the industrialized First World War and menacing forces in society.[86] In 2011, the painter, illustrator and video artist Khalil Younes started a project to reflect on and commemorate the uprising and its iconic "martyrs", i.e., victims, whose images and stories had been widely shared as examples of the brutality of the conflict. With the series *Revolution 2011*, he hoped to compensate for the lack of professional photographic documentation of the Syrian uprising, in contrast to the Egyptian revolution, and, citing the example of Goya's representations of cruelty and war as his inspiration, to create a body of work that "not only reflects on the revolution right now", but that would "last two generations from now".[87] In Chapter 3, I discussed the works of Syrian artists Fateh Al-Moudarres and Youssef Abdelké and how they used the grotesque as metaphors for those menaces that remained hidden from sight but were omnipresent in Syrian society. For several generations of Syrian artists, the grotesque has offered a space within which to articulate a variety of feelings of fear, whether existential or related to the diffuse suspicion darkening human relations in a heavily monitored environment such as authoritarian Syria. For the painter Marwan, although his experiences as a Syrian-born artist living in Germany differed strongly from those of his fellow Syrians who lived in Syria, the grotesque served to express his own discomfort during the early years of his professional life in Germany, the feelings of profound loneliness, combined with an ever-increasing worry about the deteriorating political situation in the Arab world. His early paintings convey an atmosphere of intense discomfort and *angst*.[88] They testify to a search for completeness, often in the erotic or sexual sense. Hidden limbs that protrude behind frontal figures, legs encircling heads or distorted limbs that hinder a breaking free of bonds are the means by which the artist sought to convey his feelings of desire, loneliness and yearning, often giving his figures the features of his own face. The enigmatic painting *Der Gemahl* (The Husband, 1966, Figure 4.8) shows three distorted limbs, two of which hold the upper part of his body, his chest and chin while the third holds a stick, a classic phallic symbol. The impossibility of the gestures and the tense positions of the arms all speak of a profoundly tortured emotional state.

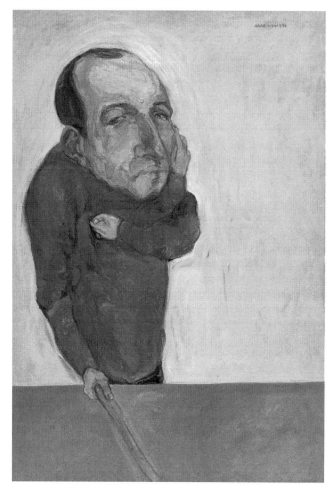

Figure 4.8 Marwan Kassab-Bachi, *Der Gemahl* (*The Husband*), 1966, oil on canvas, 190 x 130 cm
Source: Collection of Barjeel Art Foundation.

Conclusion

We have somehow come to regard it almost as a truism that contemporary artists from the "Arab world" or the "Middle East" became increasingly present at international events during the first decade of the twenty-first century. However, there is only little academic literature that offers an in-depth analysis of the international art world's inclusion of certain Arab artists and exclusion of others, why some works found their way onto the international exhibition circuit and others not. To an almost overwhelmingly large degree, the writing that exists about the representation of Arab or Middle Eastern contemporary art consists of curatorial texts and press releases for exhibitions and biennials, in other words, not the sort of literature that offers a thorough analysis of the phenomenon and therefore only offer limited help to the art historian. Even the international media specialized in contemporary art took a long time to notice the presence of these artists and the efforts of certain curators to present their work.[89]

Anybody attempting to trace a history of Arab artists' participation in international events in the 2000s must navigate this diverse and often contradictory body of writing. Studies of particular geographical locations exist and are valuable first steps.[90] But a broader analysis of the representation of Middle Eastern artists on the international scene, including curatorial preferences for particular geographies, artists, media and subject matter is still missing and would be a valuable contribution to our understanding of the globalizing art scene and its mechanisms.

The art critic Michèle Cohen Hadria has written that those Arab artists who could be described as "young" during the 2000s and who were among the first to be noticed by the international art world, were better informed and theoretically equipped than previous generations of Arab artists. According to her, their works were created from a particular "richer political, social and historical experience ... inverse to the one attributable to the nihilist and sophisticated panorama of the Western contemporary art scene since the 1990s". Working in new technological media, their critical works were informed by the particular political, economic, social and cultural factors of their countries.[91] I would like to relativize this statement and say that former generations of Arab artists were generally just as well equipped with knowledge of those theories that were relevant for their work. For this reason, the radical novelty of the young Middle Eastern artistic movement can be contested to some degree. What we did witness in the 2000s, however, was a proliferation of works in new artistic media and an increased interest of this work by the international art scene, to which a considerable number of these works found their way. But as I have outlined in this chapter, while works by artists from e.g., Egypt, Lebanon and Palestine began to appear at international large-scale events, the Syrian artists' works were rarely shown, despite a clear similarity of concerns with contemporary reality in the Middle East and a wish to engage critically with the problems of their societies and invite a reflection on ways solve them. Possible explanations have to do with the lack of an institutional infrastructure that could have served as an entry point for visiting, international curators (whose lack of time for research seems to be proverbial), a lack of opportunities for Syrian artists to travel to take part in exhibitions and residencies and differences in the artists' discursive framing of their work.

When this began to change towards the end of the decade, also thanks to the hard work of some cultural organizers in Damascus, the Syrian uprising put a sudden stop to this promising development. In the decade that followed, Syrian artists did gain in visibility on an international scale during the 2010s, but at a terrible price. As the conflict became increasingly violent, more and more artists (just like so many ordinary Syrians), were forced to leave the country and seek refuge in neighbouring countries or Europe. In their new locations of residence, they are faced with an array of new challenges, from the needs to re-organize their lives, gain necessary language skills to those of developing professional networks and seeking out opportunities to present their work. Initially, a certain sensationalism has been driving exhibitions of recent Syrian art, leaving artists with the task of countering stereotypical readings of their home country. As they integrate further into the art scenes of their new locations, artists are faced with the need to rethink their practice and avoid the fetishization of their work as "war art". We are still at an early stage in this development and it is not possible to pass any final judgement on the success of Syrian artists in rethinking their careers as artists in their new locations. As the example of displaced Syrian artists in Berlin has showed, while larger institutions might be less willing to offer exhibition space to these new arrivals (also due to significantly longer planning schedules), it is often either their own projects begun by Syrian artists or the city's smaller, artist-run non-profit spaces that have offered these artists opportunities to present their work, interact with other artists and reach new audiences.[92]

Notes

1　See www.nytimes.com/2014/06/19/arts/international/syrian-artists-set-up-base-in-beirut.html?_r
=0 (accessed 15 November 2019).
2　See www.global-contemporary.de/en/artists/12-mladen-stilinovic (accessed 15 November, 2019).
3　In 2019, Imad Issa received some late international recognition, as he was invited to participate in
the Venice Biennale, as part of the Iraqi national pavilion's exhibition "Heartbreak", organized by
the Ruya Foundation, see www.ruyamaps.org/newsfeatures/heartbreak-exhibition-announcement
(accessed 15 November 2019).
4　For a discussion of "International Art English", see Rule and Levine (2013). See also Winegar
(2008), p. 654.
5　Naef (2015), p. 496.
6　The curator Rasha Salti has pointed to the paradox that while these practices could easily be
described as "situationist", conceptual artistic practice is not necessarily common knowledge
among Syrian activists. See Salti (2012), p. 170.
7　To get an idea of these videos, see, e.g., a video by an activist group in Homs, that was sub-
sequently entitled *The Funniest Clip in the Syrian Revolution*. Available at: www.youtube.com/
watch?v=SkDjmO-eWE4 (accessed 15 November 2019). This short clip mocks the regime's
claim that the uprising was led by armed gangs at a time when protests were still largely
peaceful: in it, we see an "undercover reporter" visiting a group of "terrorists" armed with
weapons made of vegetables, which they proudly display. See also Bank (2016a).
8　These sentiments have been expressed by a number of artists with whom I have discussed the
issue.
9　See http://edn.network/news/news-story/article/a-call-from-syrian-filmmakers-to-filmmakers-eve
rywhere/activities/?tx_felogin_pi1%5Bforgot%5D=1&tx_ttnews%5BbackPid%5D=145&cHash
=20d6ae20bbb46704eb8340b575a413f9 (accessed 15 November 2019). The original call no
longer appears to be available online. See also Salti (2012), p. 169.
10　For a discussion of the filmmakers' call and its connection to previous activism by artists and
intellectuals, see Salamandra and Stenberg (2015), p. 2.
11　As pointed out to me by Silvia Naef, similar notions were and are widespread about Iraq and
its artists.
12　See https://newint.org/features/2015/09/01/syrian-revolution-and-thekingdom-of-silence/ (accessed 15
November 2019).
13　Winegar (2008), pp. 652–653.
14　Martin (1989a).
15　Ibid., pp. 8–9.
16　Buchloh and Martin (1989), p. 23.
17　Ibid., p. 22.
18　Martin (1989a), p. 9.
19　Buchloh and Martin (1989), p. 24.
20　Araeen (1989), pp. 4, 10–11.
21　Ibid., p. 4.
22　Martin (1989a), p. 9.
23　Araeen (1989), pp. 3–4; Buchloh and Martin (1989), p. 25.
24　Baykam (1994), p. 53.
25　In 2014, the Centre Pompidou organized a series of events to commemorate the 25 years that
had passed since the exhibition. See www.centrepompidou.fr/cpv/resource/c5eRpey/rERz8A?pa
ram.espacePerso=false (accessed 15 November 2019). I did not have any opportunity to visit the
documentary exhibition nor attend any of the other events or read the publication and therefore
cannot provide a qualified view on the tenor of the re-assessment of this exhibition. But judging
from the website of the event, which appear quite self-celebratory, it does not look as if the
occasion to revise of some of the original critique was really used.
26　Kee (2011), p. 372.
27　Ibid., p. 372. See also Winegar (2008), p. 670, for a discussion on the stress on secularism and
negative framing of Islam in exhibitions of Middle Eastern artists.
28　Ibid., p. 654.
29　Porter (2006), p. 14.

30 Farzin (2014), p. 92.
31 Naef (2010), p. 32.
32 See Winegar (2008), pp. 653–654, for a list of post-9/11 events related to Arab art in the USA.
33 David (1997); Farzin (2014), p. 92.
34 This is a subject that has been widely discussed, mostly in relation to individual artists. See e.g., Wu (2007), p. 725 and Vitali (2004), p. 2, concerning the artists Mona Hatoum and Shirin Neshat. See Winegar (2008), p. 655, for a discussion of the representation of artists from the Middle East as historically and/or religiously defined in the USA.
35 Kee (2011), p. 379.
36 Naef (2015), pp. 494–495.
37 Farzin (2014), p. 89.
38 Ibid., p. 89.
39 Porter (2006).
40 Farzin (2014), p. 93.
41 Winegar (2008), p. 654.
42 Behiery (2012), p. 131.
43 Ibid., p. 131.
44 Farzin (2014), p. 93; Behiery (2012), p. 131.
45 Ibid., p. 138.
46 Ibid., p. 139.
47 Naef (2010), p. 36.
48 Farzin (2014), p. 93.
49 Winegar (2008), p. 675.
50 Naef (2015), p. 495.
51 Winegar (2008), pp. 674–677.
52 Persekian (2003), p. 96.
53 Sloman (2009), pp. 12–25.
54 Lenssen (2008).
55 Naef (2015), p. 475.
56 See http://edition.cnn.com/2011/TRAVEL/01/12/old.new.damascus/, and www.nytimes.com/2010/11/27/arts/27iht-scdamascus.html (accessed 15 November 2019).
57 Marks (2003), p. 42. Marks' observations are based on fieldwork in Lebanon.
58 Ibid., p. 53.
59 A map published in *The New Yorker* in 2018 gives an idea of the dispersion of artists from Syria. See www.newyorker.com/culture/culture-desk/mapping-the-journeys-of-syrias-artists (accessed 15 November 2019). Showing an impressive level of dispersion on a global level, it gives an incomplete image, as it seems to refer to the artists with whom the author has spoken and does not list all countries where artists from Syria have found refuge.
60 Many artists chose to work anonymously, through collective identities or by using pseudonyms. This need was triggered by some instances of artists' relatives being harassed and beaten up. For instance, the parents of the musician Malek Jandali were beaten up in their home in Damascus after their son had expressed his support for the uprising during a concert in Washington, where he was based, see https://freemuse.org/news/syria-parents-beaten-because-of-their-sons-music/ (accessed 15 November 2019). See Bank (2016a) for a discussion of the aspect of anonymity in the works of critical Syrian artists after 2011.
61 See ibid. for a discussion of this video.
62 Remarks made during the Q&A session of the "Virtual Agoras" programme, which I curated for the 7th Berlin Biennale in 2012. See also Bank (2016a).
63 See www.theguardian.com/world/2011/may/31/syria-unrest-teenage-victim-hamza (accessed 10 December 2019) for an account of this case.
64 Matar (2014), p. 241.
65 A great number of more or less loosely curated spaces began to appear on the internet shortly after the beginning of the uprising. Some lasted longer than others, but they mostly presented highly diverse collections of creative works. In order to keep the focus on artistic projects in a narrower sense, I will not consider these projects here. See cooke (2017), pp. 73–89, for a presentation of a selection of such projects.
66 Hanano (2012).

67 See also cooke (2017), pp. 43–44.
68 The videos can be accessed on the group's YouTube channel: www.youtube.com/user/Masa sitMati/videos (accessed 15 November 2019).
69 See Bank (2016a) and cooke (2017), pp. 43–44.
70 See note 68.
71 Parts of the article can be read at: www.theatlantic.com/international/archive/2012/01/the-on ly-remaining-online-copy-of-vogues-asma-al-assad-profile/250753/ (accessed 15 November 2019).
72 Puppet Masters. Top Goon (2012), p. 14.
73 "Jameel", cited in ibid., p. 14.
74 See Halasa (2012).
75 Cited in cooke (2013), p. 31.
76 For details on the arrest of Abdelké and his decision to remain in Syria, see https://frieze.com/article/ what-remains, http://news.trust.org//item/20130724140733-vitwd/ (accessed 15 November 2019).
77 The video can be accessed on the YouTube channel of Kinan Azmeh: www.youtube.com/wa tch?v=nD9jbBFKetA (accessed 15 November 2019).
78 See Bank (2019a) for a discussion of these works in relation to trauma work.
79 For an impression of the videos that were part of the installation, see https://vimeo.com/ 141963628;https://vimeo.com/141963276; https://vimeo.com/141962036; https://vimeo.com/ 141891450. For an idea of the entire set-up of the installation, see www.bissanealcharif.com/la nguage/fr/memoires-de-femmes/ (accessed 15 November 2019).
80 Marks (2000), p. 5.
81 See e.g., www.newyorker.com/magazine/2004/05/10/torture-at-abu-ghraib (accessed 15 November 2019).
82 Connelly (2012), pp. 90–91.
83 In many instances of imagery showing political violence and violence in the context of war and documented by the perpetrators of violence, the original intent has been to dehumanize the victims. But, as discussed by Christiana Spens, such images often have the reverse effect, when they become known to a wider public. Thus, they rather confirm the humiliated victims' humanity and as worthy of compassion. See Spens (2014), p. 57.
84 For an impression of this image, see www.atassifoundation.com/artists/mohamad-omran.
85 Connelly (2012), p. 115.
86 See Connolly (2012), p. 113 for a discussion of Otto Dix's veterans and their relation to the tradition of the grotesque.
87 Khalil Younes, cited in Halasa (2012), p. 17. For an impression of the works, see http://kha lilyounes.com/ (accessed 15 November 2019).
88 See also Bank (2014), p. 1, for a brief discussion of Marwan's early paintings and their relation to his personal life in Germany.
89 Hadria (2005), pp. 35–36.
90 Examples are: Ankori (2006); Boëx (2011a); Boullata (2009); cooke (2007); Lenssen (2014); Scheid (2005); Shaw (2011) and Winegar (2006). Other examples, not cited in this book are: Sam Bardaouil, *Surrealism in Egypt: Modernism and the Art and Liberty Group* (New York: I.B. Tauris, 2017); Liliane Karnouk, *Modern Egyptian Art: 1910–2003* (Cairo: American University of Cairo Press, 2005); Adila Laïdi-Hanieh, *Fahrelnissa Zeid: Painter of Inner Worlds* (London: Art/Books, 2017); Nadia Radwan, *Les modernes de l'Égypte. Une renaissance transnationale des Beaux-Arts et des Arts appliqués* (Bern: Peter Lang, 2017).
91 Hadria (2005), p. 36.
92 See Bank (2018a), pp. 178–180, for a discussion of the opportunities of Syrian displaced artists in Berlin.

Conclusion

In this book, I have focused on Syrian artistic production that can be classified as "critical". Since taking up oil painting in the European modality in the early twentieth century, Syrian artists have used art as a means to articulate critique, address socio-political and socio-cultural issues and call for change. Taking the critical art production of the young artist generation which came of age in the 2000s as my starting point, I discussed how their art was related to works by older artists with which they share a critical stance towards the social environment. During the first decade of the twenty-first century, this young generation of artists sought to redefine the role of the artist in society, reach new audiences and, at the same time, overcome what they perceived as retrograde aesthetics. These young artists began to experiment with contemporary artistic media, such as video and installation, the former developing into the most important artistic medium in the course of the decade. Inspired by influential figures like the Syrian documentary filmmaker Omar Amiralay, but also driven by the wish to align themselves with their peers in neighbouring countries and to some extent, relate to the international art scene, young Syrian artists produced a number of highly interesting videos in which they strove to balance their critical commitment to their society with the pursuit of innovative aesthetics. In their commitment to change, they can be seen as standing in the tradition of committed and critical art in Syria.

Thus, for the young generation, art came – once again – to be seen as a site to rethink the world and to reimagine it as different from reality as they experienced it. By naming the wrongs of the Syrian socio-political sphere, the younger artists sought, like generations of artists had done before, to inspire the wish for change in their audiences. This particular understanding of art is what I have called the "world-making" project of Syrian artists. This project can be traced across the critical and committed painters of the previous generations, the radical cinema of the 1970s and the auteur cinema movement of the 1980s and 1990s with its complex imagery all the way back to the first artists who started practising oil painting in the European modality at the turn of the nineteenth and twentieth centuries, the so-called *ruwwad* (pioneer) artists. As an example of these artists, I discussed the painter Tawfiq Tarek, whose work, while firmly rooted in the European academic tradition, expressed critique at the contemporary political and intellectual situation of the Arab world. While the element of critique might easily be overlooked due to their academicism, Tarek's paintings are early examples of what I have called "moments of criticality", which have resurfaced at various points in Syrian art production. Looking at the history of art in Syria through such "moments" allows us to see a continuity from the beginning of modern art practice in the country up to the present, a continuity that defies the changing political systems and their various levels of authoritarianism. This is a view that offers a different

reading of the art history of the Arab world than the one usually offered, which tends to see a radical break between the pre- and post-independence art.

Artists in Syria have throughout the history of modern and contemporary art practice seen themselves as engaged social agents. The situation of artists under the rule of the Ba'ath Party demonstrates particularly well that the production of art critical of the Syrian regime could involve a variety of risks. While visual artists and filmmakers were not imprisoned in numbers that resemble those of writers and other intellectuals, being subjected to travel bans and various forms of coercion was not uncommon. But even if the personal safety or freedom of artists was not usually endangered, the state could interfere in different ways. Thus, following the defeat of the Arab armies in the Six Days War of 1967, when artists expressed the need for new aesthetic languages to address the situation, state officials attempted to co-opt this impulse and influence the kind of works produced and organized a series of exhibitions with themes related to war and occupation. The possibility of works being censored or co-opted was a risk that filmmakers in particular had to reckon with and which was widespread during the period of the quasi-monopoly of the National Film Organization. Some films produced during the 1980s and 1990s appear remarkably critical of the state and its structures and seem paradoxical in light of the tight control of cinematic production in Syria. It appears surprising that an authoritarian state would fund the production of films critical of its very foundations, only to let these films disappear into the storage space of its ministry offices. But as I discussed, drawing on the writings of Cecile Boëx, miriam cooke and Lisa Wedeen, the Syrian state needed such films to present a favourable image of itself towards the outside world.

Dealing with this situation necessitated different strategies and filmmakers and artists in Syria became very able at circumventing censorship. When working within the context of repressive regimes and tight censorship, artists adopted different strategies to ensure their safety when expressing critique of political or social issues: they may produce art anonymously, rely on ephemeral art forms that leave no traces, produce and exhibit art within private circles only, out of sight of official authorities, or they may seek to develop ambiguous languages. Especially filmmakers turned to the latter in their often strongly critical and satirical works. But even with such precautions, there was no guarantee that a film or an artwork would be presented publicly or that an artist would remain entirely free from persecution. This was true for older generations of artists and filmmakers as well as for the younger generation which strove for new and more direct ways to speak, but often had to experience similar limits of what was they could and could not say. Censorship had been quite rigid under President Hafiz al-Assad, and while rules became slightly more lenient under his son, Bashar, they remained in place and sometimes acted with unabashed force, as the example of banned videos show.

Young artists, who began to work during the 2000s, were caught in a difficult dilemma. They were driven by the hope that the new president would confirm his commitment to reforms, a hope he had inspired in his first public speeches after taking power in 2000. They also witnessed an increased international interest in contemporary art from the Arab world, a development they were largely left out of, despite a shared concern with art as a site within which to negotiate social and even political issues. But while the critical works of Egyptian, Lebanese and Palestinian artists were prominent on the international circuit of biennials, festivals and large-scale survey exhibitions of "Arab" or "Middle Eastern" art that proliferated in the 2000s, Syrian artists remained underrepresented throughout the decade. Structural problems, such as a lack of relevant institutions that could have functioned as gateways for international curators as well as

dismissive remarks by curators who only had little knowledge of the country and its art scene, influenced other curators and represented significant obstacles. Yet, at the end of the decade, this began to change and there were indications that the international art scene was "discovering" Syria and its artists. But, when the uprising began in early 2011, it put an end to these hopes for the local artistic community. As a consequence, artistic production changed in character and was transferred onto new spaces, such as the internet.

After some months of hesitation, artists started producing works that expressed solidarity with the peaceful uprising and spoke out against the excessive use of violence by the regime against the protestors on the street. The internet became an important space for disseminating this critical production and one in which works could be widely circulated within a short period of time. This artistic production soon caught the attention of international curators and art organizers, leading to a large number of exhibitions of works by Syrian artists. Sadly, this new visibility paralleled the large-scale destruction of Syria's towns and cities and the steady disintegration of the fabric of society. With increasing levels of violence, many artists – like so many of their compatriots – were forced to leave the country to find new homes in neighbouring countries or in Europe. In their new locations they are faced with the necessity to rethink their practice and find their way through unfamiliar structures. When doing so, the need to redefine themselves as artists may well pose the greatest challenge. While their practice has hitherto been defined as oppositional to the authoritarian state, they now find themselves in entirely different socio-political environments. Added to the challenges of organizing a life, learning necessary language skills and often coping with traumatic memories, comes the need to develop new professional networks of other artists, curators, critics and institutional staff and seek opportunities for exhibiting and presenting their work. Thereby, the risk is that exhibitions presenting art by Syrian artists may be driven more by a humanitarian concern than a genuine interest in the art works, as is often the case with artists from war-torn places. And despite the high artistic quality of the works, they may still be seen mainly as indicators of the "chaos and horror" reigning in Syria.[1] This approach risks giving a distorted view of Syrian artists' artistic production and the country and its art scene(s), something that is only amplified if exhibitions are organized and/or curated by institutions and people who only have rudimentary knowledge of Syria and its art world. Often, Syrian artists find themselves in the uncomfortable situation of having to "explain" their country to audiences and see the deeper layers of meaning in their work unconsidered.

Speaking of black artists, Kobena Mercer has called this the "burden of representation".[2] In this process of "othering", artists can feel obliged to self-orientalize, to frame their work as expressions of a specific ethnicity and thus to place themselves apart from the art scene into which they are attempting to integrate. This might ensure a certain initial success, but it also limits the opportunities for these artists to develop their careers and build bridges between themselves and their new audiences.[3]

As an art historian, who has also been active as a curator since the mid-2000s, I have often been directly confronted with these questions. How does one balance the wish to present undoubtedly interesting recent works of art and artists as such, and not as explanations of the horrific ongoing war? How to guarantee artists the right to express a variety of views? And, related to this, how does one cope with the wish of institutions to be at the forefront of what is considered "hot" on the contemporary art scene? I have

occasionally felt that my curatorial projects as well as the artists' works have been misused by some uncommunicated agenda to enhance the public image of an institution and to appear as cosmopolitan, informed, grounded in global realities and engaged in contemporary debates. While there has generally also been a clear sympathy for the Syrians as a people and the terrible phase the country is currently going through, the lack of interest in art-historical questions related to art by Syrian artists and the multiple layers of meaning in their works has often been difficult to deal with.

Balancing the presentation of the artists and their works in a framework that combines discussions of aesthetics with the necessity to provide contextual information that allows audiences to access the works remains a challenge. Exhibitions and other artistic events focusing on art from conflict zones are often considered more from an educational perspective than artistic one. Silvia Naef has made similar observations concerning the presentation of Iraqi art and its reception by the public in the West. Exhibitions have been presented as a way to look at "Iraq's present situation through art, of seeing history through these artists' eyes" and, in "most cases, panel discussions and debates about the situation in Iraq accompanied the exhibition".[4] The practice of organizing panels and talks focusing on the socio-political situation in Arab conflict zones as parallel programmes to exhibitions is of course not necessarily detrimental, nor is giving European audiences and Arab artists opportunities to meet and discuss current issues. They have the potential to catalyze social engagement and possibly also garner understanding for the situation of displaced people.[5] But they often seem to overshadow the artworks and artists often express feelings of being reduced to the role of serving as political commentators at such events.[6] Recently displaced Syrian artists therefore find themselves needing to take the narrative into their own hands and provide necessary background information for audiences to understand their works, while not allowing the agenda of daily news to make us forget that they are, above all, artists. Organizers and curators play an important role in creating the frameworks that enable artists to successfully perform this balancing act.

That Syrian artists have throughout the history of modern and contemporary art in their country proven to be admirably resilient and very capable of adapting to new and complex situations gives reasons for some optimism about their futures in their new locations of residence. As I have tried to show in this book, Syrian artists have, regardless of the difficulties they were facing, relentlessly insisted on producing critical artworks, in defiance of the authoritarian system in which they were living. It is my hope that this book can help situate this defiant production in the global history of art. Simplistic notions about life and art production in Syria still abound among Western audiences and institutional staff, and during my public talks about art and cinema in Syria, I have on many occasions been confronted with audiences for whom it seemed almost painful to revise their preconceived ideas. Similar notions used to be widespread about intellectual life in the countries of the former Eastern Bloc, something which led Andrei Plesu to stress the need to avoid what he called "apocalyptic simplifications" and to stop seeing intellectuals under Eastern European dictatorships as people who "thought only in terms of dialectical materialism, painted only portraits of homage to those in power, composed only propagandistic odes and wrote only socialist realist novels and poems".[7] I have tried to refute similar notions about artistic production in Syria and present some aspects of it to show its richness and complexity. I would like to conclude by expressing my hope that the violence in Syria will end soon and that Syrians, artists and non-artists, can return to their country and start the process of rebuilding. For those artists, who may choose to stay in their new homes, it is my hope that they will continue to develop exciting work and enrich the art scenes of these locations.

Notes

1 It would extend far beyond the limits of this study to attempt to give an overall picture of the exhibitions organized around Syrian themes and their reception by the media and the public. As examples, see www.theguardian.com/uk-news/2015/apr/19/syrian-artist-war-paintings-exhibition-london and www.box-freiraum.berlin/my-voice-rings-out-for-syria/ (accessed 10 December 2019).
2 Kobena Mercer, cited in Juneja (2011), p. 274.
3 See also ibid., p. 277, for a discussion of "authenticity" as a requirement for non-Western artists to access the international art scene.
4 Naef (2015), p. 489.
5 As the example of the Syrian-German artist Manaf Halbouni and his public installation "Monument" has shown, this potential might also be nullified by the recent surge of right-wing movements. See Bank (2018a), pp. 174–175 and Bank (2019a), pp. 137–139.
6 Many artists with whom I have spoken have expressed such concerns.
7 Plesu (1995), pp. 63–64.

Bibliography

Adams, Jacqueline (2005). "When Art Loses its Sting: The Evolution of Protest Art in Authoritarian Contexts", *Sociological Perspectives* 48:4, 531–558.

Al-Attar, Najah (1986–1987). "How Great Is Art?", *Al-hayat al-tashkiliyya* 25–28, 2–3.

Alberro, Alexander (2009). "Institutions, Critique, and Institutional Critique", in Alexander Alberro and Blake Stimson, eds, *Institutional Critique: An Anthology of Artists' Writings*, Cambridge, MA: MIT Press, pp. 2–19.

Ali, Buthayna (2009). *I'm Ashamed*, self-published artist book.

Ali, Wijdan (1997). *Modern Islamic Art: Development and Continuity*, Gainesville, FL: University Press of Florida.

Alkassim, Samirah (2004). "Cracking the Monolith: Video and Film Art in Cairo", *New Cinemas* 2:1, 5–16.

Alkassim, Samirah (2006). "Tracing an Archaeology of Experimental Video in Cairo", *Nebula* 3:1, 132–151.

Al Khatib, Reem and Yazaji, Rana (2010). "Cultural Policy Profiles: Syria", in *Cultural Policies in Algeria, Egypt, Jordan, Lebanon, Morocco, Palestine, Syria and Tunisia: An Introduction, Cultural Resource*, Amsterdam: European Cultural Foundation and Boekmanstudies, pp. 174–200.

All Art Now (2008). "Here I Stand", exhibition catalogue, Damascus: All Art Now.

Al-Sharif, Tareq (1984–1985). "Al-fann al-tashkili al-muʿasir fi-suriya", *Al-haya al-tashkiliya*, pp. 4–109.

Amiralay, Omar (2006). "Were It Not for Cinema", in Rasha Salti, ed., *Insights into Syrian Cinema: Essays and Conversations with Contemporary Filmmakers*, New York: Ratapallax Press, pp. 95–98.

Amiralay, Omar (2009). "Documentary, History and Memory", in Catherine David, Georges Khalil and Bernd M. Scherer, eds, *Di/Visions, House of World Cultures and Forum Transregionale Studien*, Göttingen: Wallstein, https://vimeo.com/137470700.

Ankori, Gannit (2006). *Palestinian Art*, London: Reaktion Books.

Arabi, Asaad (1995). "Matière de l'oubli et de la mémoire", in *Fateh Al-Moudarres*, Damascus: Atassi Gallery and Paris Institut du monde arabe, pp. 21–28.

Araeen, Rasheed (1989). "Our Bauhaus, Other's Mudhouse", *Third Text* 3:6, 3–16.

Arnold, Marion (2013). "Here, There and In-Between: South African Women and the Diasporic Condition", in Marsha Meskimmon and Dorothy C. Rowe, eds, *Women, the Arts and Globalization*, Manchester: Manchester University Press, pp. 121–144.

Atassi, Mouna (1998). *Contemporary Art in Syria*, Damascus: Gallery Atassi.

Avez, Renaud (1993). *L'Institut français de Damas au Palais Azem (1922–1946) à travers les archives*, Damascus: Institut Français de Damas.

Ayyam (2008). *Ayyam Gallery: Special Edition Catalogue*, Damascus: Ayyam Gallery.

Ayyam (2011). *The Samawi Collection: Curated Selections of Arab Art*, Dubai: Ayyam Gallery. Available at: http://images.exhibit-e.com/www_ayyamgallery_com/5a1850bc.pdf

Bahnassi, Afif (1974). *Les styles de l'art contemporain en Syrie*, UNESCO: *Consultation collective sur les problèmes contemporains des arts arabes dans leurs relations socio-culturelles avec le monde arabe*, Hammamet: UNESCO.

Bank, Charlotte (2008). "Veiled Visuality: Video Art in Syria", *ISIM Review* 22. Available at: https://openaccess.leidenuniv.nl/bitstream/handle/1887/17270/ISIM_22_Veiled_Visuality_Video_Art_in_Syria.pdf?sequence=1

Bank, Charlotte (2014). "Marwan: Topographies of the Soul", in Marwan Qassab Bachi. *Topographies of the Soul*, Sharjah: Barjeel Art Foundation, pp. 1–3.

Bank, Charlotte (2016a). "Calling Things by Their Real Names: Anonymity and Artistic Online Production During the Syrian Uprising", *Fusion Journal* 9, Anonymous: The Void in Visual Culture. Available at: www.fusion-journal.com/issue/009-anonymous-the-void-in-visual-culture/calling-things-by-their-real-names-anonymity-and-artistic-online-production-during-the-syrian-uprising/.

Bank, Charlotte (2016b). "Painting as Critique: Oil Painting as a Site for Social and Political Negotiation in Syria", in Silvia Naef and Elahe Helbig, eds, Special Issue, Visual Modernity in the Arab World, Turkey and Iran: Reintroducing the 'Missing Modern', *Asiatische Studien / Études Asiatiques (ASI)* 70:4, 1285–1306.

Bank, Charlotte (2018a). "Remaking a World: Recently Displaced Artists from Syria in Berlin", in Johanna Rolshoven and Joachim Schlör, eds, Special Issue, Artistic Positions and Representations of Mobility and Migration, *Mobile Cultures Studies* 4, 171–182.

Bank, Charlotte (2018b). "Translating Commitment: Some Thoughts on Critical Artistic Production in the Arab World", in Jelle Bouwhuis, ed., Special Issue, Furthering, nurturing and futuring Global Art Histories?, *Kunstlicht* 39:1, 35–42.

Bank, Charlotte (2019a). "Give Sorrow Images: Trauma and Loss in the Works of Displaced Artists from Syria", in Lucy Wrapson, Victoria Sutcliffe, Sally Woodcock and Spike Bucklow, eds. *Migrants: Art, Artists, Materials and Ideas Crossing Borders*, London: Archetype Publications, pp. 130–140.

Bank, Charlotte (2019b). "Art Education in Twentieth Century Syria", in Nino Nanobashvili and Tobias Teutenberg, eds, *Drawing Education Worldwide! Continuities – Transfers – Mixtures*, Heidelberg: University of Heidelberg Press, pp. 305–319.

Bank, Charlotte (2020). "Feminism and Social Critique in Syrian Contemporary Art", in Ceren Özpınar and Mary Kelly, eds, *Under the Skin: Feminist Art from the Middle East and North Africa Today*, Oxford: Proceedings of the British Academy (forthcoming).

Barakat, Saleh M. (2003). "The Place of the Image in the Levantine Interior: The Lebanese Case", in Bernard Heyberger and Silvia Naef, eds, *La multiplication des images en pays d'Islam: de l'estampe à la télévision XVIIe–XXIe siècle, Actes du colloque, Images: fonctions et langages. L'incursion de l'image moderne dans l'Orient musulman et sa périphérie, Istanbuler Texte und Studien 2*, Würzburg: Ergon Verlag, pp. 131–139.

Bardaouil, Sam (2016). "The Art and Liberty Group: Rupture, War and Surrealism in Egypt (1938–1948)", in Sam Bardaouil and Till Fellrath, eds, *Art et Liberté: Rupture, War and Surrealism in Egypt (1938–1948)*, Paris: Skira, pp. 16–53.

Bardaouil, Sam and Fellrath, Till (eds) (2016). *Art et Liberté: Rupture, War and Surrealism in Egypt (1938–1948)*, Paris: Skira.

Baykam, Bedri (1994). *Monkeys' Right to Paint and the Post-Duchamp Crisis: The Fight of a Cultural Guerilla for the Rights of Non-Western Artists and the Empty World of the Neo-Ready-Mades*, Istanbul: Literatür, pp. 47–61.

Becker, Howard S. (1982). *Art Worlds*, Berkeley, CA: University of California Press.

Behiery, Valerie (2012). "Alternative Narratives of the Veil in Contemporary Art", *Comparative Studies of South Asia, Africa and the Middle East* 32:1, 130–146.

Boëx, Cécile (2006). "Taḥyâ as-sînamâ! Produire du sens: les enjeux politiques de l'expression dans l'espace public", *Revue des mondes musulmans et de la Méditerranée* December, 115–116. Available at: http://remmm.revues.org/3035.

Boëx, Cécile (2011a). "La contestation médiatisée par le monde de l'art en contexte autoritaire. L'expérience cinématographique en Syrie au sein de l'Organisme général du cinéma, 1964–2010", PhD dissertation, Aix en Provence.

Boëx, Cécile (2011b). "The End of the State Monopoly over Culture: Toward the Commodification of Cultural and Artistic Production", *Middle East Critique* 20:2, 139–155.

Boullata, Kamal (2009). *Palestinian Art, 1850–2005*, London: Saqi.

Bourdieu, Pierre (1993). *The Field of Cultural Production*, ed. Randal Johnson, New York: Columbia University Press.

Buchloh, Benjamin H.D. and Martin, Jean-Hubert (1989). "Interview", *Third Text* 3:6, 19–27.

Calirman, Claudia (2012). *Brazilian Art under Dictatorship: Antonio Manuel, Artur Barrio, and Cildo Meireles*, Durham, NC: Duke University Press.

Campbell, David (2004). "Horrific Blindness: Images of Death in Contemporary Media", *Journal for Cultural Research* 8:1, 55–74.

Clark, T.J. (1973). *Image of the People: Gustave Courbet and the 1848 Revolution*. London: Thames and Hudson.

Conn, Steven (2002). "Narrative Trauma and Civil War History Painting, or Why Are These Pictures So Terrible?", *History and Theory* 41, 17–42.

Connelly, Frances S. (2012). *The Grotesque in Western Art and Culture: The Image at Play*, New York: Cambridge University Press.

cooke, miriam (2007). *Dissident Syria: Making Oppositional Arts Official*, Durham, NC: Duke University Press.

cooke, miriam (2011). "The Cell Story: Syrian Prison Stories after Hafiz Asad", *Middle East Critique* 20:2, 169–187.

cooke, miriam (2013). "Tadmor's Ghosts", *Review of Middle East Studies* 47:1, 28–36.

cooke, miriam (2017). *Dancing in Damascus: Creativity, Resilience, and the Syrian Revolution*, New York: Routledge.

Crapo, Paul B. (1991). "Disjuncture on the Left: Proudhon, Courbet and the Antwerp Congress of 1861", *Art History* 14:1, 67–91.

Danko, Dagmar (2011). *Zwischen Überhöhung und Kritik. Wie Kulturtheoretiker zeitgenössische Kunst interpretieren*, Bielefeld: transcript Verlag.

David, Catherine (1997). "Documenta X: Introduction to the Short Guide". Press release. Available at: http://universes-in-universe.de/doc/e_press.htm

Davidian, Vazken Khatchig (2014). "Portrait of an Ottoman Armenian Artist of Constantinople: Rereading Teotig's Biography of Simon Hagopian", *Revue arménienne des questions contemporaines* 4, 11–54.

De Chatel, Francesca (2014). "The Role of Drought and Climate Change in the Syrian Uprising: Untangling the Triggers of the Revolution", *Middle Eastern Studies* 50:4, 521–535.

Deleuze, Gilles and Guattari, Félix (2013). *A Thousand Plateaus*, trans. B. Massumi, London: Bloomsbury.

Devictor, Agnès (2002). "Classic Tools, Original Goals: Cinema and Public Policy in the Islamic Republic of Iran (1979–1997)", in Richard Tapper, ed., *The New Iranian Cinema: Politics, Representation and Identity*, New York: I. B. Tauris, pp. 66–76.

Dickinson, Kay (2016). *Arab Cinema Travels: Transnational Syria, Palestine, Dubai and Beyond*, London: British Film Institute.

Dormröse, Ulrich (2012). "Einführung", in *Geschlossene Gesellschaft. Künstlerische Fotografie in der DDR 1949–1989*, Berlin:Berlinische Galerie, pp. 16–17.

Dressler, Iris (2010). "Subversive Practices: Art under Conditions of Political Repression: 60s–80s. South America / Europe", in Hans D. Christ and Iris Dressler, eds. *Subversive Practices: Art under Conditions of Political Repression: 60s–80s. South America/Europe*, Ostfildern: Württembergischer Kunstverein, pp. 38–56.

Dussaud, René (1927). "La mission du peintre Jean Ch. Duval en Syrie (1924)", *Syria*, 8: 3, 248–253.

Efimova, Alla (1997). "To Touch on the Raw: The Aesthetic Affections of Socialist Realism", *Art Journal* 56: 1, 72–80.

Egan, Eric (2011a). "Regime Critics Confront Censorship in Iranian Cinema", in Joseph Gugler, ed., *Film in the Middle East and North Africa: Creative Dissidence*, Austin, TX:University of Texas Press, pp. 37–62.

Egan, Eric (2011b). "Stray Dogs: Cruelty and Humanity amid Hardship in Afghanistan", in Joseph Gugler, ed., *Film in the Middle East and North Africa: Creative Dissidence*, Austin, TX:University of Texas Press, pp. 95–103.

El-Jeiroudi, Diana (2005). "Interview mit Gerald Matt", in *Some Stories: Künstlerinnen aus Ägypten, Algerien, Iran, Libanon, Palästina, Syrien, und der Türkei zeigen in Film und Video Konstruktionen weiblicher Identität*, Vienna: Kunsthalle Wien, pp. 40–41.

Ende, Werner (1984). "Wer ist ein Glaubensheld, wer ist ein Ketzer? Konkurrierende Geschichtsbilder in der modernen Literatur islamischer Länder", *Die Welt des Islams*, New Series 23/24, 70–94.

Escovitz, Joseph H. (1983). "Orientalists and Orientalism in the Writings of Muhammad Kurd Ali", *International Journal of Middle East Studies* 15:1, 95–109.

Farzin, Media (2014). "Exhibit A: On the History of Contemporary Arab Art Shows", in Kaelen Wilson-Goldie and Negar Azimi, eds, *Here and Elsewhere*, New York: New Museum, pp. 89–97.

Freitag, Ulrike (1999). "In Search of 'Historical Correctness': The Ba'th Party in Syria", *Middle Eastern Studies* 35:1, 1–16.

Fuss, Peter (2001). *Das Groteske: Ein Medium des kulturellen Wandels*, Cologne: Böhlau.

George, Alan (2003). *Syria: Neither Bread Nor Freedom*, London: Zed Books.

Ghadbian, Najib (2001). "Contesting the State Media Monopoly: Syria on Al-Jazira Television", *Middle East Review of International Affairs* 5:2, 75–87.

Gugler, Josef (2011). "*The Extras (Nabil Maleh)*. Lovers Suffer the Twin Repressions of Patriarchal Culture and a Police State", in Joseph Gugler, ed., *Film in the Middle East and North Africa: Creative Dissidence*, Austin, TX:University of Texas Press, pp. 125–133.

Hadria, Michèle Cohen (2005). "Nothing New Under the Western Sun. Or the Rise of the Arab Experimental Documentary", *Third Text* 19:1, 33–43.

Halasa, Malu (ed.) (2012). *Culture in Defiance: Continuing Traditions of Satire, Art and the Struggle for Freedom in Syria*, Amsterdam: Prince Claus Fund for Culture and Development.

Hanano, Amal (2012). "The Real Me and the Hypothetical Syrian Revolution (Part 2)", *Jadaliyya*. Available at: www.jadaliyya.com/pages/index/4788/the-real-me-and-the-hypothetical-syrian-revolution

Hegasy, Sonja (2010). "Representing Change and Stagnation in the Arab World: Re-thinking a Research Design", *The Mediterranean Review*, 3:2, 23–42.

Hinnebusch, Raymond (2001). *Syria: Revolution from Above*, London: Routledge.

Hinnebusch, Raymond (2012). "Syria: from 'Authoritarian Upgrading' to Revolution?", *International Affairs* 88:1, 95–113.

Hussam Al-Din, Muhammad and Hassan, Abu Ayyash (1988). *Taufiq Tareq, Michael Kirsheh*, Syrian Plastic Arts Series 1, Damascus: Alsahani Establishment.

Hussam al-Din, Muhammad and Hassan, Abu Ayash (1991). *M. Jalal, A. A. Al Sououd, K. Mouaz, A. A. Arnaout*, Syrian Plastic Arts Series 3, Damascus: Salhini Printing and Publishing.

International Crisis Group (2004). "Syria Under Bashar II: Domestic Policy Challenges", ICG Middle East Report No. 24. Brussels: International Crisis Group.

Johnson, Randal (1993). "Introduction", in Pierre Bourdieu, *The Field of Cultural Production*, New York: Columbia University Press, pp. 1–25.

Juneja, Monica (2011). "Global Art History and the 'Burden of Representation'", in Hans Belting, Jacob Birken, Andrea Buddensieg, and Peter Weibel, eds, *Global Studies: Mapping Contemporary Art and Culture*, Ostfildern: Hatje Cantz, pp. 274–297.

Karkutli, Burhan (1981). *Grafik der Revolution. Burhan Karkutli. Ein palästinensischer Künstler*, Frankfurt/Main: Rita G. Fischer Verlag.

Kayali, Louay (2008). *Hasasiya al-fanan, ka-fard wa dawruha fi al-nazaha* [The Sensitivity of the Artist, as an Individual, and its Role in Artistic Integrity], reprinted in Tarek al-Sharif, (ed.) *Louay Kayyali: Hadatha Fanniyya...wa Madmun Insani* [Louay Kayali: Artistic Modernity... with a Human Approach], Damascus: General Secretariat of Damascus Arab Capital of Culture, p. 91.

Kee, Joan (2011). "Introduction: Contemporary Southeast Asian Art", *Third Text* 25:4, 371–381.

Keiso, Fassih (2006). *A Brief Survey of Media Art in the Arab Region: Mesh 19 Global/Regional Perspectives*, Melbourne: Experimenta Media Arts, unpaginated.

Klemm, Verena (2000): "Different Notions of Commitment (Iltizam) and Committed Literature (al-adab al-multazim) in the Literary Circles of the Mashriq", *Arabic and Middle Eastern Literatures* 3:1, 51–61.

Komaromi, Ann (2007). "The Unofficial Field of Late Soviet Culture", *Slavic Review* 66:4, 605–629.

LaCoss, Don (2010). "Egyptian Surrealism and 'Degenerate Art' in 1939", *The Arab Studies Journal* 18:1, 78–117.

Lenssen, Anneka (2008). "The Seasons of Tell-Al Hejara, Damascus", *Bidoun* 13, 122.

Lenssen, Anneka (2011). *Archive Map: Syria*, Cairo: Townhouse Gallery. Available at: http://speakmemory.org/uploads/ArchiveMapSyria.pdf

Lenssen, Anneka (2013). "The Plasticity of the Syrian Avant-Garde 1964–1970", *Art Margins* 2:2, 43–70.

Lenssen, Anneka (2014). "The Shape of the Support: Painting and Politics in Syria's Twentieth Century", PhD dissertation, Massachusetts Institute of Technology.

Lenssen, Anneka (2017). "Adham Isma'il's Arabesque: The Making of Radical Arab Painting in Syria", *Muqarnas* 34, 223–258.

Lenssen, Anneka, Rogers, Sarah and Shabout, Nada (eds) (2018). *Primary Documents*, New York: Museum of Modern Art.

Lundgren-Jörum, Emma (2012). "Discourses of a Revolution: Framing the Syrian Uprising", *Ortadoğu Etütleri* 3:2, 9–39.

Maari, Boutros (2006). "Tradition populaire et création artistique: L'émergence de la peinture moderne en Syrie", PhD dissertation, Paris: Ecole des hautes études et sciences sociales.

Maghribi, Reem (2011). "Raising the Flag: Atassi Gallery", *Canvas*, July/August, 68–77.

Maleh, Nabil (2006). "Scenes from Life and Cinema", in Rasha Salti, ed. *Insights into Syrian Cinema: Essays and Conversations with Contemporary Filmmakers*, New York: Ratapallax Press, pp. 87–94.

Marks, Laura U. (2000). *The Skin of the Film: Intercultural Cinema, Embodiment, and the Senses*, Durham, NC: Duke University Press.

Marks, Laura U. (2003). "What Is That and between Arab Women and Video? The Case of Beirut", *Camera Obscura* 54, 18:3, 41–69.

Marks, Laura U. (2015). *Hanan al-Cinema: Affections for the Moving Image*, Cambridge, MA: The MIT Press.

Martin, Jean-Hubert (1989a). *Magiciens de la terre*, Paris: Editions du Centre Pompidou.

Martin, Jean-Hubert (1989b). "Préface", in Jean-Hubert Martin, *Magiciens de la terre*, Paris: Editions du Centre Pompidou, pp. 8–11.

Marwan (1998). *An die Kinder Palästinas*, Munich: Goethe Institut.

Massad, Joseph A. (2007). *Desiring Arabs*, Chicago: The University of Chicago Press.

Matar, Amer (2014). "Art & Freedom", in Malu Halasa, Zaher Omareen, and Nawara Mahfoud, eds, *Syria Speaks: Art and Culture from the Frontline*, London: Saqi Books, pp. 240–255.

Mathur, Saloni (2011). "A Retake of Sher-Gil's Self-Portrait as Tahitian", *Critical Inquiry* 37:3, 515–544.

Meskimmon, Marsha (2011). "Making Worlds, Making Subjects: Contemporary Art and the Affective Dimension of Global Ethics", *World Art*, 1:2, 189–196.

Meskimmon, Marsha and Rowe, Dorothy C. (2013). "Editorial Introduction: Ec/centric Affinities: Locations, Aesthetics, Experiences", in Marsha Meskimmon and Dorothy C. Rowe, eds, *Women, the Arts and Globalization: Eccentric Experience*, Manchester: Manchester University Press, pp. 1–14.

Muhanna, Nadia (2008). "King of Darkness", *Syria Today*, February, 47–48.

Naef, Silvia (1996). *A la recherche d'une modernité arabe. L'évolution des arts plastiques en Egypte, au Liban et en Irak*, Geneva: Slatkine.

Naef, Silvia (2001). "Portrait de femmes. Figuration de la féminité dans l'art contemporain du machrek", *Horizons Maghrebins* 44, 53–61.

Naef, Silvia (2002). "Between Symbol and Reality: The Image of Women in Twentieth-Century Arab Art", in Randi Deguilhem and Manuela Marin, eds, *Writing the Feminine: Women in Arab Sources*, New York: I.B. Tauris, pp. 221–235.

Naef, Silvia (2003). "Peindre pour être moderne? Remarques sur l'adoption de l'art occidental dans l'Orient arabe", in B. Heyberger and Silvia Naef, eds, *La multiplication des images en pays d'Islam – De l'estampe à la télévision – (17e–21e siècles)*, Istanbul and Würzburg: Orient-Institut/Ergon Verlag, pp. 189–207.

Naef, Silvia (2010). "Exhibiting the Work of Artists from 'Islamic' Backgrounds in the West. Current Practices and Future Perspectives", *West Coast Line 64: Orientalism & Ephemera* 43:4, 30–37.

Naef, Silvia (2015). "Not Just 'For Art's Sake': Exhibiting Iraqi Art in the West After 2003", in Jordi Tejel, Peter Sluglett, Riccardo Bocco and Hamit Bozarslan, eds, *Writing the Modern History of Iraq: Historiographical and Political Challenges*, Singapore: World Scientific Publishing, pp. 475–499.

Naficy, Hamid (2002). "Islamizing Film Culture in Iran: A Post-Khatami Update", in Richard Tapper, ed., *The New Iranian Cinema: Politics, Representation and Identity*, New York: I.B. Tauris, pp. 26–65.

Nashashibi, Salwa Mikdadi (1998). "Gender and Politics in Contemporary Art: Arab Women Empower the Image", in Sherifa Zuhur, ed., *Images of Enchantment: Visual and Performing Arts of the Middle East*, Cairo: The American University of Cairo Press, pp. 165–182.

Nochlin, Linda (1982). "The De-Politicization of Gustave Courbet: Transformations and Rehabilitation under the Third Republic", *October* 22, 64–78.

Ory, Pascal and Sirinelli, Jean-François (1986). *Les intellectuels en France, de l'Affaire Dreyfus à nos jours*, Paris: Armand Colin.

Pace, Joe and Landis, Joshua (2012). "The Syrian Opposition: The Struggle for Unity and Relevance, 2003–2008", in Fred H. Lawson, ed., *Demystifying Syria*, London: Saqi and London Middle East Institute SOAS, pp. 120–143.

Persekian, Jack (2003). "A Diary of Disorientation", in *DisOrientation: Contemporary Arab Artists from the Middle East*, Berlin:House of World Cultures, pp. 94–99.

Perthes, Volker (2004a). *Syria Under Bashar Al-Assad: Modernization and the Limits of Change*, Oxford: Oxford University Press.

Perthes, Volker (2004b). "Syria", in Volker Perthes, ed., *Arab Elites: Negotiating the Politics of Change*, Boulder, CO: Lynne Rienner Publishing, pp. 87–114.

Plesu, Andrei (1995). "Intellectual Life under Dictatorship", *Representations* 49, 61–71.

PLO (1978). *International Art Exhibition for Palestine*, Beirut: Plastic Arts Section.

Pollock, Griselda (2003). *Vision and Difference: Feminism, Femininity and the Histories of Art*, New York: Routledge.

Porteous, Rebecca (1995). "The Dream: Extracts from a Film Diary by Muhammad Malas", *Alif: Journal of Comparative Poetics* 15, 208–228.

Porter, Venetia (2006). *Word into Art: Artists of the Modern Middle East*, London: British Museum Press.

Preda, Caterina (2012). "Artistic Critiques of Modern Dictatorships", *The European Legacy* 17:7, 899–917.

Puppet Masters. Top Goon (2012). In Malu Halasa, ed., *Culture in Defiance: Continuing Traditions of Satire, Art and the Struggle for Freedom in Syria*, Amsterdam: Prince Claus Fund for Culture and Development, pp. 13–15.

Qashlan, Mamdouh (2006). *Nusf Qarn min al-Ibda' al-Tashkiliyy fi-Suriyya*, Damascus: Ebla li-l-funun al-jamila.

Radwan, Nadia (2011). "Les arts visuels de l'Égypte moderne, méthodes de recherches et sources: l'exemple de Mahmûd Mukhtâr (1891–1934)", *Qaderns de la Mediterrània* 15, 51–61.

Rosler, Martha (1990). "Video: Shedding the Utopian Moment", in Doug Hall and Sally Jo Fifer, eds, *Illuminating Video: An Essential Guide to Video Art*, New York: Aperture, pp. 31–50.

Rosler, Martha (2010). "Take the Money and Run? Can Political and Socio-Critical Art 'Survive'?", in Julieta Aranda, Brian Kuan Wood, and Anton Vidokle eds, *What Is Contemporary Art?*, e-flux journal, Berlin:Sternberg Press, pp. 104–140.

Rule, Alix and Levine, David (2013). *International Art English* . Available at: www.canopycanopycanopy.com/contents/international_art_english

Said, Edward (1979). *Orientalism*, New York: Vintage Books.

Said, Edward (1994). *Representations of the Intellectual: The 1993 Reith Lectures*, London: Vintage Books.

Salamandra, Christa (2004). *A New Old Damascus: Authenticity and Distinction in Urban Syria*, Bloomington, IN: IndianaUniversity Press.

Salamandra, Christa (2008). "Creative Compromise: Syrian Television Makers between Secularism and Islamism", *Contemporary Islam* 2:3, 177–189.

Salamandra, Christa (2015). "Syria's Drama Outpouring : Between Complicity and Critique", in Christa Salamandra and Leif Stenberg, eds, *Syria from Reform to Revolt*, vol. 2. *Culture, Society, and Religion*, Syracuse, NY: Syracuse University Press, pp. 36–52.

Salamandra, Christa and Stenberg, Leif (2015). "Introduction: A Legacy of Raised Expectations", in Christa Salamandra and Leif Stenberg, eds, *Syria from Reform to Revolt*, vol. 2. *Culture, Society, and Religion*, Syracuse, NY: Syracuse University Press, pp. 1–15.

Salloum, Jayce (2005). "In/tangible Cartographies", *Third Text* 19:1, 27–31.

Salti, Rasha (2006). "Critical Nationals: The Paradoxes of Syrian Cinema", in Rasha Salti, ed., *Insights into Syrian Cinema: Essays and Conversations with Contemporary Filmmakers*, New York: Ratapallax Press, pp. 21–44.

Salti, Rasha (2012). "Shall We Dance?", *Cinema Journal* 52:1, 166–171.

Sarkissian, Hrair (2011). "The Past", in *Sharjah Biennial 10*, Sharjah: Sharjah Art Foundation, pp. 349–354.

Sartre, Jean-Paul (1993). *What Is Literature?*, trans. Bernard Frechtman, New York: Routledge.

Scheid, Kirsten (2005). "Painters, Picture-Makers, and Lebanon: Ambiguous Identities in an Unsettled State", PhD dissertation, Princeton University.

Scheid, Kirsten (2010). "Necessary Nudes: Hadatha and Mu'asira in the Lives of Modern Lebanese", *International Journal of Middle Eastern Studies* 42, 203–230.

Scott, James C. (1990). *Domination and the Arts of Resistance: Hidden Transcripts*, New Haven, CT: Yale University Press.

Shabout, Nada (2007). *Modern Arab Art: Formation of an Arab Aesthetic*, Gainesville, FL: University of Florida Press.

Shaw, Wendy M. K. (2011). *Ottoman Painting: Reflections of Western Art from the Ottoman Empire to the Turkish Republic*, New York: I.B. Tauris.

Shohat, Ella and Stam, Robert (1994). *Unthinking Eurocentrism: Multiculturalism and the Media*, London: Routledge.

Sjeklocha, Paul and Mead, Igor (1967). *Unofficial Art in the Soviet Union*, Berkeley, CA: University of California Press.

Sloman, Paul (ed.) (2009). *Contemporary Art in the Middle East*, London: Black Dog Publishing.

Smith, Terry (2006). "Contemporary Art and Contemporaneity", *Critical Inquiry* 32:4, 681–707.

Smith, Terry (2011). "Currents of Worldmaking in Contemporary Art", *World Art* 1:2, 171–188.

Sontag, Susan (2003). *Regarding the Pain of Others*, New York: Picador.

Sparre, Sara Lei (2008). "Educated Women in Syria: Servants of the State, or Nurturers of the Family?", *Critique: Critical Middle Eastern Studies* 17:1, 3–20.

Spens, Christiana (2014). "The Theatre of Cruelty: Dehumanization, Objectification and Abu Ghraib", *Contemporary Voices: St Andrews Journal of International Relations* 5:3, 49–69.

Springborg, Robert (1981). "Baathism in Practice: Agriculture, Politics, and Political Culture in Syria and Iraq", *Middle Eastern Studies* 17:2, 191–209.

Takieddine, Zena (2010). "Arab Art in a Changing World", *Contemporary Practices* 7, 54–61.

Takkenberg, Lex (2010)."UNRWA and the Palestinian Refugees after Sixty Years: Some Reflections". Available at: www.unrwa.org/userfiles/20100610957.pdf (15 November 2019).

Taleghani, R. Shareah (2015). "Breaking the Silence of Tadmor Military Prison", Middle East Report 275. Available at: www.merip.org/mer/mer275/breaking-silence-tadmor-military-prison

Terman, Rochelle L. (2010) "To Specify or Single Out: Should We Use the Term 'Honor Killing'?", *Muslim World Journal of Human Rights* 7:1, 1–39.

Toukan, Hanan (2015). "Whatever Happened to *Iltizam*? Words in Arab Art after the Cold War", in Friederike Pannewicj and Georges Khalil together with Yvonne Albers, eds, *Commitment and Beyond: Reflections on/of the Political in Arabic Literature since the 1940s*, Wiesbaden: Reichert Verlag, pp. 333–349.

Tramontini, Leslie (2013). "Speaking Truth to Power? Intellectuals in Iraqi Baathist Cultural Production", *Middle East – Topics & Arguments* 01, 53–61.

Vitali, Valentina (2004). "Corporate Art and Critical Theory: On Shirin Neshat", *Women: A Cultural Review* 15/1, 1–18.

Wallach, Amei (1991). "Censorship in the Soviet Bloc", *Art Journal* 50: 3, 75–83.

Wang, Dan S. (2003). "Practice in Critical Times: A Conversation with Gregory Sholette, Stephanie Smith, Temporary Services, and Jacqueline Terrassa", *Art Journal* 62:2, 68–81.

Weber, Stefan (2002). "Images of Imagined Worlds: Self-image and Worldview in Late Ottoman Wall Paintings of Damascus", in Jens Hanssen, ed., *The Empire in the City: Arab Provincial Capitals in the Late Ottoman Empire*, Würzburg: Ergon Verlag, pp. 146–171.

Wedeen, Lisa (1999). *Ambiguities of Domination: Politics, Rhetoric, and Symbols in Contemporary Syria*, Chicago: University of Chicago Press.

Winegar, Jessica (2006). *Creative Reckonings: The Politics of Art and Culture in Contemporary Egypt*, Stanford, CA: Stanford University Press.

Winegar, Jessica (2008). "The Humanity Game: Art, Islam and the War on Terror", *Anthropological Quarterly* 81:3, 651–681.

Wu, Chin-Tao (2007). "Worlds Apart: Problems of Interpreting Globalised Art", *Third Text* 21:6, 719–731.

Zayat, Elias (2008). "Introduction", in *Revival of Plastic Art Memory in Syria*, vol. I. *From the Beginnings Until the Sixties of the Twentieth Century: Selections from the National Museum Collections in Damascus*, Damascus: Ministry of Culture, pp. 16–20.

Index

Italic page numbers refer to figures.